Oaxaca at the Crossroads

Selma Holo

OAXACA
AT THE CROSSROADS

Managing Memory, Negotiating Change

Smithsonian Books

Washington

Copy editor: D. Teddy Diggs

Production editor: Robert A. Poarch

Designer: Brian Barth

Library of Congress Cataloging-in-Publication Data

Holo, Selma.

 Oaxaca at the crossroads : managing memory, negotiating change / Selma Reuben Holo.

 p. cm.

 Includes bibliographical references and index.

 ISBN 1-58834-187-9 (alk. paper)

1. Oaxaca de Juárez (Mexico)—Cultural policy. 2. Arts—Mexico—Oaxaca de Juárez.

3. Museums—Mexico—Oaxaca de Juárez. I. Title.

F1391.O12H65 2004

972'.74—dc22 2004045420

British Library Cataloguing-in-Publication Data available

For, con todo mi corazón, my grandchildren
Sam, Jo, Noam, and Ghita
and for their great-grandmother, Ghita

Contents

Preface

Oaxaca at the Crossroads: Managing Memory, Negotiating Change is a tribute to an extraordinary Mexican state and its capital city—a region where culture sits firmly ensconced at the heart of identity. This book is not a history of that culture; it is not an in-depth view of its component parts. Rather, it is an overview of a special kind of richness that can be found to be thriving in that state, wherein the primacy of creativity has been unusually accepted and honored.

Granted, *culture* seems to be a much larger word in Mexico than it is in the United States. In Mexico, the word *culture* encompasses the complete range of meaning-making—the ways of life and death—shaped by and adhered to by humankind in society. In the United States, *culture* is more generally (although not for sociologists) assumed to refer to the arts—the visual, the performing, the literary, and increasingly, the culinary—a thing apart from the other aspects of life such as economics, politics, recreation, and sport. I look at Oaxaca with the

awe of an outsider who believes that its deeply integrated culture has much to teach the civic-minded inhabitant of any city, region, or state. Nevertheless, *Oaxaca at the Crossroads* is limited to an exploration of a number of case studies related to the culture of the visual arts in the last two decades. It leaves the multitudinous other aspects of culture and the fabulous nature of Oaxaca (e.g., its beaches, its flora) to those better-equipped to discuss such areas. This book is an exploration of some outstanding instances of how Oaxacans, one by one and cumulatively, redefined their home: from a far-away place known to all Mexicans, but only to highly educated foreigners, into a world-class destination at the top of the list of any globe-trotter.

Oaxaca was, by the end of the twentieth century, well recognized for its archaeological ruins, its well-preserved colonial capital city, its thriving contemporary art and artisanry scene, and yes, its unique and unforgettable cuisine. It was considered a perfect place to study Spanish. But Oaxaca is still insufficiently known for the civic and individual efforts that have transformed the area into a vanguard force for the expression of indigenous living histories, for the preservation of the urban fabric of Oaxaca City's historic center and its environs, and by extension, for a way of life that acknowledges and participates in globalization while struggling to protect local character. Oaxaca is virtually unknown for the heroic roles that its artists, intellectuals, and private citizens have assumed as they took and continue to take responsibility not only for their individual creative production but also for the communal integrity and the quality of life that gives the state and the capital city their distinct flavor.

My hope is that *Oaxaca at the Crossroads* will illuminate the various crossroads that Oaxaca identified for itself during the last two decades of the twentieth century as it fought to manage its wealth of cultural memory by negotiating ideas for positive regional change. Oaxaca accomplished this somewhat outside of the national forces of transition

that were leading Mexico to the defeat of its antiquated authoritarian regime. Oaxaca's success depended less on the supposed benefits of government support than did the rest of Mexico's cultural establishment, while it nevertheless still engaged in experimental relationships with the various levels of government and with emerging private philanthropic forces. This book, although it is focuses largely on Oaxaca City, can be read as an introduction to a complex state (especially for the non-Mexican who does not know this place) that worked to transform itself into an artistic front speaking—not just to Mexico but to the world at large—of the importance of a highly conscious and conscientious approach to the consequences and uses of the past and its memory as one nears the crossroads that lead into the collective future.

I would like to extend my gratitude to the following people, whose generosity and encouragement made *Oaxaca at the Crossroads* possible: Scott Mahler, Robert A. Poarch, D. Teddy Diggs, Gaspar Rivera Salgado, Luciano Cedillo Alvarez, Raúl Jaime Zorrilla, Teresa Morales, Cuahtémoc Camarena, Amelia Lara Tamburrino, Femaría Abad, Juan Alcazar, Francisco Toledo, Fernando Solana Olivares, Fernando Gálvez de Aguinaga, Galería Quetzalli, Graciela Cervantes, Claudine López, MaryJane Gagnier, Raymundo Sesma, Enrique Audiffred, Laurie Lidowitz, James Brown, George Mead Moore, Russell Ellison, Galería Punto y Línea, Arnulfo Mendoza, Maffalda Budib, José Luis García and his family, Manuel Jiménez, Walther Boelsterly Urruitia, Guillermo Santamarina, María Isabel Grañén Porrúa, Dora Luz Martínez Vasconcelos, Nancy Mayagoitia, Eduardo López Calzada, Alejandro Avila, Miriam Arroyo, Selma Guisande, Miguel Fernández Félix, Nelly Robles García, Hector Rivero Borrell, Lila Downs, Sara Topelson de Grinberg, Eudoro Fonseca Yerena, Emanuel R. Toledo Medina, Francoise DesCamps, Tim Whalen, Alfredo Cruz Ramírez, Abdón Vázquez Villalobos, Manuel Blanco, Alicia P. de Esesarte, Graciela de la Torre, Teresa del Conde, Patricia Mendoza, Don Felipe Lacouture y Fornelli, and Miguel Angel Corzo.

I am grateful to the University of Southern California for providing me with the environment and resources that have allowed me to write and be in charge of our Museum Studies Program while performing my duties as director of USC's art museum, the Fisher Gallery. I want to acknowledge especially USC President Steven B. Sample, Provost Lloyd Armstrong Jr., and Dean Joseph Aoun. Thanks are also due the Lear Institute, and especially Marty Kaplan, Leo Braudy, Abe Loewenthal, Steve Ross, and Warren Bennis, for giving me the benefit of their wisdom when I presented a chapter of this book as a work in process to my colleagues at the institute. I owe an undying debt of gratitude to the USC Fisher Gallery Staff, especially to Kay Allen and Matt Driggs.

I thank warmly El Oaxaqueño, the weekly newspaper that serves the people of Oaxaca so well, so far from their native land. And finally, I thank my husband, Fred Croton, without whom I could never have written this book.

Introduction

Why Oaxaca? Why Now?

Oaxaca at the Crossroads: Managing Memory, Negotiating Change was written after several years of my grappling with a growing desire to produce a book on the changing visual arts scene in Mexico. When I began my research in 1999, my plan was to analyze whether present-day museums and museum-related institutions were, in effect, functioning as a critique of the coherent Mexican national identity—an identity that had been so carefully established, articulated, and nurtured by the Institutionalized Revolutionary Party (better known as the "PRI") for over seventy years. By 1999 it was generally accepted that the PRI and its policies were showing signs of wear and tear. Furthermore, it was apparent that the cultural life of the nation was moving in directions that were demonstrating significant independence of the PRI ideology. In many of the communities throughout the country, new ideas had even begun to surface about the nature of *mexicanidad* (Mexicanness); tell-tale cracks were appearing in the monolithic identity-construction armature that the political/cultural

institutions had once been universally charged with sustaining. Of course, in 1999 one could not know for sure if those cracks would develop into fissures, but as the election approached, there was a general anticipation that they indeed would. As luck would have it, I was in Oaxaca on July 2, 2000, the date of the thrilling defeat of the PRI and its authoritarian and corrupt regime. I watched the mixed emotions of expectation and dread grow as the leaders of the country's museums, archaeological sites, and cultural centers contemplated the consequences of Vicente Fox's political victory for their own lives and work. Would culture, they wondered, remain the centerpiece in the new PAN (National Action Party) government, as it had always been under the PRI? How would communal memory be changed and managed? And who would be charged with negotiating for the future of culture in Mexico should its long-institutionalized patron lose its power?

I was fascinated watching this ambivalent and ambiguous response to a situation that most of the rest of the world simply applauded. I had already developed a keen interest in how a nation's museums both responded to and affected cultural and political identities in the transition from an authoritarian to a democratic society. I had written a book, *Beyond the Prado*, about how museums and their associated organizations and projects contributed to the coloring and nuancing of a nation's sense of self. I had watched as those who had been in power traded seats with those who had been excluded—or as some of those who had "always" been in power managed, astonishingly, to hold on to their influence! The work I had done on the transition in Spain from the Franco dictatorship to the vibrant democracy that evolved after his death seemed at first to be a reasonable model for a book about Mexico embracing its own transition to democracy. It soon became apparent to me that in Spain, the art and cultural worlds had actually helped prepare for the transition by seeding the ground with green shoots of openness in the years before Franco's death. In the center and its periphery—Madrid and the

regions—Spain's museums had been used as test balloons and later as high-powered vehicles for the freer expression of long-repressed desires. End-of-twentieth-century Mexico was now clearly in the midst of its own transition, and to judge from some of the cultural expressions and experiments that had been planted there in those years, its own museums and museum-related organizations had played an equally active role in preparing the ground for the transition. But it did not take long for me to learn that PRI-directed Mexico was entirely different from Franco-controlled Spain: the PRI had always valued culture, and had long supported a wide variety of museums, artists, and exhibitions throughout the country and abroad, in a far more pro-active and sophisticated way than had dictatorial Spain. Official Spain, during the Franco years, had been indifferent to the power of culture.

By July 2000, I had visited many of Mexico's museums, many of them among the most brilliant and beautiful in the world in their collections and their displays. I had spoken with many of Mexico's cultural impresarios and had interviewed the audiences for their exhibitions. I emerged from talks and travels with the certainty that fresh ideas were in the air. Still, I decided to continue my research to see how those museums were handling themselves after the reality of the elections. By the end of the year, it had become apparent to me that my original plan to study the Mexican art scene *as a whole* in the light of divergent emerging representations of culture and identity was quixotic: Mexico's turn-of-the-century visual arts organizations were far too various, too complex, too dynamic, and too vast to approach in a single volume. Mexican culture, although it had never been as monolithic as the PRI would have wished it to be, was now more open, diverse, and volatile than ever. And the PAN government was, at least on the surface, encouraging that diversity in the name of decentralization and regionalization. Mexico's museums had for several decades already revealed the country's diversity—its discrete histories, presentations, and interpretations—but always within the context

of the more powerful, all-encompassing national narrative. What was so different as the Mexican transition developed was that diversity was being increasingly and unabashedly celebrated for its own sake at the same time that the larger narrative was being questioned. The saying that there are *muchos Méxicos* (many Mexicos) not only was true but had become something of an understatement. Mexico is a kaleidoscope of art and artisanry, of archaeology and contemporary art, of government and private support, and of a range of customs and attitudes that stem from its pluri-ethnic population. This panoply, which was already being intractably transformed and enlarged in the cultural spectrum, was now, as of the year 2000, widely and even officially more encouraged. As soon as the PAN government raised the flag of regionalism, it was immediately flown by the cultural apparatus, which set for itself the goal of decentralization—or, for a time, of "citizenization"—of the arts, even as it continued to shore up the age-old but increasingly old-age narrative of postrevolutionary Mexican nationalism.

During the summer of 2001 I decided that I would concentrate on the city of Oaxaca, a southern Mexican city that had undergone its own transition within the emergence of democratic Mexico at the end of the millennium. At first I thought that the book could approach Oaxaca as a synecdoche, a single city and state that might be able to stand in for the whole of Mexico. But as Oaxaca's personality asserted itself to me, I realized how daunting and ultimately wrong-headed that approach would be. What I found in Oaxaca would be better termed an arts and culture laboratory that had faced and ventured into its own crossroads somewhat before the rest of the country, certainly well before July 2000. Oaxaca's artistic life—as evidenced by its museums, cultural centers, archaeological sites, artisanry, individual artists, and philanthropy—had not been determined by the great political changes facing the nation as a whole on election day but had, rather, been determined by its own dynamic history and its own decisions about how its version of modernity and con-

temporaneity might fit within (or, in some cases, become an example for) the nation as a whole. I thus chose Oaxaca to be my exemplar of the Mexican city and state at the crossroads because of its conscious, constant, and constructive desire to manage its own memory and the attendant changes that would characterize it in its global/local future. But since this decision was made after much consideration and comparative research, I will summarize some of my observations after my Mexican travels—observations that provided the foundation for this decision and for the central premise of the book.

Around Mexico: Outside Mexico City

Contemporary Art

Contemporary art museums and exhibition spaces are always a key to a city's sense of itself—of how much that city is willing to entertain and court previously unsanctified ideas and challenges. And so, after July 2, 2000, I continued my visits to as many museums as possible in order to gauge the liveliness of the urban environments in which they sat. I retraced some of my steps as well. I went back to the Yucatán to visit Mérida's small, charming, renovated colonial palace, the completely publicly funded contemporary art museum known as MACAY. I admired its active but essentially domestic exhibition program, which was making yeoman-like attempts to expose a conservative population to the tenets and trends in modern art. Another exhibition space, a recently renovated former convent in Cankal outside of the capital, became the site of some more ambitious efforts to go beyond the conventional with shows of not only Mexican but also international contemporary artists. The capital, Mérida, is presently booming, not because of the museum but because of the efforts of young art entrepreneurs. Monterrey, the booming industrial city in the north of Mexico, could justifiably boast of MARCO, its own up-to-the-minute contemporary art museum where largely corpo-

rate funding sources had joined forces early on to support a world-class exhibition program inside the walls of its stunning, modernist, pastel-colored building designed by the eminent architect Ricardo Legoretto. The interior spaces of the MARCO building are so captivating and the regularly timed rush of water so exciting that the visitor can be mesmerized by the container as much as by what is mounted within it. Far away from Monterrey, Morelia's contemporary art museum, the Alfredo Zalce, is housed in a lovely late-nineteenth-century mansion; with its small but dedicated staff, it offers a steady if modest diet of modern art to its citizens. Immense Guadalajara, in the state of Jalisco, had some genuinely provocative painting exhibitions on display at the Ex-Convento del Carmen—even in 1999. These paintings were so erotic that I imagined they would have had trouble being funded by any government sources in the United States. They were, though, proudly supported by the state of Jalisco. Guadalajara has been the focus of immense plans for cultural endeavors, including museums built by world-class architects. It is also rumored to be a site of the ever-colonizing Guggenheim. In Guanajuato, the famous university town, there were also intriguing and provocative contemporary offerings available to its educated audiences. There are contemporary projects booming in places as far from Mexico City as Colima. And the city of Oaxaca, in its exquisite colonial historical center, immediately revealed itself to be a lively arena for the presentation of contemporary art. I watched an outrageous postconceptual performance piece in its Museum of Contemporary Art, MACO, the first time I went to Oaxaca, early in 1999; IAGO, Oaxaca's unsurpassed Institute of the Graphic Arts, was presenting graphic material by the international contemporary artists Alex Katz and Francesco Clemente, as well as the work of Oaxacans and other Mexicans, in its pretty colonial building; and the local "scene" maintained its own personality as well, activated by being the home and staging area of Mexico's most distinguished living artist,

Francisco Toledo. Thus in Oaxaca I found the whiff of the international cooexisting with a more recognizable local contemporary art.

Archaeological Sites and Museums

The archaeological sites and museums outside of Mexico City are equally wide-ranging. There are, of course, world-famous locations such as Chichén Itzá in the Yucatán. But there is also the far less known museum LaVenta, the unique outdoor Olmec museum celebrating the mother-culture of Meso-America in the city of Villahermosa in the state of Tabasco. A revelation and a surprise, La Venta stuns its visitors with the Olmecs' legendary colossal heads, steles, altars, animal figures, and a host of fantastic beings, nestled in a parklike setting so poetic and so connected to nature that one feels transported to the time of their creation, approximately 2,500 years ago. The Archaeological Museum in Jalapa in the state of Veracruz is, on the other hand, a modern museum gem, its own Olmec sculptures presented in the most up-to-date scientific and aesthetically controlled built environment, in an absolutely contemporary structure, a part of an urban setting. Mexico's pre-Columbian archaeological monuments—whether the elegant and poignant Palenque in Chiapas, the Purépecha pyramids in Michoacán, or the hidden, almost inaccessible rock/cave paintings in Baja California—are witness to a corpus of imagery and self-expression that is almost unimaginable in its depth and range. And Oaxaca State is, of course, the home of another world-famous pre-Columbian treasure trove: Monte Albán. The greatest of Oaxaca's archaeological sites, Monte Albán, is only a few moments from the capital. Monte Albán is the large, well-preserved, and concentrated priestly focal point of the ancient Zapotec culture and the later Mixtecs as well. Like other monuments in México, Monte Albán has a fine museum that offers both orientation and depth to the primary experience of visiting the ruins. Oaxaca is also home to numerous smaller sites,

such as Yagul; though perhaps not on the principal touristic route, these more intimate sites are haunting evocations of the elaborate rituals of the lost Zapotec empire.

Community Museums and Regional Museums

If one is looking for them, one can find the voices of Mexico's pluri-ethnicity everywhere throughout the land. At the community level, in Baja California, are two dueling museums in the Guadalupe Valley near Tecate near the border between the United States and Mexico. Each of them celebrates the Russian town that grew up there in the early twentieth century. There are offerings of black bread baked in traditional ovens, along with displays of photographs of the white-bearded, milk-products-only Molokh immigrants who immigrated to Mexico to escape discrimination in their native land. The tiniest community museum I have ever seen was struggling to maintain itself as a manifestation of the local contemporary Maya culture—hidden away in the farming center of Oxdutzcab, Yucatán. Ever-present as these museums are, nowhere are ethnic voices so many and so varied, so ubiquitous and so constant, as they are in Oaxaca State. The "communitarian museum movement" (as it is called) was founded in Mexico City, but it was developed to its most polyphonous stage in Oaxaca. Oaxaca State afforded many small pueblos the opportunities to tell their stories on their own terms. I found the variety, quality of presentation, and autonomy of each of these museums reason in itself to travel throughout the state of Oaxaca—to try to see them all.

Regional museums and history museums are scattered throughout the states of Mexico. In varied measure and with assorted means, these museums narrate the history of the particular place in which they are set—and endow that place with its own distinction within the country's metanarrative. Tuxtla-Gutierrez, the home of the Chiapas regional museum, is, in its visual recounting of one bloody repression and rebellion after another, an unforgettable proscenium for communicating the deep

personality of that tragic part of the world. Guanajuato's regional museum recounts the central role that city and state played in the enormous silver-mining history of colonial Mexico. And the Michoacán regional museum is dedicated almost as much to its own ecology as it is to pre-Columbian archaeology and to colonial, postcolonial, and modern history. The history museum of Monterrey, not technically a "regional museum" but the state's special voice of the past, is one of the best designed in the world. It has created displays that link the ancient and the modern and that seduce even the most blasé visitor into the dramas of the Mexican Revolution of 1910. This is a museum that dared, even before the defeat of the PRI, to feature a major exhibit on the controversial assassination in 1993 of the presidential candidate Luis Colosio. And of course, in my long exploratory trips, I discovered that Oaxaca's own regional museum, which had just reopened after a major overhaul in 1998, was superb. It was not only its brilliant collection of treasures from Monte Albán and the staggering collection of gold, jewels, and alabaster from the legendary "Tomb 7" that were compelling but also the context in which these were presented. In Oaxaca's regional museum, indigenous stories were foregrounded, and their cultures granted life and breath. When one enters the museum, an immense television screen features interviews with indigenous peoples of various ethnicities. Before the artifacts of their ancient civilizations are featured in their vitrines, it is immediately communicated that these high civilizations were not isolated phenomena buried in Mexico's glorious past, nor were they a part of a seamless web of indigenous groups that somehow formed the overall design of the national memory bank. Rather, the museum makes clear that the diverse cultures provide lasting evidence of specific human societies, complex societies that continue to exist in space and time and are still to be treasured, still to be nurtured, still to be "excavated." This regional museum is thus a kind of manifesto proclaiming the ethnic diversity of indigenous Oaxaca.

Cultural Centers

Cultural centers are ubiquitous in Mexico and are consciously appreciated as aids to civic identity construction. Some are imposing, and others are small *casas de cultura* (culture houses) that are meant to serve a limited population. One of the most resonant in that respect is the Centro Cultural Tijuana, known as CECUT. Although CECUT includes a regional museum, the Museum of the Two Californias, it plays numerous other roles as well. It is the most important cultural center in the state of Baja California, serving up a rich menu of national and international contemporary art shows, film programs, and lecture and music series. CECUT was conceived by the federal government to fulfill a specific purpose: to link Tijuana, that megacity marginalized from the rest of Mexico, to the mainstream of Mexico. CECUT thus has a much wider range of activities than one might expect and has been fairly well funded from the public purse—and all these activities are infused with the goal of expressing the often maligned city's best local, national, and international aspirations. These interdisciplinary efforts, based in the visual, literary, and performing arts, are programmed and patronized within the context of its citizens' message that Tijuana is much more than a border city ridden by crime and signifying only cheap tourism.

Cultural centers can be found in every city in Mexico. Some are more and some less ambitious, but the most intriguing and ambitious to me was the Centro del Arte Santo Domingo in Oaxaca, set in one of Latin America's grandest colonial former convents. The programming in Santo Domingo is certainly adventurous, but the complex is even more so, made up as it is of its aforementioned regional museum as well as an important special collections library, an ethnobotanical garden and exhibition area, and a public reading room for newspapers and journals. Furthermore, Santo Domingo's funding and governance were major experiments by the public and private sectors. It set precedents in Mexico for new kinds of part-

nerships and new kinds of oversight both in the government and the private realms.

The Built Environment

The built environment of a city is the megamuseum, the stage for its cultural life; it is the emanation of a specific urban life. Mérida, in the Yucatán, for example, is an odd mix of the colonial (with its beautiful, well-maintained, and much-frequented Zócalo), the modern (with its mix of distinguished and undistinguished buildings, notably its late-nineteenth- and early-twentieth-century mansions), and the constant reminder of the archaeological (with pre-Columbian motifs from the surrounding ruins creeping into the décor of all its hotels and restaurants). Monterrey, on the other hand, is all about contemporaneity. Whether its museums are displaying the art of the here-and-now or are providing a discourse on history, they are crisp and clean-lined and appear to be looking to tomorrow at every opportunity. Guanajuato is mostly colonial in its feeling, a university town with all of the pleasures and limitations of sophisticated small cities of this type anywhere, including a charming historical center. The city of Morelia in Michoacán is stunningly Spanish, or "colonial," as the locals insist on describing it. Nevertheless, one feels as if one were in Salamanca, it is so coherently Spanish and so brilliantly maintained as such. Tijuana is a myriad of architecture, some so "now" it seems futuristic, some so "ad hoc" as to be disturbing, and all so unnervingly disparate and seemingly incoherent that one wonders how it could ever be perceived except as a rough-and-ready border town. And yet it is so energetic and unburdened with the past that one is always surprised, delighted, or disarmed when, inevitably, one encounters something never before imagined. But Oaxaca, once again, seems to have the clearest idea of itself as a stage for the play of invaluable memories in the midst of momentous change. A colonial city, it offers the plea-

sure of a historical center avidly protected from the rapacious abuse by
the economic forces that always threaten it. Outside of the historical cen-
ter, development has been haphazard. Although there are no contempo-
rary buildings in that historical center, there is a welcoming attitude to
appropriate modernization of infrastructure and a ferocious protection-
ism against the inappropriate imposition of business interests above all
others. Oaxaca is a place nourished by the past that lives adventurously
in the present while creatively anticipating the future.

Commercial Galleries

One could go on indefinitely about the cultural offerings throughout
Mexico, including those in the commercial art galleries. The gallery scene
ranges from the most conservative, in San Miguel de Allende (where all
fine arts galleries seem to be aimed at the numerous well-heeled US res-
idents who live there year-round), to the vanguard experiments in the
fine arts that are on display or in the back rooms, but nevertheless for sale
in some cities outside Mexico City. Crafts galleries or centers seem to be
on every street corner of the cities of Mexico, testament to the ongoing
artisanry traditions that still flourish everywhere throughout the coun-
try, finding active outlets in the government shops, the public markets,
and all types of gift shops. Finally, Oaxaca revealed a consistently evolv-
ing commercial gallery scene that, during the five years that I studied it,
rapidly expanded in the number of galleries, the media they represented,
the artists they allowed into their "stables," and the vistas they were intro-
ducing to the consumer of art. The vitality was astonishing. And most
notably, the speed with which the contemporary arts galleries moved
from showing exclusively the so-called Oaxaca-style artists to a much
wider span of emerging and established artists from other parts of the
world (without jeopardizing artistic personality) was impressive. The
crafts and artisan galleries in Oaxaca were also dynamic, not only fea-
turing crafts in the normative sense but also, occasionally, allowing for

that indelicate crossover between artisanry and art to emerge, making the city's gallery "picture" increasingly open and rewarding.

Why Oaxaca?

It thus became clear to me that among the states of an extremely dynamic Mexico, Oaxaca had faced its political/cultural crossroads comparatively early. The state had an ongoing artistic tradition that could be profitably explored, and it also had new experiments, especially in Oaxaca City and its environs, that needed to be put in the context of an evolving future. The more I traveled around Mexico and the more I kept drifting back to Oaxaca, the more I realized that I needed to write the book about Oaxaca, not because the state and its capital represented either a synecdoche or a metaphor for Mexico as a whole but rather because they had been consistently, actively, and consciously involved with the task of managing memory and negotiating change since the mid-1980s. And they did so in every aspect of the arts: the contemporary, the colonial heritage, the urban environment, patronage, the pluri-ethnic heritage, the archaeology—even the commercial gallery scene. Oaxaca undertook this task openly and unrelentingly, long before this became the national project.

I thus decided to examine Oaxaca with respect to the arts, the institution of the museum, associated individuals, and governmental and non-governmental organizations during the fifteen or so years preceding the demise of the PRI and the period immediately following that momentous event. Oaxaca seemed to have something of everything with respect to the visual and material culture of Mexico. Oaxaca may be in the periphery with respect to Mexico City, but it is not provincial. People always travel there, bringing with them new ideas; and increasingly, its artists travel elsewhere, absorbing new ideas themselves. It is no accident that despite being one of the poorest states in Mexico, Oaxaca has always been a major player in the nation's political and cultural dramas. Heads

of state, such as Porfirio Diaz and Benito Juárez, reigning intellectuals, especially José Vasconcelos, and the country's most renowned artists, such as Rufino Tamayo and Francisco de Toledo, were born and raised there. And museums have literally been negotiating change there in ways that have the capacity to affect the hearts and minds of many Oaxacans and of visitors both from Mexico and from foreign countries.

I chose Oaxaca because it is a beautiful state that is drenched in almost all those memories crucial to the nation's history. Oaxaca has experienced every injustice and has been involved in almost every progressive change in Mexico. Its sense of its own identity is increasingly as a producer of artists and artisans. Oaxaca is one of the poorest of the thirty states of Mexico but ranks fourth or fifth in expenditures for culture. That commitment to culture means a great deal more than it would if Oaxaca were one of the wealthier states, where the expenditure would be incidental. Oaxaca is also a very diverse state, with numerous living native languages and many distinct indigenous cultures. Furthermore, Oaxaca stands at the forefront with respect to Indian issues. It was the first state in the country where the indigenous peoples were recognized as having the right to elect their officials in their own way—this is now considered a communitarian right. Oaxaca also instituted the Law of Culture in 1996 after it successfully promoted a new approach to indigenous peoples: the policy in Oaxaca has moved from the early integrationist mode to protectionism to the current attempt to support self-government. Now, cultural money is transferred directly to the pueblos. The Bureau of Indian Affairs, which used to manage the money that belonged to the pueblos, quit doing so in Oaxaca long before that duty was relinquished in other parts of Mexico. And today the Bureau of Indian Affairs has been dissolved by the new government as no longer necessary. Oaxaca led the way for the growing autonomy and higher profile of the indigenous pueblos in the national discourse. This is not to suggest that the problems of poverty in

Oaxaca are less than ferocious. But a very high level of consciousness has developed there.

Within this dynamic picture are Oaxaca's museums. They are many and of many types and with a wide range of technologies for the communication of each of their governing missions. Oaxaca's experimentations with private patronage and private-public partnerships have been path-breaking. Many of Oaxaca's artists are celebrities who take responsibility in civil society and are major figures in the redefinition of the city's cultural identities. Cultural tourism has recently expanded to include visitors who might not ordinarily go to museums. There is a blending of native and mainstream cultures in designed museum experiences. Oaxaca is the place where an exhaustive inquiry into the artistic nature of the new Mexico can be most profitably situated: where negotiating change has recently become at least as important as managing memory and where the crossroads to tomorrow is approached daily and sometimes excruciatingly.

Mexico City

Although this book focuses on Oaxaca, it is indispensable to consider Mexico City and the national context—the crucible—out of which Oaxaca's cultural aspirations were forged. During the same period that I was exploring Mexico's visual arts scenes in the regions outside the capital and was becoming aware of the thousands of museums, archaeological monuments, art centers, practicing artists, and galleries in the cities mentioned above, I was constantly traveling in and out of Mexico City. Mexico City is the megacultural giant that proves itself, on immediate contact, to be a world apart from any of the states within the country. Long the heart of the government's centralist efforts to compose and project the metanarrative by which Mexicans were able to identify them-

selves as a nation, it is home to the archaeology, the colonial patrimony, the revolutionary heritage, and the modern and contemporary art worlds. It is a city universally recognized by professionals and visitors worldwide for its staging of a museum culture *nonpareil*. Furthermore, this museum culture is acknowledged as inseparable from the people it serves; the message it presents has become embedded in the consciousness of a good part of the citizenry. Of course, not all museums in Mexico City are for all people all the time, but it was the museums of anthropology, modern art, and history that promoted the very idea of the nation. They were the high-profile institutions (along with the school curricula) that propagated, in the most accessible and visual ways, the heady patriotic myths that became foundational for Mexico—ultimately materializing as civic/religious in nature. The museum culture of Mexico City took its lasting physical shape under the government of the PRI in the last seventy years of the twentieth century—a shape that was centuries in the making. That the PRI must be credited for its awareness of the vast power of culture and for its support of the expression and promotion of culture needs to be recognized—no matter how potent and justifiable may be the fashionable postnationalist, revisionist critique of the PRI's larger means and ends. So, although this book focused on Oaxaca, it is indispensable to consider Mexico City and the national context—the crucible out of which Oaxaca's own visual aspirations were forged.

The process of building the modern Mexican civic/religious identity began with destruction rather than creation. As early as the sixteenth century, when Mexico was conquered by the Spanish, the invaders attempted to destroy the artistic production of the indigenous peoples, considering every such act of destruction to be a contribution to the noble enterprise of establishing Catholicism in New Spain. The first stage of Hispanicization, then, was to eliminate as much of the idolatrous past—as evidenced in the material culture—as possible. This stage was followed by a growing imperative to claim Spanish rights and control over the sur-

viving art, architecture, and artifacts of the Aztecs, the Maya, and the other indigenous peoples. Over the next two centuries, a dynamic tension arose between the urge to collect this material and the need to destroy its earlier meanings: the spirit of the Spanish Inquisition directed its unrelenting attention less on demolishing temples, statues, urns, and pottery and more on transforming any cult objects into aids to prayer for the "true" religion. At the same time, inexorably, a curiosity about the New World, its native peoples, and their cultural and natural resources began to spread throughout Europe. By the eighteenth century another belief, with the Enlightenment as intellectual backdrop and the Crown as financial support, was taking shape in Spain. Collecting objects from both the Indian and the colonial pasts might (or so it was perceived when considered as an organic whole) provide the core for an updated notion of science and inquiry in the justification of colonialism. And so, by the end of the eighteenth century, two major archaeological pieces discovered in Mexico City—the monoliths of Coatlicue and the Calendar of the Sun—were celebrated both as items for study and as symbols for the articulation of the mythological origins of Mexico. It was in the age of the enlightenment that the Spanish Crown saw the advantage of promulgating laws for the protection of the valuable material legacy that it had previously attempted, with such burning passion, to eradicate.

Mexico gained its independence from Spain in 1821. During the ensuing political struggles in the nineteenth century, including those radical swings between the liberalism of Benito Juárez and the conservatism of Emperor Maximilian, the governing attitudes concerning Mexican archaeological finds shifted once again. Such finds came to be understood as invaluable evidence of the shared and glorious "Aztec" past of the Indians and the Europeans and the resulting mixed race. There was a kind of grouping together, in the communal mind of the Indians, under the rubric of "Aztec." Still, the glorification of the dead Indians in no way reflected the realities of the living Indians—who were systematically

deprived of their land, their culture, their languages, their dignity, and their ability to provide for themselves in ways they had traditionally understood and valued. The Indian past became a kind of way station on the continuum of Mexican history—never to be considered as an end in itself (not unlike, one surmises, the role of the Old Testament as prelude to the "fulfillment" of the New Testament). This messianic approach to archaeology is a monument to the creative thinking of the *criollos* (Spaniards born in Mexico) as they sought to locate a positive historical position for themselves in the new nation for whose independence they had fought so avidly. It was with this goal in mind, along with the genuine excitement of the great discoveries, that the idea of a national museum was concretized in 1825, when the leadership of the rest of Mexico was inducted into contributing to its collections.

The National Museum became an active arm, along with many other museums, archives, and institutes, for underlining government policy. Ancient Indian objects were now supposed to be preserved and honored as relics. With changing nuance, but never veering from its instrumental role in explaining and building a usable past while transforming it into a functional present, the new museum inexorably moved with the country to the end of the century. It was Porfirio Diaz, the final dictator before the Mexican Revolution of 1910, who took lasting steps toward guaranteeing the museum's future. As Diaz saw it, not only had the collecting of archaeological antiquities become an act imbued with patriotism, not only had the discovery and restoration of the great Indian ruins become immensely useful politically—indeed a photo opportunity—for Diaz in the enhancement of his own grandeur, but the ruler had also learned that the production of traveling international exhibitions of the Indian antiquities was an effective means of promoting Mexico both as a powerful country with a powerful history and as a modern country. This was as effective in the worlds beyond its borders as it was internally. The successful management of memory to negotiate change was evident

by the first years of the twentieth century. As Luis Gerardo Morales-Moreno has stated, "The symbiotic relationships among archaeology, the state, and the museum formed part of the myth of the Mexican origin."[1]

After the Mexican Revolution in 1910, the visualization of modern Mexico's history was played out in the country's influential national museum with the full engagement and imprimatur of its presidents. The museum promoted and set the stage for the dramatization of those key events that led to the idea of mexicanidad. By the time it had evolved into the National Museum of Anthropology in 1964, the shared "cosmovision" of the Indian past had become firmly entrenched and glorified within the rhetoric around the idea of mestizaje, the mixture of the European and Indian races that made up the majority of the population of Mexico. It arguably reached its apogee in the brilliantly designed National Museum of Anthropology with its amazing collections of pre-Columbian art and artifacts and its all-embracing message that "El ayer es inseparable de lo que hoy somos" (Yesterday is inseparable from who we are today).[2] The National Museum of Anthropology is, however, the principal but not the only museum to play its part in the evolving culture of nationalism that characterized Mexico. The Museum of History in the impressive castle in Chapultepec Park officially took upon itself, in 1944, the huge responsibility of representing Mexican history following the Spanish Conquest in 1521. After regular updating and rethinking by its influential directors, that museum too has evolved into a required part of the education of every Mexico City schoolchild. It is, as well, a required visit by all tourists—whether Mexicans from outside of the capital or foreigners—if they are to learn about Mexican history in the modern age.

The long-standing government of the PRI did not stop there. It promoted the European strain so critical to the Mexican sense of self under a museum umbrella as well. The Museum of San Carlos displayed collections of paintings, of the finest European masters, in its own urban

palace. Its director during the transition, Roxana Velazquez, began to undertake extensive corporate fundraising for the spectacular exhibitions she started to organize in the 1990s, but the principal core of government funding remained well after the Fox victory. The Museo del Virreinato, the museum of the colonial period, was to be understood as the ultimate celebration of the Spanish-inflected past. Housed in an exquisitely preserved ex-convent in a parklike setting just outside of the capital city, in Tepozotlán, the Museo del Virreinato opened in 1964. The site, the buildings, and the collections of painting, sculpture, and the decorative arts are vivid testimony to the conquering peoples' material contributions to the historical and aesthetic fabric of "New Spain" and to the reality of the present-day Mexican psyche. Later, starting in the late 1990s, through the Friends Association, made up of extremely wealthy and intellectually influential members of capitoline society, the young powerhouse museum director, Miguel Fernández Félix, faced the future of declining government support head on. He privately raised money for breakthrough publications, such as the complete and lavishly illustrated catalogue of the permanent collection and a separate catalogue of the colonial silver; for conservation of great paintings, organized by the private "Adopt a Painting" (now "Adopt a Work of Art") organization; for impressive exhibitions, such as the show and catalogue of the paintings of Crowned Virgin in the Virreinato's collection. Fernández Félix began to utilize and celebrate volunteerism in his museum, a fount of human resources not traditionally tapped in Mexican society. He also decided to attack the financial and management problems, by revolutionizing the leadership and the systems of his museum. Fernández Félix created a modern and efficient system of participatory management never before seen in the Mexican museum system.

The Museum of Modern Art collected modern Mexican masters and provided space and encouragement for the work of realist artists, the muralists, who were the spokesmen for the postrevolutionary aesthetic.

The Modern Museum also, to its credit, showed and collected artists of the "rupture," who took the stance that Mexico, by the 1950s, needed to move away from an insistence on muralism into abstract modern art if it wanted to maintain its prestige in the modern world. The Museo de Bellas Artes has been the site, often the point of origin, for major traveling exhibitions, its walls stunningly decorated by the muralists themselves, while the Rufino Tamayo Museum in Chapultepec Park was initiated with the idea of providing a venue for contemporary art as well as a site for the memory of Tamayo and his own work. The Museum of the Templo Mayor opened in 1987 as a daring poeticization of the archaeological experience at its most dramatic and, indeed, contemporary. Its materials of stone and glass, of transparency and mystery, combine to bring the visitor into the ruins of the great temple found in the middle of Mexico City, among the pieces, inside and outside at once. It brought the idea of the archaeological museum to new heights. And MUNAL, the last national megaproject of PRI President Ernesto Zedillo, provides a history of the fine arts of Mexico. Under the inspired guidance of the director, Graciela de la Torre, until 2004, MUNAL was an early and successful attempt to come to grips, in a museum setting, with the notion of multiple perspectives. "Multiple perspectives" has been the battle cry of museum theorists, but MUNAL actually attempted to share that complex new way of thinking with the general public. MUNAL became an opening into a new realm of critical thinking about the nation's artistic history—one that would admit of the dilemmas attendant to the forces that bring history and art history together.

Thus I learned that Mexico City is a city of museums. Volumes and volumes have been written on each one and on the historical and political context within which they were created. By the last quarter of the century, every one of the foundational myths found its proof, its fulfillment, and certainly its manifestation in the panoply of the capital's museums, which, by any measure, were extremely advanced in terms of design,

even as they retained an absolute sense of responsibility to their assigned roles in the confirmation of the narration of Mexican society. Their installations and interpretive techniques were ever more seductive and engaging over the decades. The museums were expected to perform as one of the principal shapers of citizenship: every schoolchild was exposed to them; they were welcoming; tourists visited them; they were in large landscaped parks; they were ubiquitous. And on the international level, immense and stunning traveling exhibitions continued to expose the enduring contributions of the Mexican imagination to a fascinated world. Visual culture, as directed from Mexico City, had become the vehicle for increasingly sophisticated showcases that provided the proof of the nation's most ardent aspirations.

Paradoxically, even as the end of the twentieth century saw an efflorescence of Mexico's museum culture, it also saw the flowering of new thinking among the country's intellectuals and artists. Although this thinking had begun as early as the late 1960s, it had received its comeuppance in the infamous massacre of an as yet undetermined number of students at the Autonomous University of Mexico in 1968. It took years for this thinking to re-emerge in the 1990s, with the force and persuasion that ultimately led to the downfall of the PRI, rejected by a clear majority of Mexicans, and with the support of a fascinated and cheering world.

The Political Connection

Even if there were many important advances during the seventy years of the PRI's existence, there were also many travesties. Certainly the PRI was established with the highest of ideals, but the regime was marked by repression, corruption, and the cooptation of various groups (such as officials within the unions)—all of which hindered the needed social progress. Most of the nation's intellectuals were well integrated into the

dominant PRI vision by having been put "on the budget" of the govern-ment. This manifested itself in the arts by means of jobs and scholarships, or *becas*. During the seven decades of PRI rule, the gap between the rich and the poor continued to widen and deepen; the educational system fell into crisis; the economy suffered as president after president stole the country's wealth; the drug culture grew more dangerous and insidious; and politics, especially after the assassination of Colosio and the handling of the Zapatista uprising in Chiapas, moved into the realm of the tragic. It is now common knowledge this it was this broad-based cooptation of groups, or individuals within groups, that permitted the continuation of the "almost perfect dictatorship" until the year 2000. Then, on July 2, 2000, the people finally said "*basta!*" After free and monitored elections, the PRI came tumbling down.

All of the government's support systems, including those involved in culture, trembled on July 3. Relief that the PRI had crumbled was cou-pled with anxiety about the future. What would the new PAN (conser-vative) government do regarding culture—and museums? Who would lose and who would gain power as Fox appointed his new artistic rep-resentatives? What would the revised priorities be? What new messages, new stories, and new interpretations would be promoted in the muse-ums of the twenty-first century? Would museums still be the vehicles for the visualization of *mexicanidad* and for all that this old vision entailed? Museums had played starring roles in managing the prescribed mem-ory and promoting the nation's culture. Artists had received generous support, sometimes for life. The brightest and best minds had been engaged in this work.

Ironically, the political system that was comforted by the belief that it had coopted the finest minds in the country by keeping them "on the budget" turned out itself to have been coopted by many of those players in the years before the PRI fell. Without any certainty that they would see the end of the old order, many curators and directors of museums, artists,

and bureaucrats had been simultaneously honoring the requirement to manage Mexican memory as required, while also negotiating desired change. For example, by 1999 Mexico City had already seen some very daring continuing cultural projects in the realm of contemporary art. Of course, a few commercial galleries, such as the OMR Gallery, were way ahead of the political game and figured prominently in an international avant-garde circuit, but a few government-sponsored projects were also, surprisingly, permitting what some intellectuals were already dubbing "post-nationalist" art. Two such projects were the ExTeresa Arte Actual and the Centro Cultural del Imagen. The ExTeresa fostered exhibitions and nurtured artists dealing with globalization, censorship, the dematerialization of art, and art as a political instrument. The Centro Cultural del Imagen produced a barrage of unrelentingly progressive and sometimes transgressive photography exhibitions. When I spoke with Patricia Mendoza, the longtime director of the project, about the courage that it took to mount her shows, she shrugged and admitted that she could have been closed down at any time but that she decided to just go ahead and do what she thought was right and suffer any consequences. Perhaps Mendoza was protected by her strong international reputation. Or, as she said, quoting an old Mexican proverb: "It is easier to ask for pardon than to ask for permission." She never did have to ask to be forgiven.

Thus, before the election, Mexico was already a hotbed of change waiting to happen. These changes and dares from the world of art had people, as early as the 1990s, pushing this post-nationalistic stance both inside and outside the country.

Back to Oaxaca

Still, after making many trips to the dazzling Mexico City, I was amazed at how out-of-the-way Oaxaca was facing its own crossroads. Perhaps by being away from the absolute center—but living as if it *were* the absolute

center—Oaxaca allowed itself, and was allowed, the latitude to experiment. I will discuss the nature of Oaxaca's experiments in the following chapters: its peculiar evolution of the communitarian museum movement (Chapter 1); the artists' sense of private obligation to the improvement of Oaxaca's civic and cultural life (Chapter 2); the rethinking of the nature of the Cultural Center of Santo Domingo(Chapter 3); the unique contemporary art scene (Chapter 4); the sometimes traditional, sometimes transgressive position of artisanry and art (Chapter 5); the experiments in archaeological management (Chapter 6); and OaxaCalifornia and its globalizing resonance in the United States (Chapter 7).

Oaxaca is a place that breathes the air of individual and communal vision and of follow-through action. It is not a synecdoche; nor is it a metaphor. But it is a significant and influential part of Mexico—a city, a region, and a state of which the world is becoming more and more aware. In Oaxaca, individual visions often rally unexpected sources of support for the protection of the civic fabric. Its arts—ancient and modern, craft and fine—are a critical element in those visions and in the realization of those visions. And when vision and realization work in tandem in Oaxaca, they seem to work unusually, even magically well, creating both a magnetism and an effect that extend beyond the city limits. Yet it should not be ignored or denied that outside the historic center of Oaxaca, the city is characterized by the urban ills common to many cities today, with suffering and poverty being compounded by corruption and greed, with privilege and class playing a disproportionately controlling role in the lives of most residents, and with the government essentially abandoning the well-being of its most vulnerable citizens. A major worry is the need for water, a need that cuts across class lines. Other problems involve education and jobs, migration and rascism, deadly, ancient antagonisms between pueblos, and ecological threats to the forests and unique flora. Finally, Oaxaca remains one of the poorest and most marginalized of all the states in Mexico.[3]

Nevertheless, what happens in the world of the arts and museums of Oaxaca is often hopeful, and that hopefulness may be relevant to the rest of the country. It certainly is an inspiration to those of us from outside Mexico for whom Oaxaca is perceived as both a laboratory and a spur to action. The Mexican art world continued to watch the new government with a suspicious and ever more disheartened eye, especially after several years in power. Unlike most everyone else in Mexico, the artists and the members of the intellectual elite never did have high expectations of the PAN. They reacted worriedly and cynically when newly appointed officials rapidly published passionate tracts reflecting their concerns not just for the old architectural heritage but also for the future of the arts in present-day Mexico. The officials expressed a "heightened sense of civic awareness with respect to the patrimonial values of Mexico's architecture and historical sites, and of the desirability to include now, as a part of this conservation effort, the works of [the] recent past: the twentieth century."[4] Artists and intellectuals were not surprised, then, when the Fox government left it to private pressure (i.e., Francisco Toledo) to organize the citizenry to protect the Zócalo, the precious historical center of Oaxaca, from a fast-food invasion by McDonald's. Nor were they surprised when the government very consciously, even ideologically, left it to the citizenry of Cuernavaca to oppose the megastore Costco's original plans to destroy some historical murals in a long-neglected twentieth-century complex, the Casino de la Selva. The solution was to create a totally private museum across the street from Costco; here, in addition to the restored murals, one of the great Mexican private collections will be on display for a period of time. Nor were they shocked when the government proposed cutting the film industry's subsidy at a moment when that industry was making a serious comeback and bringing Mexico international prestige.

From the outside, one can see the new government's dilemma. On the one hand, many of its best-intentioned officials, like Sara Topelson de

Grinberg, claimed to want to honor and protect Mexico's multifaceted architectural heritage. They heard and registered the complaints of citizens who wanted their monuments protected. On the other hand, having been democratically elected, the government also wanted to demonstrate that it would follow only established laws and would not protect any monument simply by fiat.[5] The question, then, is to what extent this government was ready to aggressively protect that patrimony and the more ancient patrimony, by pressing for new laws. This was the looming and unresolved issue. The PAN is a conservative government, and business interests certainly get stronger protection than they would in a more left-leaning government. Art and artists, long cared for with lavish support, remained concerned throughout the Fox presidency.

Oaxaca's efforts in the realm of culture, both individual and communal, are an inspiration and seem to thrive in a world apart from the rest of the country. Its efforts have touched on many of the issues that concern any contemporary region wrestling with the power of the arts to positively influence and enhance its increasingly globalized communities as they struggle to participate in the world at large while preserving intact their own local souls.

The Pueblos Speak for Themselves
Communitarian Museums

There is no undoing that which history has wrought. When great masses of a people have died, when their culture has been brutalized, when they have been reduced to being the objects of history for centuries, their way of seeing, comprehending, and living in the world will be gravely distorted. Violently birthed social systems that are intended to subdue a people yield rigid hierarchies geared for the self-perpetuation of the conquerors. Colonizers order the building and transformation of existing temples and prayers into containers for paying tribute to their own god and country. And as they institute their own economies, cultures, and languages, they inevitably leave wreckage in their wake. Those who were once actors in the elaboration of a civilization are left with three choices: they can submit; they can adapt; or they can resist the new patterns of power and authority. This occurs whenever one civilization invades and conquers another, and the Spanish Conquest of Mexico followed suit.

But even if there is no undoing of what history has wrought, nowhere is it written that other realities cannot be acknowledged as well. With respect to the conquest of Mexico, such acknowledgment occurs only by means of open discussion. And this open discussion can occur only if two common traps are avoided: first, that of the conversation-stopping "black legend," which proclaims the unadulterated evil of all of the Spanish; and second, its Manichean counterpart, the "white legend," which proclaims only the positive contributions of the Spanish. Therefore, without denying what was created (the art and language and untold inventiveness that accompanied the conquistadors), without blaming those who inherited and profited by their colonial system, and without attributing utopian characteristics to the pre-Columbian societies, we must admit that the indigenous peoples had an evolved civilization and that they ceased being autonomous subjects once the conquest had achieved its ends. They were effectively transformed into objects in the next phase of their history.

In the twenty-first century, we can reflect on that collective pre-Columbian past and can allow some small amends, ensuring that those who have survived for over half a millennium and who still feel the wound of the conquest can take steps toward regaining a reasonable part of their autonomy. At the end of the twentieth century, steps were developed to encourage the repair of those corners of the world, called "New Spain," that are still inhabited by their indigenous peoples. Whether or not a critical mass of the nonindigenous peoples choose to participate in that repair is irrelevant: many of the "pueblos" are now actively, publicly, and unapologetically taking their futures into their own hands. The progress they have made toward recovering their identities as subjects is irreversible.[1]

None of this would matter in the twentieth-first century if all of the indigenous peoples had decided that resistance was futile. Most of them, it is true, submitted and/or adapted. But the culture of resistance was never completely eradicated. The Indians faced the ignominies of "inter-

minable dispossession and reduction of their ancestral lands, of slave[like] servitude, of physical annihilation, uprooting, intellectual repression, conversion, lies, censure, unrelenting attack on their own memories and on their languages; of imposition, oppression, frustration, persecution, of illegitimization, of total negation, disdain, discrimination, paternalism, of good will toward the "good" savage, of folkloricization, of alienation of the present, the past and of their own vision of the future, of the possibility of self-liberation."[2]

Because the Spanish Conquest was overwhelming not just culturally[3] but also biologically, Mexico could ultimately claim its dominant mestizo (racially hybrid) character as central to its nation-building project after the Mexican Revolution of 1910. In that project, Mexico constructed an ideology around the notion of la raza cósmica—that is, of a population comprising a biological mix of Indians and Europeans—thereby implying that there had also been a cultural reconciliation of colonizers and colonized. This was one of the government's principal efforts to control memory. Though Mexico had indeed evolved into a largely mixed-race population, the nation persistently modeled its political, linguistic, economic, and religious aspirations after those of the Western world. First, of course, the Spanish influence had dominated; then, after Mexican Independence, the French had their day; and most recently, the United States has lent both shape and color to the national identity. Thus, the official national fabric of the Indian is primarily what has been selectively appropriated—the Aztec, the warrior, the priest—and then reconstructed into the image of pre-Columbian glory. Mestizaje was never meant by those managing the historical memory to suggest that contemporary Mexican culture would don Indian characteristics in equal measure with European but rather that the Indians would become properly "Westernized." Indian scholars have described this attempt at mestizaje as devastating and annihilating—as an effort to absorb the "good" (i.e., the white and the European) and to annihilate the bad (i.e., the Indian) into the increasingly

amalgamated nation.[4] Manifestly not a biological or racist goal, the pol-
icy proved effective in fostering a national style of living and thinking
that would promote the eventual eradication of that which was cultur-
ally Indian from mainstream Mexican life. Furthermore, the "indige-
nism" policies that were formally adopted by the postrevolutionary gov-
ernments, ostensibly to be inclusive of the "other," fiercely attacked that
population's vitality and integrity by lumping its diverse indigenous eth-
nicities under the single derogatory term "Indian."

Huge segments of the Indian populations were destroyed by sickness,
grief, overwork, or violence. Although some were seduced by the colo-
nizers' rhetoric and blandishments, those who survived remained spiri-
tually, politically, and economically under constant attack. Still, resistance
continued during the period of more than five hundred years. Astonish-
ingly, today the indigenous are once again gaining in population. At least
10 percent of the country identifies itself as indigenous; that is, 10 per-
cent of Mexicans speak their native languages as opposed to Spanish, live
in their pueblos, practice their own kinds of medicine, and in hundreds
of other ways resist total absorption[5] Furthermore, many more people of
Indian extraction live on the margins of modernity, maintaining a resid-
ual Indianness that they might not even recognize as such—that they
might have been conditioned to not fully flaunt. And finally we are wit-
nessing "an efflorescence of indigenous organizations that show that in
spite of, or maybe as a consequence of the hegemonic pretensions, the
dominated groups can recreate a number of alternative forms of seeing
and analyzing the world, in the same way that they can serve as means for
contesting and refuting those hegemonic constructions and possibly mod-
ify the conditions that are conducive to that situation."[6]

The idea of constructing and elaborating on the pre-Columbian foun-
dations for the renovated postrevolutionary nation emerged under the
guidance of the imposing Oaxacan intellectual José Vasconcelos. With Oa-
xaca itself promoted as the heart of *mexicanidad*, Vasconcelos developed the
intellectual backbone for the ideas that were to bring the fractious post-

revolutionary agendas together and to develop, with the support of paint-
ing, literature, dance, and theater, a profound (if mythicized) sense of rela-
tionship with the indigenous past that would be shared by all. It is ironic
that the emerging power of indigenous autonomy would, by the mid-
1970s, find some of its most effective voices emerging from the same state
in which the originator of the inspiration for the homogenizing of the
pre-Columbian past was born. The Indians, who had been deprived of
recognition of their ethnic singularities throughout much of the century
(for the sake of the nation) were now reclaiming those singularities (for
their own sake). Along with their identities, they were hoping to regain
some control over their destinies. Given Oaxaca's unextinguished tradi-
tion of resistance and its sixteen extant ethnic groups, with as many lan-
guages still alive, any new path for resistance could profit there.

Indigenous life is the most miserable, neglected, impoverished, and
demeaned in Mexico and should not be romanticized or glamorized. One
of the lasting indignities of colonization was the decrease in the pueb-
los' decision-making capacities, accompanied by an increased depend-
ence on the powerful ruling system. There were, certainly, grave injus-
tices, systemic personal and class-based violations, and mind-numbing
violence in the ancient Indian ways of life; yet by the 1970s, well over
four hundred years after the catastrophe inflicted on them by the Span-
ish, the Indians had gained no autonomy in the "new world order." At
the same time, the colonial and postcolonial power structure had gained
a great deal, almost always off the backs of the indigenous peoples. But
in the last thirty years of the twentieth century, an unexpected thing hap-
pened. Within the oppressive structures of the system itself, within the
ministries that had taken everything meaningful away from Indian life,
cadres of professors and academics, especially in the field of anthropol-
ogy, arose who were able to see the world from the other side of the tele-
scope—from the side of the indigenous peoples. This scholarly shift
linked with the advent of a generation of privileged younger people,
many nonindigenous, who also perceived cracks in the calcified system

of government. They initiated a stream of inspired thinking and action that set the stage for altering the future. By the early 1970s, even the president of Mexico, the infamous Echevarría (who played an iniquitous role in the 1968 massacre of students at the Plaza of Three Cultures in Tlatelolco) felt it incumbent upon himself to allow some Indian organizations their voices at the national level. Since Indian organizations had been restricted politically since colonial times, in order to keep them weak and fragmented, this was a major political breakthrough. As cynical and even fraudulent as these inchoate efforts may have been, they created an opening for change in the nation's discourse about the nature of memory, about its validity and its ownership. A space had opened up for organizations, many nongovernmental, that could question the national ethnic policies as well as more wide-ranging policy issues associated with oppressed non-Indian peoples.

By the mid-1970s, some Mexican intellectuals became more vocal about the ironies of justice denied in a country that spoke about that subject so loftily on the international front. How could a country that considered itself on the side of the repressed have so effectively repressed and oppressed its own indigenous peoples? By the mid-1980s, the indigenous policy (the absorption of Indian into European) had started to be discredited and new practices were being put in place, especially through pressure exerted by the National Indigenous Institute (the Instituto Nacional Indigenista). Bilingual education emerged in the pueblos; individual states, notably Oaxaca, accepted the rights of Indians to elect their municipal authorities following their traditional processes; new educational opportunities eased the way of Indians into the professions; and Indian intellectuals pushed their peoples toward the assumption of greater self-development and autonomy. This last phenomenon was not without its problems and betrayals, its confusions about the relations of government and civil society, and its lack of economic resources to back it up, but along the way the dominant ideology was deeply dented. Guillermo Bonfil and other highly respected colleagues such as

Enrique Florescano were convinced that Mexico would better function in the modern world if it could recuperate and appropriate some of the wisdom of *México profundo* (indigenous Mexico). Once dismissed as idealistic, the thought that there is, within the accumulated body of aboriginal experience, knowledge and practice that might benefit not just Mexico but the world at large is becoming more accepted. To multiply "the effects of a body of wisdom/knowledge that come from many different corners is to open spaces for the multiplication of the forms of living and demands the recognition of its natural rights to equal existence and co-existence."[7]

Some influential anthropologists who had long been key informants enabling the policy of indigenousness began to participate in the subversion of the prevailing system. They believed that in promoting cultural change, they could also promote political progress, even though they feared that prospects for economic justice for the indigenous remained too threatening to the powerful. One result was a museum movement—the communitarian museum movement—born from this dawning awareness of the excessive injustices and exclusions of the indigenous peoples from the national life, history, and identity. For the first time in centuries, many pueblos are seeing themselves as integral and active members not only in their own lives but also in the life of the nation. Through the communitarian museum movement, a critical mass of men, women, and children in marginalized communities are now actively managing the narration of their memory bank while negotiating desired changes for themselves and, ultimately, for the country. They are doing so by adapting or even coopting the institution of the museum, that quintessential Western institution, for their own purposes.

Origins of the Communitarian Museum Movement in Mexico

The communitarian museum movement originated in Mexico City at INAH, the Institute of Anthropology and History.[8] It surfaced after a cou-

ple of INAH anthropologists and an INAH employee, Miriam Arroyo, expressed concern about the general absence of visitors from the indigenous pueblos in the stunning new Museum of Anthropology. After all, Arroyo wondered, if these Indians who were honored in the museum were the descendants of the glorious pre-Columbian Aztecs, Maya, and Olmecs, shouldn't they constitute one of the museum's principal audiences? After much discussion, INAH agreed that it needed to better serve those living Indians, not just the people from the capital and the tourists who were already streaming through the museum's doors. The original hope was to more effectively communicate to the indigenous peoples the importance of the national culture. Since they were not coming to the museum in large numbers, the idea was that a "museum of their own" could instead be delivered to the pueblos, and that this would stimulate an interest in the national culture. It was also proposed that certain pueblos might want to tell their stories in their own ways. Thus, the earliest stage of the communitarian museum movement was conceived strictly within "the tracks of structures of possibility provided by institutional arrangements"—that is, within the limits set by "governmentality."[9] It was not yet a radical idea.

The timing was perfect. By the mid-1980s, Mexico had constructed a gamut of museums intended to communicate the monolithic ideas that were the foundation of the modern nation. The federal government had achieved this by the sacralization of archaeology and history in these highly symbolic spaces. The religion of central power was now as completely codified as it could ever be expected to be. The National Museum of Anthropology was the cathedral of the secular religion of Mexico, with dramatic installations of powerful ritualistic objects. The combination of the intrinsic authority of the pieces combined with the aura of high aesthetics endowed by the museum traveled beyond the famous "museum effect," wherein objects in a museum are transformed into art.[10] In Mexico, the works of art in the Museum of Anthropology were

transmogrified into sacred ritual objects that conveyed the civic/religious message of the nation. Only after the nation's sense of self had been consolidated could a proposal be raised that might allow alternate histories and cultures to be celebrated. This could never have come to pass without the passionate writings of Bonfil and his pleas for a reconstitution of the country's complex and diverse cultural memory—a memory that was less monolithic and more kaleidoscopic than that manifested in the Museum of Anthropology, one that would allow living Indians to reclaim their particular histories in their own ways.

The ground had been made immensely fertile for this idea. As early as the 1970s, regional museums were being built in Mexico, the first attempts to link local populations to relevant historical events. There were parallel international movements at the time: eco-museums in Europe; pocket museums in South America; and the famous meeting in Chile in 1972 where the idea of a "new museology"—one more responsive to a museum's diverse publics, one more conscious of the need to communicate the complex nature of the social world visitors encounter within any given museum—had been, first internationally and then domestically, propounded. Museos de la casa and Museos escolares (house museums and school museums) were already appearing throughout Mexico. These were urban and suburban attempts to link discrete populations to the messages of the national museums. They were precursors to deeper changes a decade or so later, in 1983, when the communitarian museums were born under the watchful guidance of Miriam Arroyo at INAH.

Not surprisingly, though, the early communitarian museum movement reflected the national government's top-down style of leadership. INAH agents, called "promoters," were dispatched to pueblos, where they were to decide if a museum might be needed. If the decision by a promoter was positive, the agent would go to that place and lead the people in adopting an appropriate theme for the museum, finding a place to house it, and choosing techniques to make the museum functional. Critics today

complain that the resulting museums were generally established in places relating to the promoters' needs and convenience and mirrored the promoters' ideas more than the desires of the pueblos. These early communitarian museums were started in Coahuila, Durango, State of Mexico, Jalisco, Morelos, Oaxaca, Puebla, Querétaro, San Luis Potosí, Sonora, Veracruz, Colima, Chiapas, Chihuahua, Guerrero, Hidalgo, Nayarit, Tlaxcala, Zacatecas and Yucatán, as well as in Baja California. Mostly they were in mestizo pueblos, but a good number were in indigenous pueblos. Many of these museums failed. When Arroyo left INAH in 1991, the movement she had initiated lost much of its impetus.

Communitarian Museums in Oaxaca

In the meantime, the communitarian museum movement had birthed another stream, one quite distinct from Arroyo's vision. This stream developed in Oaxaca beginning in the mid-1980s and was thriving twenty years after its inception. Two young anthropologists in the employ of INAH, Teresa Morales and Cuahtémoc Camarena, were responsible for giving this vision its life and direction. Steeped in Bonfil's ideas and the "new anthropology," they had already been working in and around Oaxaca, organizing the Indian communities. They had not planned to develop a museum Indeed, Morales and Camarena got involved in the communitarian museum movement only after a delegation from the pueblo of Santa Ana came to them, in their capacity as INAH representatives. The members of the delegation asked the anthropologists to advise them in creating a museum of their own inspiration. They had decided that they had a compelling revolutionary tale to tell. They had seen how a museum could serve as a way for them to advance their visions of the future and to represent themselves as active and differentiated members of Mexican society. And they would do this through a reshaping of the idea of the museum. The pueblo itself, then, identified the possibilities inherent in

adapting the Western idea of the museum. The Indians knew that they could use that vehicle to emphasize, for example, their role in the 1910 Mexican Revolution. Indeed, Santa Ana's request for advice and support in starting a museum can be seen as a means of resistance. The pueblo had latched onto the very notion of the institution of the museum that had for so long been used by Mexico to coopt indigenous histories and material culture for the cultural project of the nation. The pueblo of Santa Ana, then, made a conscious decision to manage its own memory by means of that very same institution, and it went to the INAH representatives for help in making the desired change a reality.[11] Certainly, the irony of recruiting INAH employees to help subvert the national story was lost on no one.

The Shan-Dany Museum, which opened in 1986, offers a narrative of Santa Ana, from the pueblo ancestors, the ancient Zapotecs, through the 1910 Mexican Revolution, by means of archaeological pieces, photos, maps, drawings, and tableaus. From the beginning the museography, though modest, was never "poor" or sloppy. The people of the pueblo wanted and accepted help, but only on their own terms. They did not think of a museum as an end in itself for the fetishization of objects or the promotion of the donors through the collections. Rather, the museum was meant to directly address issues of their civic identity: everything in the museum related to the identity of the pueblo.[12] Indeed, they decided to extend the museum beyond the walls, using it as an impetus to attractively developing the town plaza, creating a sports center, and generally improving municipal existence. A later result of this pioneering effort was a children's museum. Museum goals included educating their children to know and propagate their own customs and, to some small extent, improving their economic situation. It was never a necessity that these goals be reached only *inside* the museum itself. Furthermore, as a struggling rug-making town on the outskirts of Oaxaca, Santa Ana hoped the museum could be also an economic force by helping that

industry attract tourists who might also be buyers. Although buying has been minimal, in 1992 Jeffrey Cohen wrote that the museum conferred "an institutional sense of authenticity to local weaving." He added: "[The museum] has participated in extensive exchanges throughout the state, the country, and the world, opening the door to new markets . . . and [is a place] where younger members of the community have taken an active role in the documentation of their past[,] where contradictory viewpoints concerning the village and its future are voiced[,] where women voice their concerns over the rise in immigration and where the tense relationship with state authority is mediated through dialogue and cooperation."[13]

The pueblo itself made all decisions regarding the Shan-Dany Museum, and other communitarian museums that emerged out of the Oaxaca stream of the system, according to its own system of governance—skirting, whenever possible, the limits of the governmentality of the day as known in Mexico. The administrative system of the indigenous pueblos was based on the ancient system of *cargos*.[14] Cargos are a central characteristic of the centuries-old practice of distributing administrative responsibility for the pueblo among heads of families. These responsible citizens of the pueblo gradually gain in prestige as they grow older and complete various positions. Cargos are both civic and religious in nature and are not compensated financially. Beyond the cargos themselves, heads of family get together in the pueblo assembly to deal with problems of general interest. In Oaxaca, these include the naming of authorities, the assignment of communally accepted work chores, or *tequios* (also uncompensated), and the formation of all municipal committees. Everything related to communitarian museums in Oaxaca—including the theme assumed by the particular pueblo museum (e.g., the pre-Hispanic past, events of the revolution, the history of the struggle for the local hacienda, the fight for the land, traditional medicine, traditional wedding, or labor history); where it will be located (e.g., a former convent, an old market,

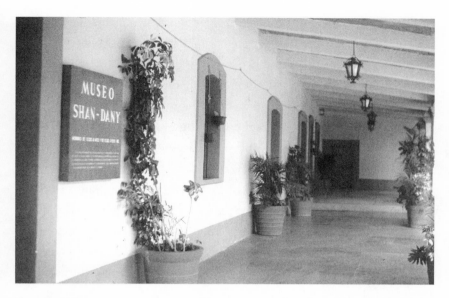

Shan-Dany Communitarian Museum (Courtesy Manuel Jiménez and Communitarian
Museums)

a school, a meeting hall, or perhaps even a nonphysical place); its goals,
obstacles, and challenges; its narrative script; and what economic and
human resources will be applied to it—is decided by the pueblo.[15] Unlike
the original, Mexico City version of the communitarian museum, a pro-
moter never decides whether or not to take on the responsibility for the
museum and never decides issues of administration or governance. And
the purpose of the museum is never related to eventual audience en-
hancement at the National Museum of Anthropology!

Once decisions have been made in the pueblo assembly, the debate
continues in popular meetings. Then, if the whole pueblo decides to pro-
ceed, a committee is named and the museum becomes integrated into
the system of *cargos* and *tequios*. The committees then organize everything,
from programming to donations, with the support of the assembly. The
cargos are a matter of great significance for the community, so if the job
is done well, the prestige is high for the holder of the cargo. If the job is

executed badly or neglectfully, the holder could be reprimanded or even
land in prison. To keep this system functioning, committees have to
renew themselves and educate succeeding generations. Most important
is that the museum does not belong to any one person or group within
the pueblo. Nor can any outsiders head the museum. Everything comes
from within—according to local community uses and customs. Thus, in
Oaxaca, the communitarian museum movement first became a radical
idea. And, its time had definitely come.

The Communitarian Museum of La Natividad, inaugurated a decade
and a half after Shan-Dany, epitomizes all of the strengths and weaknesses
of the communitarian museum movement as it had evolved by the turn
of the millennium. Its "script" and all of the content and concept emerged
as a result of the by now fully organized, updated, but still traditional
process of the movement as it is practiced in Oaxaca. The museum at La
Natividad was further enriched by this particular pueblo's unique cre-
ativity. As is the norm, the pueblo began by conceptualizing the project.
It then conducted the required original research and designed, produced,
displayed, and opened the museum. But during the process, in order to
be clear about the themes that it wanted to memorialize, the pueblo ini-
tiated intense role-playing activities and thus acted out its memories the-
atrically. At several of the dramatic climaxes, members of the pueblos rec-
ognized points that they wanted to highlight with their museum's
exhibits. Their research then consisted of collecting the appropriate
"props": the tools, photographs, documents, flags, minerals, and cos-
tumes. And the script they developed in their role-playing activities
became the labels.

Visually, the museum is a grabber. A life-sized clay statue of a miner with
hat and light greets the visitor. He strikes at the front wall of the museum,
which is covered with minerals: gold, bronze, quartz, and silver. When a
fountain suddenly squirts water, the visitor begins to have a sense of the
miner's work. An ancient cart that carried the rock of the still-functioning

mine (which once had 1,600 miners and now has 135) strikes an emotional chord. One of the first displays is a mineshaft, made expressly so that the visitor can tangibly travel through the daily life of the mine. Explanations of mineralogy and sophisticated interactive exhibits make the visit not just a sentimental journey but a truly educational one. With this museum, the miners of La Natividad make their bid for remembrance as their population shrinks because of emigration to the United States. They stake their claim for having been productive, constructive human beings despite all of the odds being stacked against them due to the exploitation they suffered by employers and by their own government. The dwindling population of the pueblo wanted people to come and to understand their lives. This museum was their only means of publicly communicating the nature of both their pride and their tragedy. After leaving La Natividad, one is overwhelmed with how much the work itself shaped the life of the town and, indeed, gave it life. In the end, this town may effectively disappear for lack of work and men. All the townspeople really had in common with each other was the work. And with that disappearing, they felt they needed to leave a footprint in the continually eroding sand of their lives. The hope is that the museum, at least, will remain, even if it becomes just another ghost in a ghost town.

On an optimistic note, in 2003 the Office of the Secretary of Tourism in Oaxaca launched an important cooperative project relating to La Natividad. That office created a tourism route that made the communitarian museum its principal cultural focus. Consequently, the museum has opened a daguerrotypes and jewelry workshop that relates directly to the gold and silver that was mined there beginning as early as 1795. Perhaps this collaboration between the Office of Tourism and the workshops run by the people of the pueblo will help to stem the flood of migration out of La Natividad.

There is another mining museum in Mexico: the National Museum of Coal, which is far from Oaxaca, in Coahuila. This museum is a celebra-

"Miner," La Natividad Communitarian Museum (Courtesy Fred Croton)

tion of the complex, sometimes tragic, and sometimes heroic history of mining. Its director writes of coal mining as having been a powerful, if ephemeral, motor of progress for the nation, an engine for the development of technology and education, for the flowering of many beautiful architectural works, and for the construction of churches, palaces, universities, and homes. This museum—funded by the national government, by private initiative, and by assorted political groups—thinks in grand terms. Even though it is a self-acknowledged "microhistory" within the macrohistory of Mexico, the museum and its leadership seek to elaborate "an identification with our roots, with our native soil, succeeding thus to maintain alive the common past as a watering hole for the present generations, as a source of peace and joy for the actors of that past, and thus to participate together in the forging of the promotion of nationalism at all its levels."[16] This goal, admirable as it is, differs

markedly from the humbler objective of the pueblo of La Natividad in producing its museum. The two museums highlight the difference between the national narrative and the communitarian museums' objectives. History in La Natividad can be no source for nationalistic pride; it memorializes a human tragedy, which merits celebration only insofar as it contributes, even if only momentarily, to the prevention of the total erasure of the memory of a handful of people. Clearly, the communitarian museum movement as it developed under the watchful eyes of Morales and Camarena in Oaxaca diverged radically from its origins in Mexico City—mostly because it traveled beyond the perceived "governmentality" of the time. Mexican society as a whole was changing: ancient communal patterns that had been despised seemed once again worthy of respect when manifested on a local level. And Oaxaca anticipated the changes. The community-specific museum movement as it developed in Oaxaca State and subsequently in other states of Mexico emerged from the traditional form of pueblo governance. Oddly, it converged with new trends in leadership—not just in Mexico but also in international leadership circles that endorsed antiauthoritarian and participatory styles. The "new" leadership theories, as developed in the 1980s and 1990s in the United States and Britain by social scientists such as Warren Bennis and Charles Handy, were premised on the evolution of group ownership of organizing concepts and governing principles, with the goal of arriving at consensus and shared responsibility and sustainability for projects. With the new leadership theories, the decision-making styles that the pueblos had operated on for hundreds of years (at least in the limited arenas where they had been allowed decision-making autonomy) now made more sense. Indeed, pueblos do govern themselves by the participatory and consensual method, as opposed to top-down, charisma-based decision-making. Naturally, pueblo-type decision-making had been anathema to the pyramidal structure of leadership under the PRI. Indigenous pueblo democracy, unlike majority-rule/minority-rights

democracy, is founded on finding and maintaining consensus. It emerges out of the framework of indigenous values that privilege collective action over individualism and the common welfare over individual needs or minority rights.[17] It is a special type of governance that brands the local pueblo museums in Oaxaca—a type that the Mexico City–style of promoter-generated communitarian museums, the earliest style of communitarian museums, could neither imagine nor foster within the governmentality of the time.

Even as the pueblos were finding their unique voices in their new museums, the trend toward globalization was allowing local, national, and international networks of communitarian museums to develop and flourish. Globalization, which might be dismissed as a complete negative for indigenous communities because of its push toward homogenization of commodities, has counterintuitively, been utilized as one tool for cultural liberation for indigenous peoples worldwide. This is one of the ironies that underlie the drive of the pueblos to ethnic specificity. The relative isolation of the pueblos has been penetrated as activists in the communitarian museum movement find themselves on the road to meetings of the Oaxacan Union of Communitarian Museums. Indigenous museum representatives are assigned to travel, throughout Oaxaca and throughout Mexico, for conferences and workshops. Some of the museum leaders are called to international conferences, where issues of significance to indigenous peoples worldwide are shared and solutions compared. Oaxacan museum leaders have found themselves to be authentic members of the globalizing impulse as they have made connections with others in similar museum movements throughout North and South American. By going from the local to the national and then back again, they have been rapidly expanding the channels allowed by the simultaneous evolution of notions of governmentality in Mexico. Clearly, the "tracks of structures of possibility provided by institutional arrangements"[18] were adding new lines to the "railroad." Allowing and fomenting indigenous autonomy,

as a state project in Oaxaca, was less about democratizing the pueblos (as in the American or British sense) than it was about enlarging the reality of democracy within the larger society of Mexico. It was about furthering the acceptance of the pueblos' own ways of governance in mainstream Mexico and not having to impose a "democratic" structure on the pueblos or even insisting on a majority rule and minority rights structure from within them. The complexity of the indigenous project within a rapidly democratizing Mexico cannot be overstated.

At the same time that the communitarian museum movement was growing in Oaxaca, new indigenous resistance movements more overtly aligned to politics were also making huge progress in Oaxaca State. Their success reflected the nation's growing tolerance of nonmainstream attitudes toward self-governance. By 1996, Oaxaca had won significant rights with respect to the governance of and elections in of indigenous municipalities in their own way and according to their own customs. Obviously, indigenous political autonomy in Oaxaca and the success of the communitarian museums, beginning with museums such as Shan-Dany in Santa Ana, are indicative of the good timing of both efforts. Every new communitarian museum after the establishment of Santa Ana's became intrinsically a laboratory and sometimes a testament to the viability and validity of entertaining "other" ways of problem-solving, other modes of community life, and other ways of understanding history within the much larger life of the Mexican nation.

Mutual Cooptation

Even as the communitarian museums became what Morales and Camarena have regularly described as "instruments of resistance of the communities against the expropriation of their collective heritage . . . of consciousness raising . . . of search for a better future . . . of a motor of democratization . . . toward surrounding society," they also became a

means of defending the pueblo's physical patrimony—a way to halt its
expropriation by the central government, by those who consider them-
selves to be the protectors of the patrimony. When the people of the
pueblo of San José Mogote went to INAH for consultation about a
museum they wanted to build, theirs was yet another history that had
not yet been told in the national framework. They wanted to tell their
children and the world at large how they had taken over the hacienda in
their midst and how they had asserted their own political power in the
earlier part of the century. They wanted to commemorate the struggles
for social justice in which they had long been engaged and in which they
had won numerous important victories. Maps, complex displays, charts,
and documents would illustrate their points. This highly elaborated visual
statement about their modern history was finally celebrated in the
museum, as was their ancient history. Going far beyond documents,
interactive displays of the Zapotec calendar engage visitors and invite
them to understand this alternative system of marking time. Archaeo-
logical pieces—major, unique, and beautiful pieces that would otherwise
have been destined to be displayed in a national or regional museum and
to become a generic part of Indian history—were mounted in San José
Mogote, in at least one case to the dismay of the national authorities. The
project turned out to be so attractive that the pueblo was able to get finan-
cial support from the Office of Tourism of the State of Oaxaca to help
restore the hacienda; and the museum housed there has since become a
destination for alternative tourism in Oaxaca, much as La Natividad is
becoming now. The activity around the creation of the museum marked
a particularly important moment in the politics of archaeology as it was
evolving in Oaxaca. San José Mogote and its communitarian museum
illustrated that there were additional outcomes in the struggle for archae-
ology and memory, outcomes that challenged the right of the nation or
the state to appropriate the pueblos' great pieces and put them in dis-
play cases far from home. The people of San José Mogote were able to

convince INAH that they themselves could take care of their own invaluable objects and that the objects should not be taken away for the sake of others outside of their community.

Indigenous communities had long been trying to resist archaeologists' appropriation of finds from their own property, though largely to no avail. Since INAH was, for the most part, sincerely dedicated to saving the patrimony, it began to make sense to allow the communitarian museums to be guardians of their own objects. Indeed, as the communitarian movement developed, the reason for beginning a museum was often the threat to the physical patrimony. The collective will would mobilize to avoid the extraction of archaeological pieces or historically significant maps and other documents by the state or nation. Indeed, when the solution of the communitarian museum had gained in credibility by virtue of its successes, it was seen as an effective way of fulfilling a pueblo's long-harbored desires that archaeological objects remain in their place of origin. In negotiated settlements, the pueblos could now make agreements with INAH to provide certain forms of security and conservation in order to guarantee their care in their own hometowns. The communitarian movement thus allowed for the framing of a new context for local archaeology—that is, the objects remain within their community but are still registered and owned by the nation. Although this has proven to be a great leap forward, the problems of inalienability of objects can get complicated when an object is perceived as possessing overpoweringly national implications—or even when there are conflicting local claims. At this point, the legislation still does not entirely recognize the pueblo's rights. The law will need to be revisited so as to help clarify custodial issues for the future. And some pieces currently residing in the National Museum or in regional museums will probably be returned to the pueblos. At the very least, it is likely that far fewer of the most meaningful pieces will be expropriated in the manner of the "enlightened coercion" of the past.[19]

Perhaps the INAH staff members were willing to negotiate these changes with the pueblos not because they were more generous than other INAH staff had been in the past or because they saw eye-to-eye with Morales and Camarena, but rather because they had to deal with the fact that the locals were quite restless. INAH had been fighting indigenous resistance to their archaeological expropriations for years—in what has been described by Nelly Robles, the director of Monte Albán, as a "low grade war with occasionally violent eruptions." Until the communitarian museum movement took hold, some of the pueblos were using hostile forms of resistance that were, in truth, aimed not at saving the patrimony but rather at preventing INAH from doing what INAH understood to be its job. Robles has noted that the Indians felt a generalized rage toward the central government for its constant mistreatment of the pueblos and for its ever-present assertion of authority. Expropriation of indigenous archaeology was the most obvious example of the nation's disdain. Individual anthropologists and archaeologists came to understand that this violent resistance in their midst could perhaps be treated constructively and thereby channeled into something manageable. They were working at a propitious moment, at a time when some in INAH had begun to understand why certain indigenous peoples were angered about having their specific histories melted down into the national memory bank. They grasped that the living Indian was being abused even as the indigenous past was being viewed as a limitless trough that served up the material necessary for the elucidation of the myths and legends of ancient glory. It was becoming clear—even to the nonindigenous—that injustices were being done to the Indians when their historical documents and material history went to national and state archives. So anthropologists, in coming to terms with the pueblos, could be cynically understood as having figured out that this cooptation of community rage for the sake of a peaceful settlement around the issues of the preservation, display, and interpretation of their objects was not a bad thing. The acceptance of

the communitarian museum movement by the government could thus be seen as a means of containing and channeling communal fury into new lines of governmentality and governability. This would have been consistent with the PRI's normal policies of coopting the complaints of certain constituencies so as to take the steam out of those complaints. This method is often offered as an explanation of how the PRI was able to maintain its power in the country for more than seventy years.

That the communitarian museum movement was a part of a zeitgeist where "the hold of the national imaginary ebbed due not only to the pull of the transnational but also to the tug of grassroots initiatives and the cultural sphere"[20] cannot be denied. There was also a general willingness in the government to resist uprisings among the indigenous. This, along with the increase in media attention on the Mexican government after 1994 and the uprisings in Chiapas, caused the government to grasp the importance of managing, not eliminating, the expressions of particular memory demanded by these reemerging forces of civil society. Allowing communitarian museums may have been understood as yet another way, within the governmentality of the day, of keeping incipient "ungovernability" at bay.

And as we have seen, the Indians had, more or less simultaneously, been coopting INAH by figuring out a creative transformation of the traditional Western idea of the institution of the museum into an instrument that INAH could accept but that would still be useful for their own purposes. Instead of simply not attending the National Museum of Anthropology in Mexico (the more passive resistance of the 1970s and 1980s), some indigenous pueblos figured out how they could now autonomously define themselves by using museums for their own purposes. The pueblos dismissed the definition of the traditional museum—founded on the notion of the collection, preservation, and interpretation of objects—as a limiting prescriptive: now the museum could consist not only of archaeology but also of the recollection of rituals, of perform-

ances, of production of goods and services, of artisanry, of the elements of a local business—of anything, that is, that the pueblo thought was important (and was feasible) for the "reproducibility" of its own culture. A museum, if the idea of it was coopted and if it fit into indigenous needs, could become part of a child-rearing cooperative, a tourism project, or a coffee cooperative, or it could join a network of training for the leadership of other pueblo museums.[21] As Bonfil has written so convincingly and so frequently, culture consists of all of the symbols, knowledge, and values, of all of the communicative abilities accepted by a particular society, of all of its material achievements and skills, its knowledge, and its property that make possible the life of that society and permits it to transform and reproduce itself for the next generation.[22]

 With these various attempts to coopt each other's institutions and each other's desires for their own purposes—the indigenous people by adopting the idea of the museum and turning it to purposes other than those for which it had been used to serve the nation, and the government (in the form of INAH) by yielding custodial care of objects to the indigenous—one has a sense that the story is not yet over. If the indigenous people in Mexico follow the trend set by the American Indians (and there is reason to believe they might, given the amount of communication between the two groups), we can expect that there may soon be claims on objects that formerly went to the nation or that, according to the established rules, would traditionally have gone to the national or regional museums. In the United States, the Native American Graves Protection and Repatriation Act (NAGPRA) has caused thousands of objects, mostly related to the funerary mobilier, to be returned to the tribes. This has caused unexpected and often unwished-for challenges in the museums, in the tribes, and of course in the very fields of archaeology and anthropology. All of the cooptation possible may not be enough to forestall similar action in Mexico. Gallaga Murrieta and Gillian Newell have written: "Although INAH does not have any legislation for the repatriation of archaeological mate-

rial, the cited event (NAGPRA) sets forth a precedent that cannot be ignored. The chain of events that is unfolding in the US cannot be seen as alien to our reality. It is important that we look at our anthropological work and our museogrophical work, and that we begin to elaborate mechanisms and answers for possible and future questioning of our discipline."[23]

Conclusion

The communitarian museum movement has had its greatest efflorescence, its most radical manifestation, and its most sustained successes in Oaxaca. At the same time, it has had a striking influence throughout much of the rest of the nation, from Baja California to the Yucatán, where it has been experienced in a number of idiosyncratic ways. It has not always been successful, with occasional thefts of archaeological objects and even abandonment of the projects. Blame has been scattered throughout. But even conventional museums fail, and it seems unfair to hold this new museum movement to a 100 percent success rate in order to prove its viability.

These museums present a myriad of tales and problems that encapsulate a microcosm of museum stories and problems everywhere. The museum in San Vicente in Baja California Norte tells about the hunters and gatherers that were the regional ancestors, about the Dominican Mission founded in 1780, and about the Magonist invasion in 1911. It is creatively funded by traffic tickets and depends financially on the malfeasance of drivers. The Communitarian Museum of Union and Progreso failed in Coahuila, even though it was a marvelous repository of fossils and archaeology. It failed, it is said, because of the indifference of INAH. And the theft of eighteen Olmec jewels in Las Choapas, Veracruz further attests to the security problems that these museums face. Then there are the confusions of governance, such as those exemplified by the Russian

Museum in Guadalupe, which bears witness to the legacy of the Molokhs who came to Mexico from Russia at the beginning of the twentieth century and developed a flourishing wine industry. Still making and selling their black bread instead of tortillas, the museums of the Molokhs present two rival structures across the street from each other, causing a problem for tourist and native alike. Which is the official museum? And then there is the teensy museum in Yucatán, in Oxatapec, the farming distribution center of the state. This museum has no building and can be found only with great difficulty (I was taken there by police escort!). It exists in the house of a Maya-speaking woman who zealously preserves all of its contents—archaeological and historical. Claiming that her museum was expelled from the Union of Yucatán Communitarian Museums, she anxiously awaits a means of reinstatement. These museums suffer problems of governance and financing, security and building, just as do their larger cousins everywhere. But more important, they succeed, as a totality, in proving the complexity of Mexican history across the land by validating the micro/particular/individual/unique histories that don't fit comfortably into the national narrative. As such, they are doing their jobs even though they have to struggle to barely survive.

Even the most successful of the communitarian museums work with limited resources and with limited experience. The support that INAH has given these museums never involves any line-budget money for operations or for setting them up. Occasionally the state of Oaxaca will involve itself in some infrastructural work if it sees tourism potential— but rarely. This is part philosophical—a manifestation of the desire by INAH not to "patronize" the communitarian museums. It is also, in part, a desire by the pueblos not to be controlled by the government. And it is, in part, an INAH prescription for keeping the museums modest and on the brink of extinction budgetarily. According to Morales, INAH's rationalization for nonfunding is that if money were given to the museums, they would become yet another colonized project of INAH instead

of the internally generated project they have been at their best. Although this appears to be philosophically sound, it does prevent the displays and ideas from advancing and evolving as far or as fast as they might: there is very little money to put into them, and once they have been established, it is sometimes difficult to summon up the communal, sustaining energy that they enjoyed when the project was new. After all, there are so many pressing needs: the cleaning up of black water; the improvement of the schools; the building of health centers; the paving of the streets. Still, one cannot help but wonder why there could not be *some* money designated to important indigenous cultural projects, money that the communities might compete or apply for. There could be national or state money available for cultural recuperation, to be used only as the pueblo wished and to be decided only by the Indians themselves. Could all of the rhetoric about the fears attending to "colonizing" and "patronizing" reveal instead a lack of interest in the museums' ability to thrive and become an even stronger questioning force in society? The fact that a museum, like the one in La Natividad, does not know if it will have the budget to continue is cause for dismay. Why should the people from the pueblo have to fund it exclusively themselves? Certainly this is not the case for federally funded projects, like the National Museum of Mining, or for all the other state and national and municipal museums. It is thus left to Morales and Camarena to seek funds from, for example, the Rockefeller Foundation and the World Bank, raising yet another paradox: What does it mean when the globalized economy sees the advantage of supporting local efforts while the nation from which they emerge thinks it best to ignore them?

One of the reasons for the extraordinary success of Oaxaca's communitarian museums is the state's relatively large percentage of indigenous peoples. This demography permitted a general buy-in to this museum idea after it was decided that the idea was a worthwhile endeavor by an indigenous community. But communitarian museums, although they are

meant for pueblos, are not restricted to indigenous peoples. Since Mexico is a *mestizo* country, obviously not every pueblo in Mexico has the system of *cargos*. So the problem of organization and administration is not solved as organically or as consistently in other places as it has been throughout much of Oaxaca. Where the organic community of people linked by relation, class, religion, and tradition has been devastated by individualism, sustaining these museums is more difficult. Still, one can feel the influence of these museums throughout Mexico. Marco Barrera Bassols and Ramón Vera Herrera speak often of those changes, those transitions—of how "one can identify a transition toward greater sensitivity on the part of educational and cultural institutions with respect to the excavation and presentation of a regional polyphony and a cultural polychromy."[24] The communitarian museums are not, in themselves, particularly diachronic or polyphonic spaces, but as a constellation within the universe of Mexican museums, they do complicate the voice and history of the country by their mere existence. They have inspired new ways of thinking about traditional museums. The *nueva museologia*, much of which has provided a brilliant foundation for the communitarian museum movement and some of which has been nurtured by the communitarian museums themselves, has undoubtedly filtered into the museology of Mexico as a whole and into museum projects that are not strictly communitarian. In the decade before the PRI's demise, more and more museums were showing signs of independence and of creative responsiveness to a multiplicity of publics and a multiplicity of stories. The communitarian museums were in the vanguard of that responsiveness. They have become part of the kaleidoscope that is making Mexico newly thrilling as a land where the *muchos Méxicos* that any visitor to that country soon discovers can be explained and understood, not just from one but from a variety of perspectives and points of view.

Finally, there are limitations to the communitarian museums. Some pueblos view their communitarian museums primarily as sources of rev-

enue tied to alternative tourism. Thus some communitarian museums have been built with tourism in mind, and once the frisson of the original urge to establish the museum has worn off, there is little community attendance or involvement beyond the fulfilling of *cargo* and *tequio* responsibilities. Although pueblo citizens are gratified to have a place to tell their stories, many of these museums remain empty and static much of the time—even in Oaxaca. An example of this problem is the wonderful museum in Teotítlan del Valle, the world-renowned rug village. Mexico's most famous artist, Francisco de Toledo, who knows the town and the museum very well, expressed his disappointment in the museum and its physical and spiritual emptiness.[25] He regrets that the museum is not used for workshops to inspire local creativity and that it has become a dead space, one that began with so much vitality and enthusiasm. Thinking of the value of these museums for the community (which they should primarily serve) and for tourists (whom they should secondarily serve) Toledo said that that if people simply wanted to know what was done in the pueblo, they could enter any house and see the rugs being made. And it is true that the museum often has only tourists in attendance. Amelia de los Angeles, who is a member of a weaving family in Teotítlan and whose father held the *cargo* of president of the museum in 2000, tells essentially the same tale, but from the pueblo's point of view: "The people in the town know the stories the museums are telling. Why should they enter?" Clearly, if these museums (and specifically Teotítlan's museum, as it remodels and moves its site) are to thrive, the passion of the creation is not enough. Tourists are relatively few and unpredictable. Using the museum as a launching pad for a better future, such as was envisioned in Santa Ana, will be the way to maintain the vitality of the idea into the future. Access to funding opportunities may be the only way to continue the dream; or, as Toledo suggested and as seems to be happening in La Natividad, active relationships with other governmental agencies, such as the Ministry of Tourism, could make worthwhile

the installation of workshops and possibly the development of original projects for income-producing artisanry.

As Barrera so eloquently put it, it was the indigenous people themselves who took the initiative to repair their corner of the world. That the communitarian museum movement has experienced its greatest flowering in Oaxaca is testament to Oaxaca's lively relationship to its history and to the management of its future—to the intersection of memory and constructive change.

2

Paying Back
Artistic Success, Oaxaca-Style

In ethnic Oaxaca, memory runs not only deep but also wide. Like a rich dye, it spreads across ethnicities and into the mainstream culture. Despite the ever-present claims for the recognition of particular identities as evidenced in the communitarian museum movement, certain memories have become broadly meaningful rather than remaining restricted to the local pueblo or ethnicity.

One of these, the *cargo* system, became characteristic of pan-Mexican indigenous pueblo leadership and governance after the Spanish Conquest. In this pervasive structure, members of the pueblo had obligations to fulfill an ascending ladder of religious and civic duties. These duties were determined by the community for the benefit of the community as a whole and were never meant as individualistic expressions. At the same time, Mexico allowed itself to succumb to a type of authoritarian power that marked the governance of the nation as well as the municipalities before and after the conquest. This power—whether wielded by a local

boss, who dispensed and withheld favors for an indeterminate period of time, or by the nation's president, who had six years to accomplish his goals—is sometimes termed *caciquismo*. Though *cacique* is usually a pejorative term, this person is loved, feared, and hated in unpredictable measure, and his succession inevitably causes a grave predicament for the community in which he operated. *Cargos* and *caciques* have existed in unequal mix, in myth and reality, in different parts of Oaxaca from time immemorial. They have created fertile ground for the growth of a unique, if hybrid, art-based phenomenon: a "Oaxaca style" of philanthropy, one based on unequal proportions of responsibility and personality.

Three artists, all with indigenous ancestry, knowledge, and affinities, led the way toward the concretization of this phenomenon: Rufino Tamayo; Francisco Toledo; and Rodolfo Morales. Though not themselves brought up in indigenous pueblos, all carry with them an awareness that they come from a special geographical and cultural region that needs care if it is to prosper. Even if "Oaxacan artists are not all 'Indians,'" almost all of them were, since childhood, in contact with these traditions."[1] They may or may not consider their donations and contributions to Oaxaca as having emerged from their own combinations of ancient traditions and current success. Still, the fact that some are sometimes accused of having a *cacique* style of behavior and/or are sometimes praised for working in the historical aura cast by the *cargos* is no accident. Rufino Tamayo, an internationally famous indigenous artist from Oaxaca, made major bequests to Oaxaca—*cargo*-like. Francisco Toledo, the most famous Mexican artist of the generation succeeding Tamayo's, improved—*cacique*-like but *cargo*-infused—the life of his city. And Rodolfo Morales, prince of the so-called Oaxaca style and standard-bearer of its sometimes tenuous credibility, contributed—more *cargo*-like than *cacique*-like—to the growing culture of civic responsibility in Ocotlán, a smaller city outside the capital. In addition, several artists in the next generation, under the influence of the three masters, have accepted that they too must work, not only for their own success but also for change for the better in their larger community.

There is no other place quite like this Mexican state—where artists in numbers disproportionate to their presence in the general population have taken on so many obligations of civic improvement. They have done this through artistic projects but also through programs ranging from literacy to technology to health. Although they have all traveled far from ancient pueblo origins, they have not renounced the most generous parts of their "Indianness." That is, in varying degrees, they have shouldered responsibilities for the community, because they cannot avoid carrying forward the moral legacies and the communal ties of the legendary Oaxaca to help make the best of the past a present reality.

Rufino Tamayo

Oaxacan creativity in the twentieth century sprang from soil cultivated by artists well before modern times. The pre-Columbian imagination had been finely elaborated in Monte Albán, one of Mexico's immensely resonant religious sites, an ancient Oaxacan center of art and architecture. Amazing pyramids, clay sculpture, gold and precious jewelry, masks, relief carvings, and stunning pottery can all be seen today in museums in the capital and in Oaxaca itself. José Vasconcelos, the Oaxacan intellectual, brought artistic attention to Oaxaca as the heart of *mexicanidad* as the nation was rebuilding itself after the revolution. Oaxaca was frequently visited by the great muralists, by Frieda Kahlo, and by many foreign writers, including Malcolm Lowry, Italo Calvino, and D. H. Lawrence. Present-day Oaxaca continues to be considered a magically creative part of Mexico, populated by whole pueblos of artisans and folk artists specializing in hand-carved and painted wooden animals, black and green ceramics, rugs woven in ancient and contemporary patterns, and elegantly embroidered clothing.

Many modern Mexican artists were actively engaged in political issues both before and after the Mexican Revolution, and much of their art served the postrevolutionary platforms. From the early provocative and

popular graphics of José Guadalupe Posada to the majestic postrevolu-
tionary murals of Diego Rivera, José Clemente Orozco, and David Alfaro
Siqueiros, the paintings of these artists inspired change in the masses. The
influence of Rivera and the other muralists, at home and abroad, cannot
be overstated. Art functioned as a major player, a hymn to progress, shap-
ing the country's modern nationalism—so much so that it was impos-
sible for succeeding artistic generations to escape those expectations.
Indeed, the muralists were so ubiquitous in Mexico that after the middle
of the twentieth century, they became the Goliaths that needed to be aes-
thetically "demolished" in order for painting to advance. There were, of
course, other artistic strains in Mexico during those years—strains influ-
enced by surrealism and by "plein air painting," for example—but they
were not respected or promoted with the same authority. Within a few
decades, the muralists' ideological imagery had become so repetitive and
dreary, surviving as a genre long after the revolutionary politics lost their
vigor, that it lost all credibility and authenticity. José Luis Cuevas took
on the task of sounding the clarion call against the muralists, and Rufino
Tamayo, a Zapotec Indian from Oaxaca, assumed the role of David, in
order to win this battle and restore to contemporary Mexican art its gen-
erativity on both the international and the domestic fronts.

Tamayo made his reputation as an artistic rebel, as a hero, as one of the
central figures responsible for restoring the notion of art for art's sake
in Mexico. An unlikely international star, silent and unpretentious, he
changed the rules of the game for Mexican art, taking it upon himself
to break the authority of the muralist culture. Tamayo was a leader of the
generation that came to symbolize the ruptura—the fracturing of the
expectation that artists would promote the political program of the gov-
ernment through highly recognizable figuration. Although the ideolog-
ical rage that called for the break was articulated most forcefully by
Cuevas, Tamayo perfected the renewal of mid-century Mexican art by cre-
ating a "universal" style that did not rely on social context, commen-

tary, or topicality for meaning, apprehensibility, and value. He did this without denying the validity of that which went before; after all, he himself had made murals. But at the right moment, his art—beautiful and harmonious, a figuration verging on the abstract, somewhat remote from daily experience—opened the door to abstraction, to what became the prevailing Mexican international style. Tamayo's rare portrayals of the darker forces were communicated by generalized, symbolic, formal, veiled, or metamorphic messages. They could not be read either as criticism of Mexican society or as propaganda for its agendas. Still, progressively, Tamayo included pre-Columbian references in his art, grounding it in mexicanidad. This sat well with the new generation of Mexican authorities who, although finally reconciled to the death of the mural, were nonetheless pleased to find "national" references in Tamayo's art.

Since Tamayo was working at a time when the PRI government was overtly and covertly oppressive, brutal, and repressive (e.g., the 1968 student massacres, the "disappeared" and tortured dissidents), the government was likely very satisfied with the apolitical path Tamayo chose to follow. By removing himself from the hold of the previous generation and by creating and fulfilling the demand for art for art's sake, Tamayo by default became a central, if tacit, affirmer of the status quo. By abandoning ideology as subject, Tamayo seemed to be implying that there was nothing more that art needed to fight for or against. So, even though breaking with the muralists was indeed a mutinous aesthetic act, there was nothing at all mutinous in the role that Tamayo played as far as the government was concerned.

Like most other working artists and intellectuals in Mexico, Tamayo was the recipient of major grants (becas) after the system was instituted by the PRI for the support of artists. These grants were a brilliant governmental tool not just for supporting the arts but also, by definition, for tacitly coopting artists and writers and for inevitably softening any unduly harsh criticism they might have of the status quo.[2] The govern-

Rufino Tamayo,
untitled etching
(Courtesy USC
Fisher Gallery)

ment discovered that there was no need to outlaw dissent; instead, it
could effectively purchase the artists' temperance. In addition to receiv-
ing lifelong fellowship support once it became available, Tamayo showed
at major exhibitions at home and abroad and was published in superb
catalogues. The government also purchased Tamayo's art for the country's
stellar museums, and by dint of all this, he came to personify the state
at important cultural moments. Not surprisingly, Tamayo and most of the
rest of his fellow artists and intellectuals of the *ruptura* generation lapsed
into a public complacency regarding the authoritarian PRI. Mirroring the
trajectory of the PRI itself (which had begun as a force for progress in

Mexican society), Tamayo thus transformed from rebellious advocate for change into sacred cow of the nation. On the other hand, since his artistic inclination was to be a modernist/internationalist with tendencies toward abstraction while incorporating the world of the pre-Columbian imagination, Tamayo was the perfect Mexican, both for export and for consumption at home.

Tamayo paid back his debt to his society, and by the time he died in 1991, he had become a philanthropist of note, giving his collection of modern art to a museum that bears his name in Mexico City and his remarkable collection of pre-Columbian art to form a museum, also eponymous, in Oaxaca.[3] Aside from leaving the imprint of his name on a museum in Oaxaca, Tamayo bequeathed an important aesthetic legacy. He imposed his own reading of the expressive and imaginative nature of pre-Columbian art on his natal city and, finally, on the history of the art of Mexico. As an older man, Tamayo was quite willing and able to use his celebrity to fight, if not for politics, for the politics of culture. He felt that the Mexican people did not properly value their ancient art because they considered it to be "pagan"—a belief in which they had been indoctrinated since the Catholicism of the Inquisition. Indeed, many Mexicans had come to despise the pre-Christian material. The Tamayo Museum in Oaxaca was the outcome of a victorious battle Tamayo conducted with the government fine arts ministry, known as INBA, Instituto Nacional de Bellas Artes y Literatura (National Institute of Fine Arts and Literature), to present pre-Columbian objects in a purely aesthetic framework, to remove them from their archaeological and anthropological context, and to understand and look at them as fine art.

This was a personal political act as well as an impersonal artistic policy statement for the sake of the nation. Tamayo succeeded in representing, in a national fine arts museum, the creative production of ancient Mexico as playing something other than the nation-defining role that the government has always given to it.[4] Tamayo was not interested in the

warrior past, the religious rites, or the agricultural rituals that could
be summoned out of the pieces of sculpture to build national values. He
was not enthralled by the utility or the religious instrumentality of these
objects. Tamayo therefore successfully challenged the political culture in
this struggle. Normally a pre-Columbian collection would have gone to
INAH (the Institute of Anthropology and History) as part of the archae-
ological and anthropological heritage, but Tamayo agreed to give the col-
lection to Oaxaca (and thereby the nation) only on the condition that it
be governed by INBA. The government finally agreed, and this became
the only mainstream museum in Mexico with pre-Hispanic content to
be governed by the national ministry of fine arts and to thereby be con-
sidered solely as fine art. It is quite different from the eccentric museum
built in Anahuacalli by Diego Rivera, his *museo-pirámide-tumba* (museum-
pyramid-tomb).[5]

Tamayo, who constantly referred to these ancient themes in his own
paintings, envisioned elevating the pre-Columbian in status for Mexicans
and for the world by means of his art and the museum he left in Oa-
xaca. He wanted to raise it to such a level that it would be consid-
ered "another imagination"—in the way that African or Oceanic art has
come to be considered. And thus he hoped that his relationship to pre-
Columbian art would parallel Picasso's to the art of Africa. Tamayo won
that war and persuaded the government to give him the marvelous colo-
nial mansion where the museum is now housed—the old Casa Colón.
Fernando Gamboa, seminal museographer, determined the means of dis-
play, which is roughly categorized by region and chronology. The displays
have no sociological or anthropological descriptives or labels to distract
the viewer from the act of seeing. Most radically, the objects are placed
in galleries, each of which is painted another one of "Tamayo's" colors:
purple, green, orange, blue, rose. By Tamayo's act of will, these pieces
have become, indisputably, art; and more than that, they have become art
that generates art.

Was this generous gift to the town of his birth the fulfillment of a *cargo*? Surely Tamayo, the totally cosmopolitan artist, would not have described it as such. But just as his art hailed from ancient times, his grand gesture of this gift to Oaxaca also harks back to powerful, communally based moral sources. Tamayo lived and died the epitome of an international celebrity, having abolished the need for the Mexican artist to engage in direct political commentary through painting. Honored at home and abroad, he became a significant influence—through his themes, his compositions, his attitudes, and his palette—throughout Mexico but especially in Oaxaca, which emphatically claimed that stylistic legacy. Even though he had not lived in Oaxaca as an adult, he fulfilled another important *cargo* by creating a new means and venue for honoring Mexico's oldest artistic production. He thus reignited, within a modern context, the tradition of "paying back," and it continues to burn to this day.

Francisco Toledo

Against the looming artistic influence of Tamayo, another Zapotec Mestizo-Indian from Oaxaca, Francisco Toledo, emerged to dominate the next generation. Toledo benefited from Tamayo's having freed the artist of any responsibility to paint socially motivating murals. Like Tamayo, Toledo did not generally create art that involved overt political messages. Nor did he dismiss or disdain the muralist tradition, even if he did not participate in the movement in any way. Unlike Tamayo, he used the artistic authority that he possessed as *maestro* to act politically in order to achieve his civic ends. Yet the Mexican transition to democracy in which Toledo participated as a young man happened after the "awakening"—that is, after the massacre of the university students in Tlatelolco in Mexico City in 1968. (And according to legend, Tamayo, who refrained from overt political action, did "put out the word" that the young Indian artist, Toledo, who was agitating in Juchitán in the 1970s, should not be killed

by the PRI.) Toledo, therefore, because he was born into the next gener-
ation, was, unlike Tamayo, able to imagine that the PRI might not have
absolute power forever—and that a new government might have to be
responsive to the will of the people. Risks that may have seemed worth
taking when Toledo was a young man would have been unthinkable
when Tamayo was young.

Like Tamayo, of whom he always speaks respectfully, Toledo acknowl-
edges his rootedness in Mexico, and like Tamayo he is a committed inter-
nationalist and man of his time. But unlike Tamayo, Toledo is not a
spokesman or representative of the government and could never be called
the "State Artist." He has managed, even though he has accepted gov-
ernment prizes, monetary support, and recognition, to have retained the
lifelong persona of the independent, aesthetic priest—to whom even the
president of the Republic pays homage. Toledo became a unique figure
in modern Mexican history and in the transition to democracy, embody-
ing all of the contradictions in Mexico: prosperity and the appearance of
poverty; the radical and the conservative; generosity and capriciousness;
and above all, the exercise of absolute authority (caciqueness), but only to
inspire a democratizing populace to assume ever-greater responsibility
for its civic life.

Toledo was born of Zapotec parentage in 1940, probably but not cer-
tainly in Juchitán on the Isthmus of Tehuántepec. After living in Juchitán
as a boy, he left to study art in Oaxaca City. In 1957 he moved to Mexico
City, where he began his career. Toledo traveled to Paris in 1960 and lived
in France, where he came to know Tamayo and became familiar with the
latest artistic trends in contemporary art and with European art history.
In 1965, nostalgic for his home, he returned to Juchitán. He participated
in the dangerous radicalism of the mid-1970s by supporting the dynamic
and engaged artistic environment on the Isthmus of Tehuántepec. At the
same time, he began his productive relationships with Mexico City gal-
leries. Later he fled Mexico in fear of his life because of his political asso-

ciations, and he subsequently lived in Oaxaca, Paris, Barcelona, New York, and finally Mexico City. By the end of the 1980s he finally settled, with his family, in Oaxaca City, where he would create museums, libraries, gardens, artistic workshops, and even a cinemathéque, thereby totally changing the cultural landscape of that sleepy colonial town.

Toledo's retrospective exhibitions in London and Madrid at the end of the millennium, along with an established history of shows throughout Europe, Asia, the United States, and Latin American, have garnered him an international reputation. But his fame as an artist, as a wildly imaginative maker of images, is matched by his equally imaginative envisioning and fashioning of civic marvels in Oaxaca. Toledo is an admired, sometimes loved, but also feared cultural figure whose consummate power comes from his ability to broker deals with the government, using both his own funds and the currency of "the aesthetic" as leverage. Dreamer and pragmatic activist, Toledo has imparted new authority to the citizenry even as he has continued to amass more and more power unto himself. His objective during the last decade and a half has been to engage Oaxacans in the enhancement and preservation of their endangered cultural and natural heritage—to minimize the totality of the power held by the government and to place the power in the hands of the people.

In the late 1980s, Mexico was moving, in fits and starts, toward the democratization that would culminate in the election of Vicente Fox on July 2, 2000, and in the defeat of the PRI. Toledo's ability to mobilize public support may have been the result of good timing. In 2000, he said: "I am not a leader. There is a moment in society that reflects a consciousness of fear: fear for the environment, of violence and of the destruction of the countryside. People of good conscience are then easily convinced to join in efforts that altogether form a weave which makes sense. It hasn't been difficult. It just all seemed to come together."[6] Believing that the time was right, he quickly seized on the potential of the non-

governmental organization (NGO) in Oaxaca as the structure through which he could raise awareness, gather public support, articulate his proposals, and win his battles. The NGO that he chose, and of which he became president, is PROOAX. It began its work in 1992 with the aid of all of the major artists and many of the intellectuals of the city. Its sole purpose is to fight for the culture and natural environment of Oaxaca. PROOAX, which issued its first newsletter in August 1995, quickly became Toledo's means for opposing the powerful economic and political interests that were poised to turn the city into an adult "Disneylandia." Toledo understood, from his early political exposure in Juchitán, how government worked, how art could lend prestige to political efforts to garner supporters, and how he could seduce politicians into doing his bidding.

Most important, he grasped how he could create a celebrity culture around himself, one to which influential Mexicans would flock. His presence in the city caused other artists to move there or return to live there. As a result, within a decade of his arrival in the mid-1980s, Oaxaca had become a city populated with creative people, politicians, wealthy residents, and average citizens, many of them doing his bidding, imitating his ideals, and generally changing their world to suit his vision of Oaxaca as a city with an economic engine run by visual culture. Toledo helped Oaxacans assume power over their civic lives, though he did this while playing the role of the classic *cacique*. He wielded power, not capriciously as do most *caciques*, but single-mindedly. Toledo's charisma came from his authentic artistic stature and his compelling, if often recalcitrant, personality. Through this triple role—as *cacique*, as celebrated artist, and as democratic activist—he seamlessly crafted that often fatal conjoining of celebrity, art, and politics into an astonishingly successful marriage.

Paradoxically, Toledo developed his cult of celebrity by constructing an ostensibly anti-celebrity persona. He can be seen on the streets of Oaxaca: scuffling around the city, unkempt, barely shod, eyes averted,

like the stereotype of an Indian visiting the big city from the highlands for the first time. Then, on a second sighting, he might be the high priest, the sophisticated leader, impeccably clad in pure white and sandals— granting and withholding audiences with presidents, governors, and visiting artists and intellectuals, profoundly affecting the shape and direction of Oaxaca's communal aspirations. The glamour surrounding him is irresistible. This is certainly not the first time a Oaxacan Indian has crossed the boundaries normally set by his origin, but it may be the first time a Oaxacan Indian has done so without pretensions to looking and living like a western European in Mexico. Appearances aside, Toledo fits perfectly into an ideal of liberal exceptionalism that has long pervaded the Mexican national imaginary—that is, the belief that even the most ordinary of Mexicans can become extraordinary human beings. Exceptional Indian figures, saviors, and dictators such as Benito Juárez (the "father of his country") and Porfirio Diaz (the forty-year dictator preceding the 1910 Mexican Revolution), formidable thinkers such as José Vasconcelos (the principal intellectual of the postrevolutionary period), and major and minor artists have also emerged from Oaxaca.

Toledo's enemies accuse him of using his Indianness to advantage when he is actually, they say, a *mestizo*. But if Indianness can be measured by a preponderance of values instead of blood, he qualifies: many of Toledo's attitudes do derive directly from Indian roots. Certainly he has supported Zapotec Indian culture aggressively and courageously. He claims, though, that he does not feel "Indian": he sheds no tears at the sound of the *Zandunga*, a lovely and sentimental local folk song, and he does not really speak Zapotec, even though his parents both did.[7] Still, Toledo seems to derive pride from the fact that one of his five children does speak Zapotec and writes poetry in the language. And his taste for the collective reflects indigenousness, such as when, admiring the caves of Altamira, he says: "It is a type of collective work, it is realized, nevertheless, alone—that is, the works have had the participation of several

hands and have been added to over time. In my work there is that spirit." Toledo's taste in politics reveals his roots as well. He claims not to vote in elections, nor does he believe that any of the parties in Mexico will make the needed changes: "If I had to reply which is the best system, I would say that it is that of *usos y costumbres*, that system in which a bell is rung, the people meet, they debate things, and they decide. If a politician doesn't fulfill it, *lo colgamos* [we hang him], and that is it. As it is done in many [indigenous] pueblos." And finally, in answer to a question about whether he is aiding his city because of the collective tradition in which he grew up, he stated: "Yes, in Juchitán a culture of mutual help exists. . . . Perhaps it comes from there."[8] Clearly, through his life and art in the larger world, he has demonstrated indigenous pueblo values, forgoing the accumulation of material goods and the normal accoutrements of individualistic success for the sake of the community.

The Art of Toledo

Most of Toledo's art is an elaboration of his vision of the physical world and its mythical components, along with an ongoing commentary on art itself. He is at his best when appropriating elemental images from his childhood, from the legendary city and countryside of Juchitán. Its flora and fauna have been fertile sources for his paintings, sculptures, and works on paper: lizards and turtles, dogs, serpents and insects—all inevitably making their appearance in strange and unexpected relationships with human beings and other species in the animal kingdom. Toledo's art never loses its connection to specific sources of inspiration and still reaches a universality of meaning. Mirroring Juchitán's unique position in Mexico, distant from the capital of the country and other cosmopolitan centers of Mexico, Toledo's art is also never merely provincial: for centuries, Juchitán has attracted foreigners because of its production of the coveted indigo and cochineal dyes; its eccentric culture was thus never isolated, and the need to communicate in order to do business kept

Francisco Toledo, detail of untitled etching from *Una carpeta para PROOAX* (Courtesy
Fernando Gálvez, director of IAGO)

its people aware of the international and the modern. People traveled
there from long distances, and some from the Isthmus, such as Toledo's
father, regularly traveled to Mexico City.

Toledo's art, mythic in its attachment to the "local" that Juchitán rep-
resents, is further complicated by the fact that he is a man who has trav-
eled and lived outside of his country and who can see Juchitán as a
"stranger." Since his early adulthood, he was involved in the world of
international contemporary art. In the 1960s, while living in Paris, he
had already begun to appreciate the radical aesthetic possibilities of non-
traditional materials being explored by Tapiés and Dubuffet. His larger
cultural references were Kafka, Borges, Goya, Blake, and Durer. Toledo's
penetrating glance and often outrageous juxtapositions (whether record-

ing and capturing the movement of a cricket, drawing a self-portrait, registering the meanderings of his inner life, or commenting on the mythification of history) awaken primal and contemporary responses in the viewer. That he has also absorbed the widest range of art history and experimented with the latest photographic technologies is also critical to an understanding of Toledo's art. Some of his most intriguing recent work emerges from, for example, his contemporary, photography-based serial adaptations of Durer's drawings of his pillow. In addition, Toledo has long delighted in breaking the boundaries of traditional artists' media, having worked in clay and mica and having lately become increasingly involved in his own surrealistic brand of landscape gardening. His best work is haunting: it hints at the whole and the resolved, but it is a mixture of the shifting dream-life, of natural imaginings, and of reality. It is simultaneously secretive and inviting. Honoring, revealing, encoding, and transmogrifying the multifarious worlds he has encountered and absorbed into his imagination, Toledo has arrived at his own unmistakable artistic view of the world.

Toledo's art is recognizable immediately. Unlike most other Oaxacan painters, who imagine the prettier, dreamier aspects of their surroundings and propagate what is known as the "Oaxaca style," Toledo captures the concrete and the tangible but always transforms its scale, its color, its texture, and its form into images that are haunting, tense, tender, or surprising. His art is distinguished for its range of materials, a range that may perhaps best be compared—in its variety, its daring, and its usurpation of the quotidian into the realm of the aesthetic—to that of the Spaniard Tapiés. But whereas Tapiés represents the thoroughly European encounters with city living (concretized bedsheets, battered doors, and displaced manhole covers), Toledo's hails from the country, from nature, from its pagan earthiness, from its generativity, from its sexuality. Fernando Gálvez in his manuscript for the book *Arte Oaxaqueño Contemporáneo*, introduces a sampler of Toledo's materials. He writes that they constitute

a catalogue of a local market where one could find everything from ostrich eggs to ancient postage stamps, tortoise shells, gold leaf, fossils, pistachios, and more. Gálvez insists that Toledo is not merely a virtuoso manipulator of these materials but an artist manifesting his intense sensual relationship with the world around him. By confronting his viewers with his artistic world, Toledo heightens their sensual awareness of and relationship to a universe they might have abandoned but would be well served to rediscover.[9]

Toledo's art is also distinguished by his palette, totally unlike the so-called Oaxaca style of bright colors stolen from the rainbow, each juxtaposed gaily to one another—extensions of Tamayo's and, to some extent, Rodolfo Morales's art. Grays, browns, and charcoals dominate Toledo's grave canvases. Toledo may owe his chromatic subtlety, his limited range of palette, to Tamayo, but the colors he admits to his artwork certainly do not belong to the pastel universe invented by Tamayo. Even when Toledo works with mica, a material characterized by its brilliant shades of green, that green seems to come out muted and retiring. His colors may best be imagined by thinking of excrement, sand, earth, seeds, and dead leaves. Indeed, the relationship to *mierda* (excrement), was made explicit in his *Cuadernos de la Mierda*, exhibited in 1996 in Oaxaca's Museum of Contemporary Art (MACO), the institution Toledo was instrumental in founding after he moved back to Oaxaca. The principal imagery of the notebooks is from the world of insects, but as they interact with other animals, humans, and cadavers in erotic scenes around the subject of excrement, they open up a normally unheralded dimension in the arts to what we might not have previously termed the life force.[10]

Although Toledo's paintings are almost never about politics, he did produce a memorable series in which he compulsively meditates on the power of political celebrity to blind one's critical thinking. For almost three decades, beginning with his return home from Paris, he painted and assembled images decrying the distortions that celebrity can bring

to the historical-political sphere of memory. Toledo began *Lo que el viento a Juárez* when he returned to Juchitán in the mid-1960s, continued working on it until the mid-1980s after he had settled in Oaxaca, and then put it aside until 1996. The series emphasizes the critical concept that the deification of Juárez's image went beyond any historical reality and that the totality of this deification negated the complexities and contradictions of Juárez's great but flawed life. The series reveals the stunning impermeability of Juárez's image as a result of having been infinitely and identically repeated in stamps, currency, monuments, photos, pictures, books, and innumerable paintings and other illustrations.[11] Toledo revived *Lo que el viento a Juárez* in 1996 because, in the dying days of the PRI, he sensed an opportunity to question (metaphorically) the reverence still directed toward the office of the sitting president, Ernesto Zedillo. By re-questioning the impermeable representation of Juárez, Toledo hoped to inspire a willingness to judge and satirize Zedillo. Later Toledo admitted to Robert Valerio, the Oaxacan art critic: "What is sad about it is that the show didn't result in any controversy, any debate; I am sorry that the Oaxacan [citizen] lacked the fire to protest; there has been no protest." Valerio wrote that this lack of protest was due, ironically, to the aura that by 1996 had surrounded Toledo as well. Toledo had, by virtue of his own mythification in Oaxaca, arrived at a place where debate and dialogue were unlikely responses to his art. Furthermore, according to Valerio, Oaxaca was no longer a city amenable to satire; it had become a very solemn city.[12]

The Politics of Toledo

In the mid-1970s, after Toledo had returned from Paris to Juchitán, he became implicated in the earliest Mexican municipal efforts to unseat the PRI.[13] He and his comrades in the Juchitán struggles welcomed local intellectuals and students, as well as creative people and ideas from the outside world, to help them in this enormous effort. Toledo had become

involved in a movement of the left called COCEI (the Worker-Peasant-Student Coalition), formed in 1974—an extremely ambitious local political group that took on the PRI to help Juchitán recover its lost rights of property and culture. COCEI assumed this role long before it was fashionable to do so in Mexico and became the first left-wing opposition party in the country to win major municipal elections: in 1981 and again (after being ousted in 1983) in 1992. The 1981 victory was achieved by Juchitán's indigenous population, with the indispensable and always acknowledged help of artists, performers, poets, and writers (not all of them indigenous, and some international), of which Toledo was the star figure. Thoroughly incorporated into the rough-and-tumble idealism of the day, the artistic role of Toledo and his colleagues was to spread the word about the COCEI struggle through poetry, song, and visual imagery—through a blend of contemporary art and the indigenous imagery so easily summoned up in Juchitán.[14]

Toledo is credited for his role, even by social scientists who spend no ink on art: "Francisco Toledo, one of Mexico's foremost contemporary painters and a native Juchiteco, has spread images of COCEI and the Isthmus Zapotecs to the cultural capitals of Europe, the United States, and Japan through his colorful and provocative work."[15] COCEI maintains itself as a legendary presence to this day and retains its status as one of the incubators of democracy in Mexico. Composed of native Zapotec peoples, COCEI earned its political savvy through the Zapotec tradition of centuries of resistance to powers that wished to subjugate them entirely. Toledo did more than simply make art for the cause. He was one of the principal patrons of the Casa de Cultura, the local center for studying, affirming, and promoting the living history of the Zapotec pueblo. During the early years, Toledo lent his important art collection of Mexican and foreign art to the Casa and infused significant cash into the care of the collection to make it continually viable during those years. He published a strikingly designed magazine, illustrated by superb graphic

artists, entitled *Guchachi'Reza*.[16] The purpose of the magazine was to express the aspirations of the local Indians and to try to bring attention to their political victimization. That the spread of Zapotec culture "has always been inseparable from politics and thus has entailed acts of resistance and self-affirmation" is undeniable.[17] And that Toledo "almost single-handedly circulated the news of COCEI's ethnopolitical movement to the world's cultural capitals" is also widely noted—although he was joined by important Mexican photographers. Toledo subsequently formed *Ediciones Toledo* to further address Isthmus culture.[18] And then, in 1983, after having been attacked by a PRI group and almost killed, he went back to Paris.

When Toledo returned to settle in Oaxaca in the last years of the 1980s, he came with a complete vision of what he wanted to accomplish—a vision of the current political situation and of the process that he would need to activate to accomplish his goals.[19] He had been well trained for political action during his Juchitán years. Oaxaca had seen much better days: that it was economically distressed by the 1980s was undeniable, but that the nefarious exploitation of its cultural resources was necessary to rescue it from misery was not an acceptable premise to Toledo. His point of view flew in the face of Oaxaca's political and business leaders, whose style of power had been inherited from pre-Columbian days in that it remained unquestioned. Furthermore, the acceptance that control by a ruling class was natural and inevitable persisted: whether it was Spanish control by the vice-regal powers and the hacienda owners and the church; control by the postcolonial heroes and the strongmen of the Independence, up to and including Porfirio Diaz; or control under the reign of the PRI and PAN. The *cacique* figure had retained legitimacy throughout all of these centuries. But the leaders of Oaxaca had met their match in Toledo. The artist transformed himself into an end-of-the-millennium version of the *cacique*: he changed a troubled city into a lively urban place with a thriving historical center in spite of its politicians.

Toledo's Achievements in the Civic Realm

Toledo calculated that change was possible if he could get Oaxacan citizens involved in the preservation of their beautiful colonial center, their stunning natural environment, and their traditional art and artisanry. He knew that he could not achieve the salvation of Oaxaca on his own, that he would need to have supporters, and that he could find them by gathering a critical mass of people who would join him in his projects. He found the means with PROOAX, a local but moribund NGO of which he immediately assumed the presidency. Toledo never hesitated to use his prestige (and his own money) as a magnet to attract all the right people to become members. In 1995, the PROOAX bulletin he published related the initial victory his group enjoyed: it defied the government's intentions to put up a statue of Don Quijote in a place deemed inappropriate by Toledo and his followers. His group's success represented the first time that the Oaxacan citizenry overturned a decision of their municipal government: "It was thus that the municipal authorities accepted that they had to consult with the citizens by way of referendum about the placement of this sculpture."[20] Toledo went on to push and pull PROOAX to develop Oaxaca in the ways he thought appropriate. He contributed his own money, art, property, and energy as he helped build lobbying groups to make Oaxaca a cultural Mecca. Some of the money came from the sale of his art, some from taxes he had saved by donating art to the state, and some from prizes and *becas* he was receiving on a regular basis from the government. He developed a relationship with the governor and with the wealthy of the city, and he used his influence to ensure that successful artists understood that they too were expected to "give back"—so that what had become a thriving art region would continue to grow more prosperous. Within less than a decade, other artists began to develop and nurture their own civic projects.[21] Almost every preservation effort— every museum and garden and every library and cultural center in Oaxaca City that was built since the late 1980s—was inspired or promoted

or shaped by Toledo. This is notable in a country that took for granted that its government would either provide cultural amenities or destroy them at will. Toledo's actions were radical in that he empowered the citizenry to exercise democratic control, but they were conservative in that he created institutions that would outlive him and that were partners with government. And he did all of this by constantly exercising his own authority as the *cacique*—a recognized figure of power in Oaxaca and one whom it was never wise to offend.

That Toledo was aware of his attraction is indubitable: he was fascinating; he was extremely handsome; and he surrounded himself with powerful intellectuals. He gave and withheld his attentions capriciously. He spoke or did not speak for his own reasons. As the financial interests of Oaxaca began to parallel his own, Toledo's objectives became easier to achieve; individual, business, and governmental aspirations were fulfilled by the visits of wealthy Monterrey *señoras* eager to invest in art and local properties; the city became a more compelling tourist destination, a place for second homes, and a location for the collecting of art. First the collectors came to Oaxaca because Toledo was there, but soon the artistic environment evolved and other artists and projects became enticements too: more galleries; more restaurants; more hotels; more language schools; more social life; more status. Still, the centrifuge was Toledo. That Toledo accomplished almost everything he did during the twilight of the PRI without ever being a member of that party is astonishing. PRI bureaucrats dismissed him by saying that he was like a ball of Oaxacan cheese—tied up in knots, difficult to unravel. But they were not in a position to resist his blandishments. Nor did Toledo rely entirely on local enthusiasms. He could count on regular support from one of Mexico's most progressive and respected national newspapers, *La Jornada*, probably because he had played a major role in the paper's early success. When presidential candidates came through Oaxaca in 2000 and had their pictures taken with him, those photographs always appeared in the news-

papers. When questioned about the propriety of having his picture taken with both PRI and PAN candidates, he retorted: "I, too, am a politician."[22] But he is a politician who has never belonged to the PRI and was not a proponent of PAN. Toledo fiddled with both parties, always politicking on his own account.

Oaxaca became what it is today because of Toledo's vision, exercised when necessary with the authority of a *cacique*, supported by his culture of celebrity, and aided by the incipient sense of civic responsibility and democratization in the face of urban crisis. Toledo's biggest goal has been, to create an environment in which Oaxaca can survive and can sustain an economy based on its cultural offerings; in which it can avoid becoming a theme park; in which it can support artists and nurture scholarship; and in which it can encourage a participatory ethos to further positive municipal goals. There is no doubt that he has achieved notable accomplishments, though not always without some controversy. The following paragraphs discuss major projects, in or near Oaxaca City, that have been signed, sealed, and delivered primarily by Francisco Toledo. (The discussion does not include the numerous less-noted efforts in which he has also engaged and offered innovative leadership: supporting AIDS education; backing the Amnesty Law benefiting Indians; or encouraging owners of small agricultural farms in the southern Oaxacan Sierra in their creative projects such as bottling organic fruit with mezcal so as to keep their pueblo from disappearing because of extreme migration to the United States for lack of work at home.)[23] The success of each such project is due to his inspiration, leadership, political organizing, and alliance building, as well as to his recognition of a particularly opportune moment. By capitalizing on that moment for the conservation of artifacts, nature, or the built environment and for the general advancement of culture—in the grand Latin American sense of the word—Toledo has been able to achieve most of his ends.

One of Toledo's earliest institutional successes in OAXACA was IAGO

(The Institute of Graphic Arts), created in 1988 soon after his arrival. It has already become one of the most complete graphic art collections and art libraries in Mexico. The elegant seventeenth-century structure in the historic center had once been Toledo's house; he donated it, along with its fine collection of art and books, to the city for the Institute. Exhibitions of graphics out of these holdings are regularly organized by IAGO's staff and lent to neighboring museums, with a few traveling outside of Oaxaca and even internationally. Artists shown include Tamayo, all of the great Mexican muralists, José Guadalupe Posada, Otto Dix, Francisco Goya, James Ensor, Salvador Dali, and Henry Moore. IAGO has also afforded many Oaxacans their first exposure to contemporary artists, including foreign luminaries such as Francesco Clemente, Alex Katz, George Moore, and James Brown. Toledo has garnered some significant subvention for IAGO from the National Institute of Fine Arts (INBA), thus guaranteeing its sustainability. In the meantime, because of Toledo's iron-hand rule, directors are hired (and fired) or resign with alarming frequency. One of those directors, in trying to explain the problem, pointed out that for all of the good Toledo does and all of the value he brings to the city, he is a "monopoly" and that like all monopolies, he does only what he wants: he shows the artists he wants Oaxacans to see; he keeps out the foreign artists he does not want to show; and he ultimately determines all of IAGO's activities, including details of daily operations.[24]

The Museum of Contemporary Art of Oaxaca (MACO) is housed in a palace popularly believed to have belonged to Hernán Cortés. Though it was a slum building when Toledo first saw it, he soon convinced the state government to purchase the property, renovate it, and dedicate it to contemporary art. Completed in 1992, it constituted a big step toward making Oaxaca a cultural destination where visitors could encounter not only regional but also international art. MACO will be discussed further in chapter 4.

The Centro del Arte Santo Domingo is dedicated to the celebration of

the present and past culture of the region. It includes a museum and exhibition spaces, an ethnobotanical garden, and libraries. It is one of the most impressive accomplishments in which Toledo had a very large hand and will be discussed in depth in the next chapter.

The Paper Workshop at San Agustín exists today because of the purchase by Toledo, along with the state of Oaxaca, of an unused and abandoned property in the pueblo of San Agustín Etla on the outskirts of Oaxaca. Toledo prevented the destruction of this intriguing but absolutely deteriorated property and transformed it into a workshop and factory for making paper from locally grown products. San Agustín opened in 1997, and artists now conduct classes in which participants learn to make paper in traditional ways, using regional plants. They use these papers as the basis for contemporary art production, for exhibition, and for sale. San Agustín is emblematic of one of Toledo's goals: to recover ancient artistic techniques for the purposes of fostering their use in the creation of an authentically contemporary artistic production and to avoid the kitschification that comes from the mindless repetition of ancient techniques. Economic goals at San Agustín include developing a profitable and self-sustaining institution while providing work for artists. With a long-term strategic plan, the project is hoped to survive Toledo and to become institutionalized. On the same property, an abandoned textile factory has been destined as a future training ground for artists of all types and has been discussed as a possible site for artists' residencies from all over the world.

The Alvaro Bravo Photo Center is a gorgeous photography exhibition space occupying one-half of a colonial house in the center of town, another house once owned by Toledo. It opened in 1996 and is used as an experimental venue for photography and as a stage for the work of artists such as Bravo and Toledo as well as for the display of artists from elsewhere who would never otherwise be seen in Oaxaca. It also housed the Library for the Blind, a previously ignored group with respect to their

adult intellectual desires. Because of the photo center, its blind users are now, themselves, making photography, having devised ways of taking pictures to display. Elegantly preserved, the center is a simple space with a waterfall leading to a canal that divides the two halves of the facility.

El Pochote is a cinemathéque, free to the public, showing foreign and art movies not ordinarily seen in Oaxaca. Thematic series are curated to make the offerings as rich as possible. El Pochote occupies another former home of Toledo's that he gave to the people. Here he continues to plant his own garden, an ongoing work of art. Abutting the ruins of the colonial aqueducts, the garden has become one of Toledo's ways to make his visitors see their surroundings anew. His palette is the green, yellow, and red soil of Oaxaca—which, in one of the early iterations, he distributed to differentiate the planting plots. The garden, which one enters by passing through the centuries-old arches, is a living painting in a private/public landscape, filled with only native plants and punctuated by the strategic use of water and pavement.

This list of Toledo's projects is far from complete, but it demonstrates the sweep of his ambitions and achievements. Notably, although his philanthropic contributions are far more numerous than those of Tamayo in Oaxaca, none of them bear his name. Nevertheless, all of them are imprinted with his personality. Reminiscences of a world of *cargos* and *caciques* float through all the projects, while responsibility for the community and absolute authority over it overlap and contradict each other. As noted previously, controversy has arisen over the years, much of it surrounding the high degree of control and micromanagement that Toledo has exerted in the realization of his goals. His foes accuse him of discouraging independent thinking and of fostering an atmosphere in which people are afraid to tell him the truth. And finally, some complain about the elitist nature of his dreams for the shaping of his city. Still, even the head of INAH, Eduardo López Calzada, has credited Toledo with being a "moral model" of artist as citizen, saying that he has led, pushed,

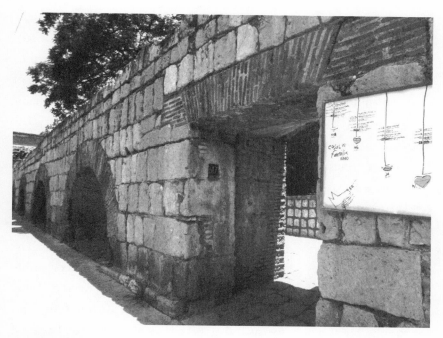

El Pochote, entry arches (Courtesy Manuel Jiménez)

inspired, bullied, and/or intimidated an influential part of the citizenry
into assuming a more participatory and responsible role with respect
to their urbanistic lives. No one, he concluded, denies that Toledo has
always had the interests of the city at heart and not those of his own
pocketbook.[25]

Yes, Toledo's existence in Oaxaca has yielded a net gain for the city. Not
surprisingly, there seems to have been a net loss for Toledo's art. Nurtur-
ing all of his projects and pursuing all of his political goals left less time
for the high level of artistic production that had had legitimized his
power in the first place. Toledo became so involved with the life of the
city that even his biggest fans began to notice the decline in the quality
of his art around the year 2000. Realizing this himself, Toledo went to
Los Angeles for a year to work. Unlike so many others who move to that

city, Toledo was not seeking celebrity but was escaping from it. In Los Angeles, Toledo reasoned, he could work, most people would not recognize him, and no one would make demands of him for their own or for the city's well-being. He could simply exist—outside of the circle of celebrity culture and politics that he had created in Oaxaca while remaining connected, nevertheless, to the thriving Oaxacan community Los Angeles. Toledo returned home after a year, having worked on his art and having sent thousands of books to IAGO, his beloved library.

Toledo was badly needed back in Oaxaca. The disappearance of the *cacique* had caused a leadership vacuum that only Toledo could fill. While he was gone, McDonald's had been making plans to put one of its hamburger franchises in the Zócalo, the historical central plaza of Oaxaca. The Zócalo is a living, breathing testament to the continuity of Oaxacan life and to values that have defined it for centuries. It is surrounded by Mexican and a few Spanish (run by the families of their Basque founders) restaurants, all of which feel as if they have been there forever. The food is prepared laboriously and is treasured for its savory tastes, smells, and textures. The local population and tourists eat there, talking business and trivia unhurriedly. The adjoining Cathedral plaza is joyously noisy with concerts and vendors and children playing. For those who care about Oaxaca retaining its uniqueness the McDonald's incursion represented the worst of globalization. On the other hand, the city's bourgeoisie saw this business as a way of jumpstarting the economy and of providing much-needed jobs for the impoverished city. The longer view took into account that the reason tourists come to Oaxaca has never been for a McDonald's. (In fact there already was a McDonald's in Oaxaca, but it was outside of the historical center.) PROOAX, the NGO that could have been expected to fight against McDonald's, had fallen into complete disarray in Toledo's absence: the executive officers had resigned, and its passionate purpose had dissipated. The McDonald's looked like a *fait acccompli*.

The battle began on Toledo's return. Almost immediately, he, his fellow artists, and his legion of supporters arranged a tamale supper in the Zócalo. Thousands of beautifully prepared tamales were given away, served on banana-leaf-covered tables. Locals contributed fruit-flavored waters, money, and song. The point of this *fiesta* was to remind the public that this incursion by McDonald's represented the potential destruction of a way of life. As was indicated by the widely circulated PROOAX petition, signed by influential artists and intellectuals, it would destroy values and memories, shredding them into billions of homogenized hamburgers for the sake of quick profit. It would further the destruction of the tropical forests in Latin America, destroy small businesses, and discourage culinary diversity. McDonald's would spread the pollutants of plastics and paper in the historical center. The petition also discussed the US labor policies that PROOAX believed to be permitting the exploitation of illegal aliens in that country. The problem faced by the protestors was that McDonald's had apparently followed all of the obvious laws in obtaining its governmental permits. At the time, McDonald's was in a frenzy of adding franchises to enhance its sinking profit margin and share price: all the Zócalo meant to McDonald's was money. As McDonald's representative Erick Fregoso said in the local newspaper, El Imparcial, McDonald's would "open one of its franchises in the Historical Center because the law warrants it."[26] Still, he indicated that he had no desire to fight with the painter Francisco Toledo. Fregoso confirmed that the company had secured the approval of INAH, that it had signed a contract with the owner of the property, and that all it had to do was to launch a marketing campaign to convince the Oaxacans that McDonald's was not going to threaten the local architecture. Yet Fregoso did not seem to understand that this was not simply about architecture. Julie Watson, an Associated Press writer, noted that Toledo said: "This place is not for McDonald's, this is a sacred space." The Zócalo was, without a doubt, a major influ-

Banana-leaf-
covered table,
anti-McDonald's
tamaliza, Oaxaca
Zócolo (Courtesy
Fernando Gálvez)

ence on art and creativity in Oaxaca. And many artists were determined
to keep the new arches out of view of the venerable old arches that mark
the sacredness of the space.[27]

Toledo led an amazing campaign against McDonald's. He and his many
sympathizers organized public forums where the by-now very hot issue
could be discussed. He lobbied the leadership of the Congress to estab-
lish new legislation protecting the architectural patrimony, especially that
at the heart of the city. And he found that there was indeed a ruling that
the government could use to protect this "City of Humanity." With Mex-
ico and Oaxaca at the crossroads of an enhanced democracy, it was
important that such a regulation could be found and appealed to—a per-
sonal victory would no longer be sufficient.

Francisco Toledo (left) at anti-McDonald's *tamaliza* (Courtesy Fernando Gálvez)

Eventually, the battle was won. McDonald's, with 225 outlets in Mex-
ico and with more than half of its 30,000-plus branches outside of the
United States, came to its knees in the face of Toledo's passion to con-
serve his city's history. This artist, this man of the people, this citizen who
fought for and protected what he and his fellow citizens believed was
right, won. He proved himself to be the local *cacique* who mattered. He
proved that, with David-like ingenuity, he could fell an international
Goliath—and that he could do so even when no one else thought it was
possible.

Rodolfo Morales

Toledo's influence has led to the formation of a number of foundations
in Oaxaca, a legal structure that allows artists to "pay back" to society
once they are in a position to do so. The most successful of these foun-

dations was formed by Rodolfo Morales in 1992. Morales was born in 1925 in Ocotlán, a city in Oaxaca State not very far from the capital. He left his hometown when he turned twenty-three to study fine arts and spent most of his adulthood in Mexico City, where he taught drawing for thirty-two years. When he was fifty years old, Morales was "discovered" by Tamayo at an opening for an exhibition in Cuernavaca. Tamayo attended the show, was impressed, and wrote a now-famous letter promoting this fine "new" artist. Tamayo's power was unquestioned in those days, and Morales soon had major gallery representation in Mexico City and enjoyed modest success there with the help of the gallery owner Estela Shapiro. At the age of retirement, in 1985, Morales decided to leave the capital and return home. The day before he was to leave, the city suffered a huge, devastating earthquake. Morales was packed and ready to go, but he participated in the civic rescue effort after the earthquake and then, without remorse or ambivalence, returned to Oaxaca and resettled in Ocotlán, where he purchased the biggest and most beautiful home in the pueblo.

Once back in Oaxaca, Morales began to enjoy surprising success and was soon taken up by an ambitious new gallery, Arte de Oaxaca. At that time, Oaxaca had no high-quality art galleries—the boom had not yet occurred. Although Morales continued with Shapiro for some years, his new angels became Nancy Mayagoitia and her partner, Dora Luz Martínez, at the flourishing Galería Arte de Oaxaca.[28] Paralleling the higher demand and the higher-priced sales set by Shapiro, they raised Morales's prices to heretofore unexpected heights. Soon he was working exclusively with Arte de Oaxaca, and the revenues from his paintings were more than this modest artist had ever imagined. Morales took pride in being able to live on his teaching pension of four hundred dollars a month. He also took satisfaction in never having accepted a beca from the government, in functioning as a truly independent artist. Taking stock of his income and his needs, he soon agreed with Mayagoitia, who had legal training, that they should start a foundation.

The demand for Morales's work continued and grew. He was the thoroughly independent artist. He had been an outsider when he started his career, just as he had been an outsider in Ocotlán in his youth. As a young man in the capital, he never tried to fit in by adopting the prevailing muralist dogma. Nor, later, with the advent of the *ruptura* and the flood of the new abstract aesthetic ideology, did he adapt to the new artistic thinking. Morales's work always remained faithful to his brand of magical realist, quasi-surrealist representation and was thus considered old-fashioned, irrelevant, and even primitive by the contemporary art establishment, to the point of being scorned by his colleagues in Mexico City and at the academy where he was teaching.

Appreciation, then, for Morales's work was both overdue and overdone: His oeuvre spawned innumerable slavish imitators who claimed to be working in Morales's ultimately inimitable style: angels and girls, their hair flowing into each other; palaces and dream cities; deep colors emanating from a personal but undeniably Mexican and melancholy paradise; the profound darkness of Indian women's faces engaged in secret conversations; disembodied heads and hands delivered lovingly on plates to waiting laps; featureless corpses. All of these, Morales's elements contributed to a vision never before imagined. When his colors were bright, they were somehow dimmed by his overriding loneliness, their brightness placed in such unlikely juxtapositions that their usual meanings were transformed—yellow earth, green and pink buildings and railroads, black loggias, brides without bridegrooms and the blues that became the whites of their eyes. Everybody who could afford to wanted to buy one of Morales's paintings. Flying seraphim; old ladies aloft; hair into veils; heads spouting water that turns into showers; outstretched arms reaching for and grasping "nada"; flowers overflowing a prison-like gate, almost drowning a woman locked inside. Deep and true, following an inner logic yet paradoxical, these paintings captured the sad joy of small-town Mexican life, poor yet rich in ways that most Americans and Europeans never experience. A pure painter, Morales did not experiment with

avant-garde materials until, later in life, he would awaken every morn-
ing and "play" with collage. In the manipulation of materials other than
paint—bits of fabric, metals, papers, beads—he allowed his imagination
to enter as-yet-unexplored territories. Unashamedly beautiful but still
adventurous, without any pretensions to narrative and now, with an
almost gentle, humorous surrealism, these collages added yet another
dimension to Morales's work: more abstract; more fun; not as filled with
his existential sadness. One could smile looking at them and not feel the
usual tinge of grief.

Morales's philanthropic work was primarily directed outside of Oaxaca
City, in the environs of Ocotlán. Although he had a studio in Oaxaca City,
he made his family home in Ocotlán. After fully restoring his big house
there, he transformed the sections of it he did not need for himself into
a kind of cultural center for the city. Antiques and flowers filled the liv-
ing quarters, and the old kitchen was dizzying with the smells, tastes,
and sights of Mexican spices and fruits. One sun-filled room was loaded
with thirty computers, its space dedicated to children from the town,
all of whom needed access to technology. He was an avid reader and des-
perately wanted to encourage reading among the students. When Morales
finally accepted that he would not get very far with a reading program
in his rather unprogressive pueblo, he set up the computer center, fos-
tering another way of learning—one that he felt could redirect the stu-
dents' lives along positive paths.

Notwithstanding the lack of passion for reading in his pueblo, Morales
installed a community library. He fretted about the lack of charm, of artis-
tic life, in Ocotlán and thus held musical events, poetry readings, con-
ferences, film and theater presentations, and other cultural celebrations
in his home. This house remained open to visitors and collectors who
wanted to see his studio and living space. Aside from continuing, gen-
erously, to help the town in ways such as these, Rodolfo provided a new
ambulance, and he planted trees and flowers everywhere. He created a

projection room for documentary films and an open-air theatre. He
looked forward to Ocotlán becoming a more beautiful city and attract-
ing more tourists and also more jobs for its citizens. Indeed, as the critic
Fernando Gálvez has said, Ocotlán, once the most unimpressive of cities,
did begin to look more beautiful, more like Morales's paintings, every
day. Or as Oscar Wilde remarked much earlier: life showed itself to be
engaged in its unending struggle to imitate art!

Morales was not a political man by nature. He did not like to bring
attention to himself. And he was not a *cacique*. The one break in his apo-
litical nature involved an event that took place between Ocotlán and
neighboring St. Antonino. The Ocotlán merchants, *mestizo* mostly, had
decided to exclude their indigenous neighbors from the local market.
They claimed misdeeds on the part of the Indians. But Morales decided
that the exclusion was a racist rather than an economic problem. He
fought the exclusion and made many enemies along the way. Death
threats forced him to accept the services of a security guard furnished by
the government. Usually silent, Morales remarked after this that racism
and prejudice were ubiquitous and that he felt obliged to protect the
Indians from the irrational hatred of their *mestizo* neighbors.[29] Certainly,
Morales's own suffering and the extent to which it was a motivation for
his fierce protection of the downtrodden cannot be determined here; but
we do know that he believed that culture had a role beyond being some-
thing that could be purchased by the wealthy for their own pleasure. And
once the wealthy, by paying so much for his paintings, had enabled his
own position to be one of a wealthy man, he would direct all of those
funds to help culture play this other role. Rodolfo believed that culture
could help us overcome the worst in ourselves by encouraging us (seduc-
ing us?) to prefer a "higher" existence, one catalyzed and made possible
by a love of art and music and a more beautiful urban environment.
Ocotlán, as he explained it, was a city that had lost its sense of cultural
aspirations and traditional identity in its thirst for modernity. Morales

would spend the rest of his days and the rest of his money investing in that very city.

The money flowed into the foundation because his works sold so well. Furthermore, according to Mayagoitia, collectors from the wealthy city of Monterrey would come to Oaxaca, see Morales's work, and want a piece for their collections.[30] The collectors would make a major donation to the foundation and would then be given a gift of a painting by Morales, thereby receiving both the tax deduction and the painting. After paying his own taxes to the Department of the Treasury—with six paintings, the maximum the nation could take—Morales would owe no more taxes, and the money he received now needed to be spent. He thus found socially beneficial projects and tackled them. Unlike Toledo, who is described as having had a complete vision for Oaxaca, Morales took on projects on an *ad hoc* basis—but always related to his dream regarding the efficacy of culture in altering human nature and especially, but not exclusively, in neighboring Ocotlán. Nor was every project that he took on his own. He was also extremely helpful to others. According to María Isabel Grañen Porrua: "There was a hurricane in Oaxaca, and Alfredo Harp asked the artists to give a work for the Friends of Oaxaca [Harp's own foundation] for an auction, telling them that the money realized would be directed to the repair of the disasters caused in the zone. Everyone, with the exception of the Maestro Rodolfo Morales, asked for half of the money for themselves. Only Morales gave his work one hundred percent."[31]

Morales's foundation also supported projects to protect nature in the region: he created communitarian nurseries to preserve native species; he helped to reforest the copal forests, which supply the wood for the artisans who carve and paint their popular animal sculptures; he planted 6,000 jacarandas in Ocotlán; he partnered with thirty pueblos to save the Atoyac River from contamination. He restored five historical houses so that they could be used to further the foundation's goals; he restored the railway station so that it could be used by the Red Cross; he partnered

with PROOAX and, by definition, with Toledo to help save the archaeo-
logical zone of Monte Albán from being overrun by people seeking to
build their homes on the archaeological site.

But, finally, Morales was most interested in spending his foundation
money to restore architectural monuments. He had become educated
about colonial architecture during his life in Mexico City, attending lec-
tures on the subject, reading about architecture, and traveling intensively
throughout Europe and the Americas. One of his biggest projects was the
restoration of the former convent at Ocotlán. The convent was a wreck,
having become a prison after Mexico's exclaustration. The cost for restora-
tion was in the millions of dollars. Every time that Morales thought the
work on the convent was finished, an old fresco would be discovered and
yet another section of historical beauty had to be reclaimed. The clergy,
astonishingly, resisted this restoration, but Morales prevailed in the face
of the propietariness and jealousy of a local priest. Consistent with his
belief that Ocotlán needed to have beauty in its midst, Morales placed his
expectations in the hope that completing this project could help the
pueblo, by turning it into a magnet for tourists. He envisioned creating
a museum of folk art, with a section for colonial and religious art.

And the former convent did become a stunning and seductive struc-
ture once again—reason enough to travel to Ocotlán. Indeed, in the year
2003, in memory of Morales, a cultural corridor opened between the
towns of Huajuápan de Leon, Ocotlán, and a number of neighboring vil-
lages. Many visitors are coming to Morales pueblo to celebrate the arts
and regional culture. Sponsored by state and national funding, this fes-
tival is yet another proof of the power of the individual to mobilize in
Oaxaca. Morales would have been pleased to see the appreciation of the
fine arts growing in his once culturally deprived birthplace.

Another of Morales's architectural triumphs was the restoration of the
Church at Santa Ana Zegache. Zegache is a little pueblo made up of two
conflicting populations: Zapotec and Mixtec. As a child, Morales had

Former convent, Ocotlán (Courtesy Manuel Jiménez)

attended *fiestas* there with his parents). It is an interesting edifice, located in an almost unknown spot outside of Ocotlán. Like so many other colonial churches, Santa Ana was built on the remains of pre-Columbian ruins. Many of the ancient stones were incorporated into the colonial structure and can still be recognized as such today. The church has an ancient patio in front where masses were held because the Indians had been accustomed to fulfilling their rituals outside of their temples, unlike the Christians, who always went inside their temples to attend the Mass. Thus Dominican priests began the ceremony outside, where the Indians could see the sky and the clouds. Then, after having been made to feel comfortable outside, after processions around the pyramidal towers that had been added at the corners of the patio, the Indians would be brought inside. Making the Indians comfortable cannot have been an easy process, given the particular history of Santa Ana Zegache. The Spaniards had initially ruined their land by bringing in grazing livestock, causing the

locals to massacre of the livestock. The Indians were then punished by the Spaniards. By the end of the twentieth century, bitter memories continued to color the pueblo. The past had been debilitating, and Morales once again hoped to improve the local situation through art.[32]

Morales paid for all of the work at Zegache himself, with the exception of some help he received from INAH on the entryway to the plaza. He engaged the local community in the restoration, giving the unemployed in the pueblo an opportunity to work and earn money. They learned skills that they could apply in the future. Morales encouraged them to paint the façade of the church in the bright, popular colors the pueblo Indians loved. Baskets of flowers were painted in the niches of the facade. Never one to be deterred by "modern" ideas of good taste, Morales wanted the people to love their church. At the same time Morales was entranced with some baroque mirrors, decorated with two-headed bronze eagles and painted paper under glass, that had been found in considerable quantities in the church. He was assembling and studying them so that the young people could learn how to make copies to sell. With that in mind, Morales initiated the Workshop for Conservation and Restoration in Santa Ana Zegache. He also paid for all of the restoration work and offered advice for the conservation of other convents as well: San Baltazar Chichicapam; San Pedro Taviche; San José Progreso; San Jacinto Ocotlán; Magdalena Ocotlán; San Felipe Apostól; and San Martín Tilcajete. His dream was that a tourist route would focus on the arts, crafts, and food of his natal area, and perhaps that will happen with the cultural corridor mentioned above.

Morales died in 2001. The sustainability of his projects remains unclear. Properties he had wanted to develop, such as a colonial house in the heart of Oaxaca City that would have become a conservation training institute, were left unfinished. The workshops in Zegache were discontinued for lack of funds. The future of the museum at the ex-convent was in doubt. None of this was because of a lack of assets, since Rodolfo had left

Rodolfo Morales
(Courtesy Rodolfo
Morales Foundation)

enough, with the value of his pictures, to continue his work—even after having taken care of his family. But a recession reduced the value of his pictures, and funding became a struggle for the foundation. Sadly, there seemed to be no workable plan, no coherent vision, to continue the work of the quiet gentle Morales.[33] On the other hand, the president of the foundation, Morales's nephew Alberto Morales, is planning to strategically show and sell the artist's remaining works.[34] He has a large cache of works and is, he says, waiting for the art market to revive; he already arranged a European tour of Morales's work to seed new desires for and awareness of his uncle's art. A tax structure, he added, has been organized that would allow for donations to the Morales Foundation from other foundations and from private entities. Morales's home will remain a cultural center. Still, whether or not the foundation will be able to further his vision, to add to, and even to maintain, what Rodolfo already contributed remains to be seen. Nevertheless, what Morales did accom-

plish was a more than sufficient legacy for any single individual. Morales once remarked that he did not know if he would be remembered as a painter but that he wanted to be remembered for having helped his pueblo.[35] A quiet and unassuming man, he became another leading Oaxacan artist who was committed (in this case without a trace of *caciquismo* but with a large dose of the vestigial memory of the *cargo* system lighting his *mestizo* way) to "paying back" to his community.

Conclusion

This tradition of helping the community remains an active one among successful artists in Oaxaca. For example, Sergio Hernández has created his own foundation and has already built a beautiful building that has functioned as a *kunsthalle* for the display of artists and of collections that the Oaxaca public might not otherwise have the opportunity to see. Hernández is an internationally recognized Oaxacan artist from the little pueblo of Huajuapán de Leon, and he spent years working on building his career, all the while being criticized for selfishness. By 2002 he had made a clear statement that he was ready to add to the cultural life of Oaxaca. The exhibition space he built is in an expanded and renovated Oaxacan house, notable for the canal of sweet water that surrounds the main floor. This little canal ends in a fathomless well that is covered over by an elegant circle of glass. Looking into its depths, who could not call on this city's age-old memories as it negotiates the new millennium for itself? Who could not be convinced that the artists who add beauty to the city are not fulfilling an ancient charge? Luis Zarate, another contemporary Oaxacan artist, has toiled uncountable hours in the creation of the city's ethnobotanical garden in the Santo Domingo Cultural Center. His contribution of beauty and usefulness could be made only by someone with memory, foresight, and generosity to spare. The younger Guillermo Olguín, an up-and-coming painter, worked in La Costa Chica on the

beaches of Oaxaca with the black population of Mexico that calls this area home. After a devastating hurricane, Olguín took it upon himself to restore the roof of the town's cultural center after it was wrecked by the winds and rain. He felt obligated to "pay back" the community because the Oaxacans whom he had employed as models were now in trouble and because he now had the means to do so—the series he had painted in which they had participated as models had completely sold out![36]

There is not really a conclusion to this chapter. Undoubtedly, Oaxaca will continue as an intriguing city; it has always been so. With or without the living artists and their commercial success, it has always attracted visitors who want to see ruins and museums and artisanry rather than hang out on the beaches, which the state also has in great quantity. Oaxaca City attracts curators and directors of museums—and collectors as well as artists. But what will happen next, when Toledo, the last of these legendary artists, has died or has left once more? Will all of the institutions he created survive? Are they sustainable without his leadership? Will subsequent generations of artists continue to honor the obligations to the community that gave them their lives and treated them so well—as Tamayo and Toledo and Morales have done? Will the younger artists, as they move further and further from the vestigial memory of pueblo traditions, forget entirely about *cargos*? Will the *cacique* tradition be discredited in the full light of democracy in Mexico, where law, not the individual, is expected to govern? Will anyone else be able to prod the people and the government as Toledo has? One can only hope that the inspiration and memories of Rufino and Francisco and Rodolfo will, indeed, continue to light the way for other artists—for those who come to Oaxaca from the outside and also for those who were born in the state but grew up far away in time from the memory of communal responsibility as the highest good. Oaxaca is what it is because the ties of community do still bind. Artists are central figures in Oaxaca's continual improvement, and they will need to continue to play starring roles. They have a

special gift in this city to negotiate for the future—whether for the protection of the built environment or the natural landscape; whether for libraries or developing creative means of employment of the youth. They are indeed "moral models" in a city that knows it cannot count on its government officials, its business community, or even its church fathers for protection now or in the foreseeable future.

3

The New Philanthropy
Private/Public Partners

The first time I visited Oaxaca, in 1999, I went to the Santo Domingo Church, long a favorite stop on the tourist route. Decorated exuberantly, gold leaf flaming through the brilliant blues and reds of the Tree of Jesse, it has been extravagantly restored. Widely used by worshipers, Santo Domingo is easily accessible in the heart of the historic quarter. As I was leaving, I noticed that a cultural center had recently opened in the adjacent building, formerly a convent. Entering the ex-convent, I encountered a magnificent, columned Renaissance courtyard; some of the columns are only decorative, carved with fine relief designs; some are structural; and others support nothing but tiny domes. A fountain stands in the center of the courtyard, which is surrounded by the processional walkway with innumerable mysterious archways and entrances. An impressive staircase, grandly decorated with frescos and still more gold leaf, leads to what was modestly termed a regional museum. The collection on dis-

Outside hallways,
Santo Domingo
Cultural Center
(Courtesy Manuel
Jiménez)

play included fabulous objects from Monte Albán, from other nearby pre-Columbian archaeological sites, and from neighboring villages.

The next time I came to Oaxaca, a lecture was scheduled at the Francisco de Burgoa Library, part of the Santo Domingo Cultural Center. I entered one of the exterior archways into a perfectly furnished and maintained reading room with modern, glassed-in bookcases filled with old volumes. Restored centuries-old frescoes—some abstract, others vegetal

Patio, Santo Domingo Cultural Center (Courtesy Manuel Jiménez)

and floral, a few figural—represented the Dominican monks who origi-
nally built the convent. Vitrines with a well-curated exhibit of photos,
documents, charts, and specimens set the stage for the talk. In addition
to eleven precious incunabulae, the cases held 23,000 volumes, many
first editions, including a rare seventeenth-century Dutch atlas, volumes
on the military history of the Spaniards, medical texts and botanical
books, extremely rare books in the local language called Mixtec, and
other singular items nowhere else to be found. The library also conducted
many sophisticated conservation activities, including the restoration of
centuries-old maps treasured by the pueblos as evidence of their land
claims and their communal identities.

Over succeeding visits I attended concerts, book presentations, round
tables, literary readings, artist talks, and exhibitions at the Santo Domingo
Cultural Center. The Hemeroteca Pública Nestor Sánchez, another facil-
ity of the center, offers a large range of Mexican newspapers without

Ethnobotanical garden, Santo Domingo Cultural Center (Courtesy Manuel Jiménez)

charge to the public. And the ethnobotanical garden at the rear of the complex had grown from a once-barren site into an ebullient and evocative, multilayered landscape. Carefully elaborated relationships between plants and archaeological remains, including a pre-Columbian water source, form a visual epic poem that effectively links modern Oaxaca to its ancestral past. Ancient fragments and infinitely diverse plantings were excavated, reactivated, and replanted. The collection of plants, composing an encyclopedia of the local religion and medicine, is fast becoming one of the most important resources of its kind in the Americas.

Finally, during one of my later visits, I saw dozens of children from the Triqui pueblo playing and studying in the inner sanctums of the museum. Normally the children stationed themselves outside the museum, under the coral trees, selling their woven bracelets to museum visitors for pen-

nies apiece. I became interested in finding out what had brought on this change of venue. I also felt compelled to learn about the background of this immense and complex cultural center. It was both new, having opened in 1998 as a cultural center, and old, with the convent portion finished by 1577. How had it come to be in its present form? Who was responsible for it?

The story of this center can be summed up by two questions posed by Hillel in the Old Testament: "If I am not for myself, who will be for me? But, if I am for myself only, what am I"? In Oaxaca, new means of funding and of governing monuments of the general culture emerged; wealthy individuals, artists, and intellectuals decided they could not live only for their own success; and government (perhaps reluctantly) allowed them to participate in both the fundraising and the decision-making. The recuperation of Santo Domingo is a tale of Oaxacan citizens working with and monitoring the government instead of being led by the government. These citizens altered the assumption of a predetermined result that would signify Oaxacan culture for themselves and the world at large from that moment onward. This story begins with the monument itself, continues with its physical and programmatic renaissance, and ends with a glimpse of the implications that its evolution has for the birth of a more civil society in at least one city in Mexico.

Santo Domingo was originally erected as a convent for the Dominican Order, which took over Oaxaca after the Spanish Conquest. It was begun in 1547 and largely finished by 1575. By 1635, its imperial staircase had been updated with the extravagant frescoes that remain today. And by then it had become known as one of the most important mission structures in all of Latin America. As it happens, the role of the mission was well documented, and extant documents make clear that the order achieved its goal rather thoroughly. Although the bishop of Oaxaca, Obispo Fray Bernardo de Albuquerque, was one of the kinder of Spain's

emissaries sent for the purpose of conversion, his role was still "to erad-
icate these idolatries and ancient rites that in the Indians of [his] bish-
opric have been described, by giving them sufficient indoctrination" and
by destroying their idols, their *caciques* and their witchdoctors.[1] When the
Indians resisted conversion, the bishop did request milder punishments
than were normally meted out, but he also accepted that if they were
indeed guilty of bad faith, they should be punished yet more harshly.
Depending on whether they were judged to have acted naively or pur-
posefully and depending on who was in charge at the time, they were
then punished more or less harshly. By 1812 the convent and the church
no longer served religious purposes, having been commandeered for the
state in the church-state separation that marked Mexico's increasing sec-
ularism as it moved toward independence. Both structures became the
property of the military, and the ex-convent served as military quarters.
Some room had also been set aside in the ex-convent for a small, undis-
tinguished regional museum. In 1895 the church reverted to its religious
role; later it was restored, in various stages, to its present glorious state.
Although sometimes considered "over-restored," the church is undeni-
ably gorgeous, and its maintenance since the restoration has been superb.
Another large building on the property is attached to the convent, form-
ing yet another impressive courtyard. This was built in the twentieth cen-
tury especially for the military. The large "patio de estudios" is stark, with-
out a single living plant to relieve the severity. One is awed by the stone,
the arches, the rows of windows, and the numerous domes under the
seemingly infinite dome of blue sky and clouds (the latter are so defin-
ing in this part of the world that in ancient days the inhabitants called
themselves "cloud people"). The rhythm of the architecture from this
vantage point is broken only by the Renaissance tower, tiled at its rounded
top and topped by its own tiny tower. This is architecture emanating force
made bearable through its unrelenting harmony and beauty. The military

handed this property, in deplorable condition, over to the state in 1994.
At the time, there was no clear vision for the use of the ex-convent—
other than that it would be used for "culture."

Partners in Recuperation

The determination of what to do with the huge site was made after
unprecedented deliberations with the citizens of Oaxaca. The only clear
agreement was that it would be a cultural, not a business, project. People
from all walks of life had the chance to suggest possibilities for the next
iteration of Santo Domingo. Oddly, only the Dominicans of today feel that
they were insufficiently consulted in the process. (History's revenge?) [2]
After arbitrary management by the military for more than a century and
a half, the citizenry would now have their say—including, of course, rep-
resentatives of the government agencies INAH and INBA, the Oaxacan
Cultural Institute, and the Tourism Ministry of Oaxaca State. Above all, it
was made clear by the government that the inclusive effort was not meant
to serve any predetermined agenda and that the project needed to bring
significant "added value" for all Oaxacans. The debates that followed were
among the earliest examples of totally democratic cultural decision-
making in modern Mexico.

Key to the success of the rebirth of Santo Domingo as a cultural cen-
ter was PROOAX. One of the earliest assignments taken on by PROOAX
was to serve as "watchdog" for the integrity of the Santo Domingo Cul-
tural Center process. Run by the most successful and vocal artists in Oa-
xaca, presided over by Francisco Toledo, but also led by other artists such
as Juan Alcazar and Rubén Leyva, PROOAX was thoroughly supported by
many of the city's influential elites. Its voice was heard consistently
through the PROOAX newsletter beginning in August 1995 but also
received coverage in the local and national media. Hungry eyes saw this
project first as a commercial opportunity for enterprises inserted into the

complex and later as a parking lot, then a restaurant, and finally a convention center. PROOAX kept the lines of debate above board and prevented any business agreement from slipping in and partnering with the government in a deviation from the initial agreement.

In late 1995, well after the critical 1994 decision had been made to dedicate the center to culture, an official announcement declared that the state government indeed now had other plans. The leaders of PROOAX immediately wrote the governor, and a follow-up letter was published in the PROOAX Bulletin early in 1996: "The members of PROOAX were surprised by statements sent out in the media recently about the intent of the State government to manage the Sto. Domingo project as a convention center under the tourism branch of the state. This unforeseen posture obliged PROOAX to send a letter to the governor, Diodoro Carrasco Altamirano, to remind him of the commitment to respect that space totally for cultural purposes. . . . By means of this letter, we wish to make absolutely clear our rejection of your declarations with respect to the uses of the ex-convent of Sto. Domingo de Guzman. . . . You referred to the installations of the Ex-Convento as destined for a Convention Center complemented by artistic and cultural activities. And this contradicts the commitment to convert it into a Cultural Center as the result of a public convocation which took place in the month of May of 1993." The letter reminded the governor of the official signatories to the agreement and implied that this change would not go forward without a fight.[3]

The Santo Domingo struggle and its great success can now be called upon to function as an example for new kinds of cultural partnerships in Mexico. It preceded the elections of July 2, 2000, and was a sign of the increasingly vocal Mexican population. It is a model that the increasingly democratized populace can only find valuable as a reference. It documents that close involvement of the people of a city with the government decision-makers is the only way to get desired results. Certainly the support of the federal government was indispensable to the success of Santo

Domingo, and it was available on a very large scale. The work began
under then President Carlos Salinas, when he authorized the turnover
of the site to civil society, removing it from the control of the military.
The work was finished under his successor, President Ernesto Zedillo. It
thus always had the huge resources of the nation behind it. Besides the
financial implications of federal backing, once the work became a flag-
ship presidential cultural project, it had CONACULTA (in effect, the
Mexican Ministry of Culture) as its supporter. This link meant the avail-
ability of the expertise of INAH and INBA, of archaeologists and anthro-
pologists, of art historians, of museum educators and museum design-
ers, and when it was time to spread the word, of the press. And since this
was a national project but one not located in Mexico City, the state of
Oaxaca was yet another financial partner. Through its Instituto Oaxaqueño
de las Culturas, the Oaxacan State had a fundamental stake in the triumph
of Santo Domingo and would become an equal partner.

But even this traditional partnership was not enough to fund the whole
Cultural Center. A nontraditional partner was invited to enter the project:
the Fomento Social, the foundation of the privately owned bank Bana-
mex. This three-way partnership allowed for a new and potent voice—a
nongovernmental voice—to be heard in Mexican cultural decision-making.
It allowed for an unprecedented relationship with respect to decision-
making about the birth of a major cultural institution. Banamex was run
at that time by Alfredo Harp, a wealthy Oaxacan who definitely had the
interests of Oaxaca at heart. Harp *was* Banamex for Oaxaca, and it was the
pure force of his own commitment that made the corporate involvement
so remarkable, possible, and sustainable. Alfredo Harp Helú was born in
1944 in Mexico City, of parents who had been living in Oaxaca. His
father died when he was three years old, and he grew up a very poor boy.
He was educated by the LaSalle Brothers School, and he always worked,
growing up with laborers and learning their culture. Harp went to the
national university (UNAM) and studied to be an accountant, after which

he was given a position with his extremely wealthy relatives in the financial sector. A combination of diligence and luck brought him wealth, and he then took on major civic national duties such as serving as the president of the Council of Administration of the Mexican Stock Exchange and the Institute of Values. This position allowed him to participate in policy decisions such as stabilizing the exchange rate, lowering interest rates, and drastically reducing inflation, which had risen to about 200 percent annually. In 1991, when Harp was just beginning to think that he would like to retire and commit himself to baseball (his passion), his group bought Banamex. Instead of retiring, he continued working, and Banamex went on to purchase many works of art and historical buildings, to support exhibitions, and to provide funding for the preservation of the Mexican artistic patrimony. Harp founded the Banamex Cultural Foundation, which he dedicated to protecting the most vulnerable people in the country, especially in the rural regions. Then, in 1994, Harp was kidnapped. During his 106-day ordeal, he pledged that he would "serve the neediest, enjoy every minute of life and dedicate himself to baseball" if he was ever released. He wanted, finally, to take charge of his life and allow no one else to manage his agenda.[4] He was released, and he was finally ready to leave the business.

In 1995, Harp was invited to participate in the restoration of the Santo Domingo Cultural Center. He saw this as a marvelous opportunity and a worthy model precisely because it would bring together, for the first time, the federal government, the state government, and Banamex. He made certain that the private partnership was equal to the government's in input, not just in funding.[5] That is, he received assurances that in the ongoing commitment of money and with the involvement of the bank, the private voice would be heard.[6] Santo Domingo thus became the first major cultural center in Mexico to be conceived of as a private-public partnership and to have its financial participation policy planning and management built into its future.[7] And the private sector quickly intro-

duced an active and healthy suspicion of the government to the planning process. As the head of the Banamex Foundation explained: "The government said to us at the beginning, 'You give us the money and we will match it.' We refused, knowing that once they had the money, we would lose our influence. Finally they agreed to put the money into a trust, and we all considered together what to do. This was the breakthrough—being true partners in the decision-making."[8]

The attraction for Harp was, as always, more than artistic. He liked that Santo Domingo created employment for more than one thousand people for over four years and that it rescued lost trades, such as gold leafing, from oblivion. And so in 1995, he returned to live in Oaxaca with his new wife, María Isabel Grañén Porrúa. She and their newborn child became his chief passion, along with Oaxaca State itself: "I returned to Oaxaca because I remembered many passages of my childhood there, and once recognizing my desire to be in this beautiful state, I made the decision to look no more and I made the decision to help advance Oaxaca."[9] Now that he no longer runs Banamex, Harp remains clear about his interests: he wants to create alternatives to combat poverty, and he prefers projects with long-range, sustainable partnerships (large or small). He has no preferences for political parties or religion and accepts a project strictly for its intrinsic social, cultural, or educational implications. Thus he created the Friends of Oaxaca in 1997; he started a superb LaSalle School in Oaxaca in 2000; he created the Stamp Museum called MUFI (a focused and state-of-the-art small philatelic museum); he helped restore treasured but dilapidated colonial former convents outside of the city; he made music available to many pueblos and supported their local bands; and he assumed many other social and cultural projects.

In every instance, Harp provided yet another voice that pierced the monolith of the government. A good example of his prodding and of his own brand of philanthropy was his engagement with the library of the venerable intellectual Andrés Henestrosa. The government of Oaxaca

State would not consider helping to build or offering a building for this undertaking, perhaps because of jealousy of the increasingly loud private voice that was beginning to shape Oaxaca's cultural profile. Harp had offered to pay for the restoration of an appropriate building for the library but insisted that he would not be at the mercy of the state government and its unilateral decision-making process. When the governor refused to help, Harp went to the city government and persuaded it to donate a colonial mansion in the historical district. Despite the subsequent rage of the governor, the project would proceed independently. Grañén Porrúa will supervise the inventory and the transfer of the books, and Oaxaca will receive yet another cultural treasure. Numerous such examples—in the worlds of the visual arts, music, ceramics, and education—attest to Harp's distinct voice and to its clear benefit in Oaxacan society.

One can already see the Santo Domingo project being a model for similar recuperations in the rest of Mexico, where there are so many important colonial buildings that could be "adaptively re-used." One example: the extensive ex-convent of San Luis Potosí, the Franciscan equivalent of Santo Domingo, has served as a regional museum since 1952. It is presently being adapted, with much of the same strategic planning underlying it as the Santo Domingo project. Starting in 1998, this project has gone forward in several stages, including the remodeling of the building and the rethinking of its displays and its museographical script and point of view. The huge effort to rescue this piece of the national patrimony began, however, as the usual partnership between federal, state, and city governments. In 2002 the Potosine community became involved, and it has since formed a civil association, called the Friends of the Franciscan Complex. The involvement of civil society can only bode well for San Luis Potosí.

If partnership is measured by outcome rather than by mere dollars or pesos, PROOAX also needs to be considered to have been a full partner

in the project. Nevertheless, the extent of this partnership was not always consistently recognized, as for example, on the night of the official opening of the Cultural Center, PROOAX was not mentioned. Francisco Toledo, its president, was offended, and he threatened not to show up for the festivities. But history is now recognizing the NGO's power. It was PROOAX that consolidated the idea of artists and their supporters as indispensable partners in the fashioning of the Cultural Center and, therefore, in the fashioning of Oaxaca as a preeminent center for the introduction, preservation, interpretation, and dissemination of its culture. In fact, the partnership was a four-way one: the national government (CONACULTA), the state of Oaxaca, and Banamex were financial partners along with the moral partnership of PROOAX, with the artist Toledo being a financial participant in the ethnobotanical garden—one of the pieces of the Cultural Center closest to his heart.

The Original Plans and Beyond

PROOAX exerted more than moral suasion. The self-appointed charge of PROOAX was to protect, rescue, and enable the conservation of monuments, especially one of the size and importance of the Dominican convent. That the Cultural Center would offer the much expanded permanent collection space for the important regional museum was a given. It also seemed to be a given that the center would contain the hemeroteca. But it was PROOAX that actively formed and nurtured the rest of the center. Under the inspired leadership of Toledo, PROOAX—in association with Alejandro Avila (who became the director of the garden)—conceived of the concept of the ethnobotanical garden. There was sufficient proof that a garden had existed on the property when the Dominicans were in charge to justify rebuilding it. The sixteenth-century garden had been dedicated to the acclimatization of plants, including apples and oranges and lemons, after they had been imported from Europe and also local

plants before the seeds were extracted and sent back to Spain. A perfect location for the rejuvenation of this garden lay beyond and behind the museum.

The library, Fray Francisco Burgoa, was also instigated by Toledo and then by PROOAX, but always with the full support of Dr. María Isabel Grañén Porrúa, currently its director. Toledo had noticed that books formerly belonging to the convent had long been under the custodial care of the University of Oaxaca, where they had been tragically neglected, chewed on by rats and cockroaches, sacked, and trashed. Toledo tried to rescue them, first by transfer to the Central Library of Oaxaca and later to the Contemporary Art Museum's library. Finally, it became clear that they belonged in the center itself, in the heart of Oaxaca State. As Toledo insisted: "Independent of the decision about what would be the best space for the conservation of the originals (the heart of the matter), I believe that it is very important to reinforce the capacity for research outside of Mexico City and not to privilege the research centers of the capital, as if they were unique: it is necessary to train specialists in the interior of the country, especially in this concrete case due to the natural tie that exists between the research and conservation of the collection."[10]

The force behind the library soon shifted to its director, Grañén Porrúa. She was responsible for inventorying the works (in inferno-like conditions), for restoring and stabilizing them, and for providing their continuing care. She raised funds from Alfredo Harp (before they were married), providing for its protective shelving and cabinets. She was also responsible for establishing the Taller de Restauración de Documentos y Libros Antiguos en Oaxaca, the restoration workshop that functions as a conservation institute for the documents and old books from the state, and the Bookbinding Workshop Gabriela Guzzy, which was personally funded by Toledo and Alfredo Harp. People from the pueblos take their precious foundational documents to these workshops to be restored and learn to care for them. This ability to conserve their own maps and doc-

uments enables them to argue for their rights to keep these precious doc-
uments, for their pueblos' ability to care for the documents, and for their
right not to have to turn the documents over to the national government.
Once the documents are restored, the pueblos can then return their mate-
rials to, for example, their local communitarian museum, with renewed
autonomy over and with the knowledge about the proper care of their
patrimony. The trust that the library and the conservation center, under
Grañén Porrúa, have built up among the indigenous peoples has helped
extend "ownership" of the Cultural Center beyond the typical museum-
goer or tourist into the interstices of the state—serving the democratiz-
ing impulse of Mexico as well as critical conservation needs.

Each of the other parts of the center is run by capable and inspirational
people. The garden is directed by Alejandro Avila, who conceptualized
and first proposed the fully articulated project of an ethnobotanical gar-
den. He stood up for this idea against pressure for a sculpture garden or
a garden of raw materials for artists. Avila was certain that an ethno-
botanical garden could relate to the museum and to the library and be an
organic part of the complex. Above all, the garden would be a depository
and a laboratory for gathering and studying all plants native to the region.
It would reveal the two hundred million years of evolution that led to the
diverse flora of the state. These plants would be studied for their medic-
inal properties, their uses in the local cuisine, their ritualistic associations,
and of course, their functions as raw materials for traditional and con-
temporary artists. One can only imagine that in today's world, when the
drug companies of the globalized economy are desperately searching for
new solutions to illnesses and for secrets to longevity, the curative prop-
erties of these plants might provide some valuable clues. By creating a
garden that is both decorative and research-based, the center may enable
indigenous groups, who have long known about these properties, to
obtain patents and to enjoy the fruits of their ancestral knowledge and
to resist the exploitation of their resources by outsiders.

Toledo so believed in the ethnobotanical garden that he put his own money into it, officially channeled through PROOAX. The 1994 trust agreement has, in this instance, three different partners: the state of Oaxaca, Banamex, and Francisco Toledo. Because Avila temporarily left the project—almost as it began—to prepare for his doctorate in anthropology, linguistics, and botany at the University of California, Berkeley, the money that had begun to be invested in the garden was set aside until his return and earned quite a bit interest. When he reassumed the directorship in 1997, considerable funds were waiting to be spent. Avila initiated the design process, with the artist Luis Zarate and, to some extent, with Toledo.[11] This stage of the garden inspired much public debate and controversy: Mexico City landscaping specialists, such as Mario Schedman, were invited to contribute ideas, but none of them were convincing; Urquiaga, the original architect of the Santo Domingo building complex, tried to control the architectural aspects of the garden, but his work eventually had to be undone. The ideas that prevailed were those of Zarate, Avila, and Toledo. Finally, in 1998, Toledo, Zarate, Avila felt they had it right, and they began to plant. But by now, the situation had reversed; they were running out of money. Toledo, who had been so important to the garden, began trying to get civil society to lend more than moral support, by trying to get the members of PROOAX to pay dues. This proved to be a challenge and a frustration. It became obvious that Toledo could not stand in indefinitely for civil society and that there would have to be some sharing of the financial burdens from that sector. In the meantime, the project was temporarily rescued by the nation: INAH, which was not an original signatory to the trust, chose to help out in 2002 and directed some money to the garden at that time. Toledo's ability to persuade INAH to step in is not surprising: by 2002, the garden had become one of the great gardens in the world.

The now grown plants, the pre-Columbian archaeological remnants of water sources and ovens, the contemporary sensibility, and the architec-

ture harmonize with the changing rhythm of trees, bushes, cactuses, and flowers. For example, an oven in which the Dominicans made their glazed pottery was found in the garden space and is highlighted by rectilinear paths and tall cactus. The latest addition to the garden is a massive entrance sculpture designed by Toledo immediately after his return from Los Angeles. Absolutely contemporary, it nevertheless recalls much of the aesthetic history of the region. Cochineal red–dyed water cascades continuously over a massive wood armature, seeming to both reflect and absorb memories while simultaneously allowing for their fluidity and inevitable permutation.

Though Avila has an absurdly small staff, it is the system of *servicio social* that reigns in Mexico that has made his work possible. Although there is not yet a lively tradition of volunteerism in Mexico, such as is critical to the operation of US nonprofit organizations, all university students, to receive credit for graduation, must do "social service." Many, as it happens, choose to work at the garden. Avila has also developed programs associated with the school curriculum.

The overall hero of the Santo Domingo Cultural Center—after it was established—was the executive coordinator of the center at the time, Amelia Lara Tamburrino. Lara fought, from the moment the museum opened, to make the center a lively and open space for the promotion of the local and regional heritage, as well as for the exposition of works of world culture. She also was determined to make the museum available to all segments of society. Her long experience in the Mexican museum world made her the perfect choice for this pioneering effort. Having served as the director of the National History Museum in the Castillo of Chapultepec DF and as the director of the Centro Regional of Puebla, Lara well understood the nature of the bureaucracy of Mexican cultural institutions. Having been the Mexican cultural emissary to Italy until 1998, she also appreciated how the larger culture outside of Mexico operated. Lara brought all of that experience, as well as her indomitable and charming personality, to the new project. As she wrote in her argument for bet-

ter financial provision from the Board, Santo Domingo was different from traditional Mexican cultural centers, which are often rigidly disciplinary and hierarchical.[12] Lara insisted that Santo Domingo was a cultural forum that needed to accommodate many different, perhaps contradictory elements in society and in history. Fostering multiple perspectives would allow for a wider intellectual reach than in most Mexican cultural centers. With art and material culture of past and present, foreign and Mexican, European and indigenous origins, the center aimed to project Oaxaca as one of the important generators of culture in the world but also to bring to Oaxaca, for Oaxacans, other important cultures of the world. The permanent collection was intended as a museum's treasure house in the traditional sense, but the attendant exhibition spaces ranged from the most rarefied and intellectual to the most direct and immediate. Culture, as Lara expressed it, was to be made intimately relevant to the society from which it springs. Exhibitions would be permanent, temporary, traditional, and when appropriate, contemporary and revisionary. There would be music, dance, theater, academic programming, and, Lara hoped, publishing and extensive outreach as well. Running the center was a Herculean task: the staff was tiny (only six), and the governing structure was complicated, with heads of the various parts reporting to a number of agencies but with Lara responsible for the whole. In addition, art criticism in the local newspaper and other Oaxacan media was relatively undeveloped and provincial and funding shockingly minimal. Yet despite excuses from the board, Lara did not hesitate to demand that all of the center's partners give more so as to make the missions and objectives—her vision—possible. What she accomplished was impressive.

The museum offers informative and welcoming displays, designed to combine the conventional, awe-inspiring "museum effect" with the more progressive goal of interactivity and outreach. Computer terminals allow visitors to approach the art pieces and to learn something broadly cultural, personal, and academic by means of games and puzzles. The first

exhibit establishes the museum as being one grounded in the region. It is a giant video screen on which contemporary Indians talk about their fears of losing their languages and their cultures. Immediately, the politics of the museum are expressed: the indigenous legacy is "a great inheritance." The didactic panels stress: "The ethnicities that now inhabit Oaxaca are the closest inheritors of the civilizations that developed here before the arrival of the Spaniards. Many of their current agricultural practices, their forms of government, the uses and customs, are an echo of those societies of the past."[13] Fears of losing the native languages are real in Mexico, and extraordinary efforts have been made in Oaxaca to preserve the indigenous languages and to encourage bilingual education. Where Spanish had once reigned supreme and where severe attempts had been made to eradicate the indigenous languages, the museum places itself at the crossroads, opting to celebrate those languages. Losing a native language is a terrible thing; as the poet writes, it is the first step to losing a worldview:

When a language dies
 divine things,
stars, sun, and moon;
 human things,
thought and feeling, are no longer reflected in that mirror. . . .

Mirrors are forever broken,
 Shade of voices forever silenced;
Humanity is impoverished. . . .
 Then a window
Is closed to all of the villages of the world.[14]

This museum, therefore, is a safe place for the efforts to preserve diverse ethnic identities. It immediately communicates its interest in and

concerns for the survival of the sixteen different languages, for the eth-
nicities of the region as living peoples, and for the particularized histo-
ries that are of poignant interest to the citizens of Oaxaca State and to its
visitors.

The museum displays ancient indigenous pottery, some typical and
some extraordinary, such as alabaster bowls, especially the Copa de Tecalli,
with an engraved pre-Columbian base. Religious figures and figurines
and utensils are mounted with care at the museum and are always well
lit. Monte Albán funerary urns of all types can be seen, along with devo-
tional figures, vases, and magnificent gold jewelry. Deep-gray clay figures
of priests wearing a variety of headdresses, earrings, and necklaces, as
well as what appear to be early *serapes*, attest to the artistry, the "other
imagination" of the ancients—even if they are shown in sociological con-
text. No one piece of sculpture is the same as another; each is expres-
sive of an individual sensibility within a civilizational frame. Whether it
is exquisite turquoise jewelry from Tomb Seven of Monte Albán or San
Juan Teitipac or San Jose Mogote, the artifact reminds the visitor of the
power of what the Spaniards were certain they needed to destroy in order
to build a civilization in their own image. The immediate tone through-
out the museum is one of respect and awe for all of those who passed
through the Oaxaca Valley and made it their home. At the same time, this
is not a communitarian museum. This museum cuts a broader swath; it
does not intend to provide a narrative of any given pueblo. It sits at a
lively midpoint between the communitarian and the national.

The greatest treasure of the museum is the cache of gold, alabaster, and
turquoise archaeological jewelry, vessels, and ritual accoutrements from
the famed Tomb VII of Monte Albán. An exciting orientation film reenacts
the discovery of the tomb. Afterward, the galleries lead the visitor through
the rise and fall of the various neighboring indigenous groups.

The colonial hallways, with their *bóvedas* and brick, are extremely res-
onant as homes for the all of the pieces in the permanent collection of

this regional museum. The architecture creates a context that controls the way the visitor sees and comprehends the pieces. We understand, without being told, that the colonial building was built by the Indians and was a symbol of their domination. The long history following the Spanish Conquest is then told, exhaustively, throughout the rest of the museum. There is a stunning array of sixteenth-century colonial objects: majolica pottery, musical instruments, costumes and textiles, agricultural tools. The change in the material culture follows the spiritual revolution that paralleled it. Nevertheless, the indigenous point of view is consistently presented along with the perspective of the conquerors of "New Spain." The center's museum honors the indigenous civilizations in a way that—according to Ing. Javier Sandoval, then the director of the now-dissolved INI (Instituto Nacional Indigena) in Oaxaca—was (even with the problem of the colonial building) a "step forward" in the life of the nation's museums.

All of the labels in the museum are clearly written and artfully designed, screened over distant scenes of ancient and contemporary activities, thus subliminally reminding the viewer of the persistence of memory in a changed and still changing environment. Every object is displayed to its best advantage in elegant and secure vitrines. Aside from the object labels that one would expect, each area has large label boards, which can be carried around, "for tired eyes," for "children," and for those who want to "know more." Interactive monitors allow children and adults to play games and test some previously unquestionable assumptions—such as whether Benito Juárez, "father of the country," was always good to the Indians of Oaxaca. Indeed, some of the questions on these monitors are answered with revisionist replies—such as that Benito Juárez was not always good for the Indians of Oaxaca, even if he was good for the nation of Mexico. Why? Because he expropriated many ancestral lands from indigenous communities. This is the beginning of critical thinking—of being able to see even national heroes with a critical eye.

The displays of the conquest and its aftermath promote empathy for the Indians and break down the stereotype that they were puerile or stupid in their adaptation to the invaders. For example, one label reads: "Despite all of the challenges, the Indian pueblos responded positively. From the beginning of contact with the Spaniards, they learned everything they could that would be useful: the care of small cattle, silk manufacture, the seeding of wheat. . . . They lived some years of prosperity but ultimately became impoverished and weakened by disease. Their old governing systems were undermined." The visitor leaves the museum with a better idea of how the Indians were conquered and why they ultimately made the choices they did. According to the labels, they needed to survive, but since the Spaniards would not allow them to keep their own religious systems, they needed also to accept the Spaniards so as not to be left with a total void. Another label states: "The ancient gods had promised their people that the Spaniards would abandon this land, but that never happened: The Indians had to adapt to the new order. . . . They had to give new meaning to their lives, and so they adopted what the priests taught them." The museum also points out, respectfully, without condescension, indigenous spiritual resistance and subversions. And it duly notes both the contributions and the brutalities of the Spanish. The museum presents the subsequent histories of Mexican Independence and Revolution as related to Oaxaca, up to and including discussions of the present-day problems surrounding the economy and the environment.

Temporary exhibitions and events at the Santo Domingo Cultural Center fulfill its mission of being both local and international. All of its exhibitions are accompanied by guided visits, lectures, poetry readings, performances, and whenever possible, publications, including catalogues and brochures. A Rodin display, borrowed from a Mexico City Museum, represented a major effort to introduce this seminal European modern artist to a public that might not have had the chance to see a large number of his figures together or to get close to understanding his creative

process. A smaller but perfect display featured work by the disturbing German printmaker Otto Dix. A collaboration with the Goethe Institute and IAGO, this also enlarged the possibilities for artistic viewing by the general public. Daring revisions of Mexico's modern art history—such as the stimulating Periferias—questioned the assumptions of absolute hegemony of the Mexican muralists in the modern construction of Mexican identity. Great Folk Art Masters, an immense exhibition sponsored by Banamex, gathered together the national treasure artists from across Mexico, representing all the popular arts. Pottery, weaving, woodcarving, paper, and glass masterpieces affirmed the ubiquity of creative and varied artisanal capacity and production in the country. This, along with exhibitions of the artistic weavings, the huipiles, by the women of the Isthmus of Tehuántepec, invited a closer look at the larger Oaxacan region itself. These temporary shows encouraged repeat visits to the center—visits that would not likely have occurred had the museum housed only a permanent collection. At the same time, Santo Domingo gave display space to the women of Polvo de Agua, participants in a ceramics collaborative that attempted to overcome extreme poverty by making contemporary art—not artisanry—born of the ceramic tradition of the Mixtec people of Oaxaca. Strange and unexpected international phenomena in art history, such as Anamorfosis, found room at the center as well. And then, in a powerful statement that the pre-Columbian imagination and expression is not dead, an exhibition called Forms of Beauty: The Pre-Columbian Aesthetic and Its Impact on the Present World reminded visitors of the ongoing influence of México profundo in today's world. Mexico's special relationship to Spain was honored in an all-city Spanish cultural festival and an exhibition, The Spanish Exile in Mexico—a montage of the books, documents, photographs, and art of those philosophers, writers, painters, filmmakers, actors, and playwrights who left Spain because of the Franco dictatorship and received refuge in Mexico during the Spanish Civil War.

The Cultural Center also became a showcase for contemporary art and literature and has invited innumerable authors, musicians, and poets to give talks about their work. Lara's commitment to contemporary art is courageous, since it expands the mission of the Center and takes the risk of crossing territorial lines in a small city, showing contemporary artists who might ordinarily be able to exhibit only at the contemporary art museum, MACO. Living Mexican artists, not only those from Oaxaca, discuss and sometimes present their work. For example, Adolfo Patiño gave a lecture in the spring of 2002. Then, a few months later, the center used the anniversary of September 11 as a prod to thinking about the nature of war and the misuses of power, and it created an interdisciplinary event: Art against All Forms of Violence. Within that event, Patiño presented his piece *Cosmos y Damian*, a highly ritualized work referring to the Twin Towers and to blood, fire, and wind—all of which was incorporated, physically and metaphorically, into the heavily charged, rainy setting of the evening. Two other artists, Carlos Poblano and Rodrigo Islas, made a video focusing on man's brutality to man and the need to reflect on it. All of this activity was accompanied by a contemplative exhibition that included eight other well-known artists from Oaxaca and that concurrently introduced artists from different parts of Mexico to the Oaxacans. The over-riding message of this effort was that we must face the bellicosity within us as directly as we face and claim the desire for peace because by facing the worst within us, we might be able to overcome it. Art can help us do that.

Of course, the Santo Domingo Cultural Center has been criticized as well as praised. It has been criticized for not engaging in enough in-depth research, for being a showcase for its public and private supporting partners.[15] Lara, at the same time, fought incessantly for the means to enhance the research capabilities of the center, but to no avail. The Cultural Center has also been dismissed—by Ing. Sandoval García, for example[16]—as being unwelcoming or intimidating to the indigenous. The intimida-

tion, he explained, lies precisely in the center itself, in its architecture, which to the Indians is an ongoing symbol of the oppression of the past. According to Sandoval, the Indians never enjoyed entering these impos- ing colonial structures. They know still—cerebrally, instinctively, and/or vestigially—that something bad happened to them there: that hundreds of years ago, thousands of their ancestors (especially the Triqui group) had been forced to work, in terrible conditions and for years, to build Santo Domingo.[17] When I told Sandoval about the Triqui children's activ- ities inside the center, instituted recently by Lara, even he admitted that the center needed to be credited for taking the first steps toward increased accessibility for the indigenous.

This particular change came through an enormous effort by Lara. She had long been bothered that the children seemed so afraid to enter the center, that they seemed to have no idea that everything in the museum was theirs and was free. For all they knew, she said, the uniformed guards at the door were police and they would be courting danger to try to enter.[18] Soon after the museum opened, Lara organized what became a regular Sunday event: the Triqui children came to the museum to spend the whole morning. They socialized, they ate, and they played. Then they were brought to the exhibits, where they saw examples of their own past, honored and explained. They went later to the garden and the library. At the first of these events, the children were asked if they knew the Mixtec language. They were all ashamed to say yes. There was then much talk about how beautiful and important the language is, about how the Cen- ter was theirs, and about how the library had special and precious books written in that very language. These were children who do speak their native language at home and have inherited a fear of expressing it, of demonstrating that they are still connected to their traditions. But the program that Lara originated and that was supported by Cuauhtémoc Camarena, the anthropologist who advised the Communitarian Museum

movement in Oaxaca, is cause for optimism. Although there is still much
to change and much more to do, these children have been allotted some
of the attention that would ordinarily have been directed to the usual
visitors—the culture-hungry middle and upper classes, the tourists, and
the intellectuals. The Triquis come regularly to the museum—every Sun-
day. With luck and continued commitment to the Sunday visits, they might
even come to believe, someday, that the museum and its contents belong
to them. Efforts are being made to expand the outreach to their schools,
and Lara tried to raise money to further the work of education and out-
reach for all visitors to the museum. Once again, however, the center was
severely underbudgeted for the full realization of her vision.

The number and the scope of the activities, exhibitions, and perform-
ances at the Santo Domingo Cultural Center have fulfilled all of its orig-
inal intentions, but under Lara, the center has progressed significantly
beyond the original vision. Between the additions engineered by Toledo
and the dynamic administrative leadership of Lara, it became a true spur
to the expansion and enrichment of the lives of all Oaxacans and of all
interested tourists passing through. Yet the Santo Domingo Cultural Cen-
ter never did have the staff or the budget to realize its plans indefinitely,
and Lara continually pointed out the problems and the imminence of cri-
sis. Perhaps it was because of her persistence in crossing disciplinary and
institutional barriers, in questioning history, defying the idea of cultural
fiefdoms; and in being both elitist (in the best sense of the word) and
democratizing at the same time that she confounded the governor, who
became the greatest obstacle to fulfilling her vision. She was finally forced
to leave her position at the center in 2003. Santo Domingo was left at a
crossroads: would it retain its vitality, its iconoclasticism, and its open-
ness, or would it go back to a simpler vision of a center that would sim-
ply present a permanent collection, house institutes, and rent projects?
Only time would reveal that.

Conclusion

The restoration of Santo Domingo was so phenomenal that it received international recognition, having been awarded Spain's First International Queen Sofía Prize for Conservation and Restoration. But perhaps most important, the experience of the Santo Domingo Cultural Center has proved that Oaxacan civil society has advanced beyond the days when its cultural life was the result of decisions made by the government. With the center, the citizens have shown that they are capable of depending less on the government and more on themselves for the construction of their cultural identity. With the center, the citizens have added another "attraction," the colonial equivalent of Monte Albán, to the list of Mexico's world-class destinations. All the while, they used the NGO structure to guarantee, through the activities of PROOAX, that both national and state representatives would serve the people of Oaxaca by fulfilling their responsibility not just to fund the center but to help fulfill expanding mission. Whether the Oaxacans demand that the Santo Domingo Cultural Center continue at the high level envisioned by Lara will depend on the new leadership of the center and on the energy and private funds that can be summoned up by PROOAX.

Abuses by the Mexican government had long been common knowledge, but now—thanks to the trajectory of the Santo Domingo process and the involvement of PROOAX—the citizenry knows that abuse of both natural and cultural patrimony by the government can be controlled. The erasure of certain histories and the imposition of others, the destruction of precious forests and landscapes to serve economic interests, and the commercialization of the unique Oaxaca Historical Center (the Zócalo) can be halted or diverted if there is the communal will to do so. After the experience of building the Santo Domingo Cultural Center, it is unlikely that civil society in Oaxaca will retreat into innocence and apathy. The power of the artists has been acknowledged, though whether this

is a truly "moral" force or only another newer player among the economic oligarchies of the city has been openly discussed by artists and intellectuals themselves.[19] Furthermore Banamex has been acknowledged for its own ability to temper the will of the government. Alfredo Harp and his foundation, Amigos de Oaxaca, have followed the rule of not buckling to the power of the government but rather of using the Banamex money as a way of helping to advance the conversation. Of course, every partner in any major enterprise must protect its own needs, but if the needs are complex rather than simple, if the partners are diversified in their requirements, the results will most likely be more democratically nuanced than if the enterprise is only a manifestation of the government's authority. Every partner in the Santo Domingo project, with its ever more mulitfaceted character, representing ever more layered interests in society, can unhesitatingly answer Hillel's question: "If I am not for myself, who will be for me? But if I am for myself only, what am I?" They know they did both: every partner stood up for itself and also gave of itself. Santo Domingo emerged serving the whole society: local, national, and global. The Cultural Center of Santo Domingo was Oaxaca's early triumph of democratic participation, of individuals making a large difference in the definition and affirmation of their own cultural contributions to the city's best self. Santo Domingo also anticipated the slippage in government financial support for the arts in the "neo-liberal" environment that was the result of globalization in Mexico. Oaxaca's solution of a new brand of public/ private philanthropy will be resorted to by nonprofits everywhere—sooner rather than later.

Contemporary Art in Oaxaca
"Yes, but . . ."

Living artists form part of the backbone of civic leadership in Oaxaca. Without their singular and concerted civic efforts, the city would have remained a charming, if provincial, backwater over the last two decades. But political successes aside, these artists are still principally creators, and their communal authority comes from a general recognition and acceptance of their authenticity and integrity in their chosen vocation. Although there is agreement about the importance of art to the economic well-being of Oaxaca, there is no consensus about the nature of that art and about whether it has a shared nature or is even "contemporary." The degree to which Oaxaca can maintain its identity as a unique setting for the production and sale of fine art is intricately related to the degree to which it can sustain itself as a discrete entity and as a respected part of the art world simultaneously. Oaxaca is presently facing a crossroads in its once crystal-clear artistic identity. There has been a remarkable influx of artists to the city and an equally remarkable amount of exposure to

new trends by its own native artists. The comings and goings have been such that the future of the art scene in Oaxaca is an ongoing subject of discussion. The polar questions are: "How far can Oaxaca go toward internationalism before being swallowed up in its homogenizing maw?" and "For how long can Oaxaca afford to repeat its old formulas without becoming banal and boring?"

As the old millennium wound to its end, the arguments and questions about the nature of contemporary art in Oaxaca grew noisier: Is there really such a thing as the "Oaxaca Style"? Does it matter if there is or is not an "Oaxaca Style"? If it does exist, is it increasingly determined and degraded by market forces? Is art in Oaxaca closed and provincial? Or is it cosmopolitan and sophisticated? Is Oaxaca's art truly of its own time, or it is just a number of living artists engaged in a constant rehashing of the lingering pre-Columbian imaginary and its mythologies tempered by the overpowering authority of Rufino Tamayo and the current craze for the art of Francisco Toledo and Rodolfo Morales? Has the host of other stars in the Oaxacan firmament created anything? Are there newer, younger artists who are members of the so-called family but are touched by globalized artistic concerns and issues as well? Oddly, the answer to all of these questions is a resounding "Yes, but . . . "

The "Oaxaca Style"

If indeed Oaxaca is the locus of mexicanidad—with all of the attendant implications of the pre-Columbian, the visual culture of the colonial period, and the genesis of the ideals of the postrevolutionary state—and if mexicanidad is colored by the charm of present-day indigenous life, then Oaxaca must also be recognized as a site where art is being created by working artists every day. Forged in the 1970s with the Tamayo Workshop along with the ongoing, if posthumous, legacy of Tamayo's oeuvre and the emerging lights and shadows of Morales's and Toledo's paint-

ings, Oaxaca's art began to take on a look of its own. The best of this pro-
duction was tempered by personal artistic histories and tendencies,
whereas the worst endlessly repeated tired formulas for touristic con-
sumption. Notwithstanding a certain predictability, the "look" allowed
for a seemingly limitless flow of paintings, drawings, and prints and
became a welcome and even meaningful presence that fed both the spirit
and the economy of Oaxaca by the mid-to-late 1980s. By that time,
Toledo and Morales (with artistic visions so unlike each other as to be
unrecognizable as hailing from the same "school" or "family" or "style")
had come home to Oaxaca, spawning dozens of so-called Toleditos and
Moralitos. Toledo's and Morales's influence spread so thoroughly that it
affected the core look of the artistic output. The term "Oaxaca Style" had
already been coined as a catch-all by the Oaxacan intellectual, Andrés
Henestrosa, at the end of the 1970s, but by the 1980s it became the um-
brella phrase under which both the better and the worse artists found
themselves. Yet the term is really useful only to describe that body of
work spawned by the Tamayo Workshop and affected by Toledo and
Morales—the popular style that satisfied the seemingly insatiable market.

This style of painting is obvious to anyone visiting Oaxaca for the first
time. Much, but not all, of it is the product of an "industry," cruelly but
correctly called a factory, or maquiladora, by the late critic Robert Valerio.
Valerio wrote about the excessive reaction against realism in Oaxacan art:
"Misery is only one of many realities that are absent in Oaxacan art now;
nor do deforestation, sickness, drug traffic, other ecological, social and
economic circumstances appear . . . and ideology, one of the motors of
the art of Rivera or Siqueiros, . . . is tabú."[1] He wondered if, so long after
the "rupture" from the muralists, it might not be time to look at the real
world again. This "look," this painted paradise, attracts attention and sales,
according to its critics, and is the basis of relatively expensive souvenirs
for the recollection of the idealized trip to Oaxaca once the traveler has

returned to hearth and home. The pictures with the "Oaxaca Style," with its familiar colors and subjects and its comforting attitude to time and history, become indispensable souvenirs for travelers to Oaxaca.

Whereas Toledo and Morales are major artists whose work is acquired not only in Mexico but also in Europe, Asia, and the United States by private collectors and museum curators, those works in the Oaxaca style are rarely displayed in museums outside of Mexico. It has profligately distributed selected fragments of pre-Columbian archaeology into the general culture.[2] The palette is usually linked to the legacy of Tamayo—his soft pinks, greens, blues, and orange/reds juxtaposed to his browns and grays that refract all other colors. This style also includes infinite bowdlerized visions of Morales's work—his reveries of a Oaxacan domestic and urban paradise, of angels floating in and out of colonial pueblos encountering ghostly female figures, of buildings, of empty trains traveling the sky, and of native women sharing waking dreams while holding their dogs or being watched by their dogs from a distance. Morales's palette offered another option; hot yellows, oranges, purples, and greens meld and collide, becoming something more mysterious in the encounter. On the other hand, innumerable canvases pay homage to Toledo and his animal/human obsessions; these are populated variously by copulating iguanas and turtles and are painted in his distinctive palette of earth-soaked browns and grays, musty reds and oranges, and green-grays. Yet though Tamayo, Toledo, and Morales were responsible for lending the Oaxaca Style its art-world references, they are not the style. Unmarked by the resounding creativity of these three masters, who simultaneously incorporated and transcended their origins and who infused the heat of their own locally inspired creative language into transcendent visions, the Oaxaca stylists would still be promulgating a repetitive if fungible iconography, a recognizable if unreal vision, a mix-and-match of tropicalized heavens in a very real region of the world.

The "High-Oaxaca Style"

The "Oaxaca Style" umbrella is not properly employed as a pejorative to cover another group of artists, who work at a level below that of Tamayo, Toledo, and Morales but above the general production. These are artists who are deeply conscious and respectful of world trends. In addition to the Mexican artistic vocabulary, they have thoroughly absorbed the European modernist ideas and spirit, which they have transformed into the Oaxacan pictorial vocabulary. Yet they have not transformed the ideas further and have never taken the next imaginative leap—the one that Tamayo and Toledo and Morales all made—toward the absolute ownership of their own Mexican aesthetic, but with that transformed vocabulary and syntax that made their art both a more personal and a more universally communicative language. Their comforting repetitions of the palette and subjects mentioned above and their insistence on a kind of pre-Columbian/colonial/nature-based timelessness make the High-Oaxaca stylists easy targets of assimilation by the lesser artists who abound. Who are the cast members of this "high-Oaxaca Style"? One of the most famous is Rodolfo Nieto, with his referencing of DuBuffet and Soutine. Another is Luis Zarate, who makes Europe his own with his dashes of de Chirico, Picasso, De Kooning, and Kandinsky and with his changeable palette that at times smolders like that of Morales. At other times, Zarate seems to recall Tamayo (with an equally mercurial range of subject), sometimes almost unrecognizably abstracted and other times charged with direct references to local themes. Some of Zarate's most original work has been in his landscape design at the ethnobotanical garden that he worked on with Toledo. Another, José Villalobos, is one of the rare Oaxacan artists to work abstractly, his imagery recalling native landscapes and ancient glyphs. Villalobos's canvases also bring Tamayo and Toledo to mind even as they introduce Klee. Rubén Leyva, also deeply influenced by Klee, paints extremely attractive childlike, playful figures over and over in ways

that are always delightful and amusing. With their European-influenced art, these artists form an interesting stratum within the geology of Oaxacan art—one more open to outside influences, one more cosmopolitan, but one still speaking to and mostly serving a touristic and/or Mexican audience and Mexican collectors.

The Tamayo Workshop

The famed "Taller Tamayo," or Tamayo Workshop, founded in 1972 by the artist Roberto Donís, spawned what became the most recognizable practitioners of the Oaxaca Style. Still functioning today under the leadership of the artist Juan Alcazar, this workshop continues to launch one artist after another, many of whom have become the stars of Oaxacan art. Purposely planned to be an antidote to the Academy of Fine Arts, which offered and continues to offer a formal curriculum that teaches the trade of art-making (and is principally intended to train teachers for the public school system), the Tamayo Workshop is far more informal. It appeals markedly to young people, especially those from the indigenous pueblos, who might not have qualified for the Academy of Fine Arts. The mission of the workshop is to form artists who can express themselves more freely than they would ever be permitted to work in the academy. At the same time the workshop is also an "identity machine" of sorts, directing the artists toward an understanding of the value of connecting with their culture, of approaching their heritage through the prism of printmaking and painting. There is a conscious attempt to steer the artists away from internationalist trends and fashions and also to motivate the pueblos to rescue their identities and, to some extent, their economies, through the work of their own artists.

According to Alcazar, there is a lot of talk about identity in Mexico, but little is done to protect it.[3] He is especially dedicated to training artists who can live by their labor, who can have shows, sell their art, and not

have to leave Oaxaca to find work in the United States or Mexico City. The
Tamayo Workshop has historically boasted a camaraderie and family-like
character (with all of the feuds and the warmth of any family). But the
workshop—and especially its founder, Donís—had a somewhat troubled
history with Tamayo. Although it bears Tamayo's name and the artist did
occasionally visit, he never made a major donation of money for its sup-
port. Still, in the end the workshop was incorporated into INBA, Mex-
ico's Fine Arts Ministry, due to Tamayo's influence and to his ability to
organize communications with the government. Although this link to
INBA does not yield much in the way of revenues, it does allow the work-
shop a slight modicum of financial stability and enabled it to continue to
exist after Tamayo's death. And it has been, as per its mission, responsi-
ble for the formation of a number of artists who do indeed live by their
work. To this day they continue painting those languorous figures, situ-
ated in paradise, quotidian time and place always ostensibly eradicated.

The workshop recently introduced another project, an enlarged com-
munitarian aspect of its mission. The workshop now goes out to the
pueblos to find students, knowing that with extreme emigration, it can
no longer depend on enough young people finding the workshop
themselves. It employs ten instructors from Oaxaca City who travel to
the poorer Mixtec and Zapotec regions of Oaxaca State in order to ini-
tiate workshops for the people from their pueblos—especially work-
shops in the medium of printmaking. These workshops are free initially,
but once they are organized, the communities have to manage their
own classes and programs. Above all, Alcazar does not want to create a
long-term dependency on the workshop, knowing that this would be
counterproductive.[4]

Alcazar notes that this program can be achieved only now because
Oaxaca had already made so much progress in bilingualism. Whereas
before, the people in the outlying districts could often not communicate
with the representatives (who would, as officially required, speak only

Spanish), they are now allowed to speak in their indigenous languages to those representatives. Furthermore, Alcazar points out, the mission of the workshop is an organic process in the pueblos. Potential students already know how to engrave, since the Mixtecs have been etching into gourds, called *jícaras*, for centuries as a local craft. They used to be able to sell these gourds, but no one buys these objects today, and the *jícaras* have ceased to be a means to an income. To transfer that once-viable craft into an art form, to transfer it to print-making, is, he insists, a small and teachable leap. And the works being produced in these workshops in the outlying areas of the state are predictable in their imagery but are nevertheless fine examples of a highly local and energetic version of the "Oaxaca Style."

According to Alcazar, he envisions learning how to make paper as the next step. But the last, larger step is learning how to turn these skills into a means of supporting a family. The workshop hopes to expedite the salability of the etchings by creating a means of marketing the works. With that in mind, Tamayo Workshop traveling exhibitions are being mounted throughout the distant parts of Oaxaca, from the coastal areas to the remote sierras of the Mixteca. Alcazar describes what he is trying to do in the pueblos as a search for freedom, for an alternative to living in extreme poverty, and significantly, as a way of stemming migration. Alcazar patiently explains when asked about the limitations of the Oaxaca style: "I am not looking for geniuses in painting; I am trying to produce artists who can put food on the table."

Comparison with Mexico City

There is, to this day, lively argument over whether or not the Oaxaca Style exists. To resolve this question, all one has to do is compare the art that has been produced in Oaxaca with the art that has been made throughout the rest of Mexico, but filtered through Mexico City in recent years.

A number of exhibitions, both inside the capital and traveling, represent Mexico to the outside world. Most of them take advantage of the unchallenged freedom of expression in Mexico since the end of the PRI in July 2000 and testify to the difference between what is happening artistically in Oaxaca and what is happening in the art scene in the country's biggest city. Although Mexican artists in the capital are also bedeviled by identity questions and essential art issues (e.g., whether or not there is a "Mexican contemporary art," whether or not it should be highlighted as such in international exhibitions, what the relationships of politics and art are or should be), what these artists are producing usually fits, neatly or not, into the category of international contemporary art.[5]

Mexico City artists who are receiving international exhibitions, both group and individual, also appear not to want to respond to that question in any single voice. For example, the art star Gabriel Orozco usually prefers not to be in "Mexican" national shows, since he considers himself a thoroughly international character—even if his work may be referencing his native land. Although artists such as Santiago Serra and Francis Alys come from other countries to Mexico to work and seem to assume partial Mexican identities, they inevitably leave to pursue their international lives. Some artists will flourish in the new light being cast upon them and will make art responding to a particular subject—as many did, for example, for the traveling exhibition *Mexico City: An Exhibition about the Exchange Rates of Bodies and Values*. This show originated in New York City, at the avant-garde P.S. 1 Contemporary Art Center, and featured work addressing inner-city violence, the exploitation of outcasts even by the artists themselves, the persistence of the class system, and the horrific infantilization of beneficiaries of untold wealth (such as the "rich and famous" women of Danielle Rosells). Some of the disgusting conditions of urban life, including the handling of the dead, yielded a harsh and unrelenting critique of Mexico City (and, by extension, of conditions in the globalized megacities of today). Another exhibition was the

2002 *Mixed Feelings: Art in the Post-Border Metropolis* at the USC Fisher Gallery, an exhibition that examined, through original installations by mostly Mexican artists, the legal fiction of the border between Southern California and Mexico and the counter-reality of its distinct, but recognizably hybrid, populations. Artists like Rubén Ortiz, going back and forth from Mexico City to Los Angeles, produce art that proves the hybridity, with low-rider, dancing lawnmowers being among the stars of the show. *Axis Mexico*, mounted at the San Diego Museum, attempts to demonstrate that Mexican artists have thoroughly absorbed international influences and are part of the largest possible, most au courant discourse. At the same, these artists cannot help but ask, as they fight for inclusion in international shows, "Whither and why 'Mexicanness'"? What is troubling most of Mexico's artists is perhaps best summarized in the catalogue for *Mexico City: An Exhibition about the Exchange Rates of Bodies and Values:* "Throughout the 1990s, many of us fell prey to the notion of contemporary art as a means of escaping the ideologies of 'national culture' as well as the oppressive seduction of 'the international.' Peripheral artists (and by extension their fellow travelers) have to perform a trick, which consists in de-identifying themselves and abusing, distorting, parodying or sometimes even deconstructing their assigned role as their nation-states' virtual civil servants, while at the same time renegotiating the 'center's' symbolic control as an art-historical point of reference."[6] Obviously, there are many ways to sell out, buy in, and/or be tortured, and most of these ways now seem to be emerging from the art of Mexico City—whether produced within or outside the country. It is not surprising that the new Mexican artists are often described as nomads—with all of that word's implications as their baggage.

Yes, the Oaxaca Style—with all of its localisms, identity culture, folkloricisms, and adaptations of the art of Tamayo, Toledo, Morales, and the pre-Columbian—does indeed exist. And its reality becomes apparent when it is examined in the light of the internationalized art world that

characterizes Mexican contemporary art as a whole. Yes, the style does exist, but . . . The booming art world of Oaxaca is also characterized by contradictions, perplexities, and breaches, just like complex art scenes anywhere. Nevertheless, the questions that are asked in Oaxaca and the perimeters that are breached consistently fall within a more restricted frame of reference than those posed in the capital. If Mexican intellectuals still sometimes consider themselves to be a part of the periphery of the art world, with all its attendant "tricks," then Oaxaca is firmly rooted in the periphery's periphery.

The "but . . ."

It is the "but" of the "yes, but" that contributes so much to the vitality of the art-think of Oaxaca and that will sustain it in the onslaught of globalization. The works of a number of artists working in Oaxaca are redolent not only with their own native experience but also with their encounters in the larger world. Some of these artists have explored visions that are not immediately recognizable as being strictly Oaxacan, and others have advanced the local to a more heroic scale, thereby demonstrating their own larger ambitions. These works are purchased by collectors from the wealthy cities of Monterrey and Mexico City, as well as by museums worldwide—although they do not command the prices of the works of Toledo, Morales, and Tamayo. These are artists who may be featured in art expos and international art galleries and who may even be found on the secondary "market" at Sotheby's and Christie's auction houses. Three examples are Sergio Hernández, Santiago Filemón, and José Luis García. The first is an artist who, at his best, advances the "high-Oaxaca Style" into a personalized vision; the second is an eccentric who has created his own hallucinatory reality, not immediately recognizable as Oaxacan at all; and the last is an artist who normally works in the Oaxaca Style but has developed a new heroic style completely his own and

not for sale. There are many more artists, each deserving a book of his or her own, but this will introduce some of the heterogeneity now suffusing the Oaxacan scene and deliciously complicating the discussion.

Sergio Hernández is the most flamboyant of these artists. Although his works are indelibly marked by the influence of Toledo, he has managed to create an artistic oeuvre that has earned him his own stature. Hernández, was among the very first contributors to the artistic boom in Oaxaca. Born in Oaxaca State in a little Mixtec town called Huajuapán de León, he has traveled often throughout Europe and the United States, where he has exhibited frequently. Hernández unabashedly plumbs the imagery of his indigenous state but manages to universalize it as he adeptly appropriates signs from all of art history at will. He transforms symbols and primeval fears and urges them into his own vocabulary; he then creates something that the uninitiated viewer finds surprising but with which he/she can empathize. Some of Hernández's strongest work has claimed and exploited the color blue intermingled with gold and brown, reinventing the color of the sky so that it holds its beauty, becomes jewel-like, moves into the primitive, and ends up being elegant and terrifying at the same time. One of his great works, *The Birth of Death* (1999), portrays a woman with long hair and gold eyes and mouth in a field of browns, yellows, and oranges. Her legs are spread while she gives birth to a skull. At the same time, upside down, a gloating skeleton seems already to have gained dominance of her nether region—to have had, as it were, the last(ing) word. The fleeting corporeality of the woman and the incipient horror of humanity's shared end mingle freely with the much-vaunted Mexican (but, some say, invented by non-Mexicans) lusty acceptance of death. Sand on linen makes for a lively surface for much of Hernández's most stunning works, with the tactility adding yet another dimension to the image. Other works in that series, such as *The Girl of the Night*, include a little female figure with huge scorpion hands and Medusa-like hair standing on a globe, seemingly outside of our planet. Hernán-

dez's eccentric blue is a variation on further themes in other groups, where reds and yellows seem to dominate the artist's imagination.

Death and eroticism coexist for Hernández as he peers at the life around him and extracts the essentials. Earlier series were more interested in the prehistorical, and his *Pre-History of Everything* (1990) takes the viewer on a journey that brings together the Spanish caves of Altamira and Mexican cave imagery. This series also includes whimsical sculptures that are reminiscent of Max Ernst, Morris Graves, or Picasso, of the pre-Columbian, and of the modernist encounter with an earlier art. Before Hernández discovered that he was a colorist, in the late 1980s he "drew" paintings without any color at all. He scratched out naked figures and pottery; wheels unconnected to machinery; and repeated forms that seem like a disconnected alphabet for an ancient code. Hernández's work thus appears to be the fulfillment of Tamayo's dream that the pre-Columbian might function for contemporary artists as a memory bank for an alphabet that would yield a new vocabulary for the creation of a heretofore unsung visual poetry. Hernandez's recent work recapitulates all of his previous stages, with, for example, a series of seven undersea scenes bound together by his special use of blue. His huge installation at the Punta y Línea gallery is an homage to Moby Dick, populated as it is with undersea creatures. Once inside the gallery space, the viewer believes in this universe inspired also by the artist's readings about the gulf of Baja California. In the balance, the artistic imagination takes over from the written word; the painter built layers of earthy sea with pigment in a vista so energetic that Hernández' place as a worthy heir to the Toledo legacy can be firmly claimed.

Hernández's role in Oaxaca is multifaceted. Concerned with the continuing vitality of the cultural life of his adopted city, he is currently buying art to fill his museum, a magical building designed by Juan Urquiaga, the architect responsible for the renovation of the Santo Domingo Cultural Center. Urquiaga doubled Hernández's space while maintaining the

Sergio Hernández, *Habana* (Courtesy Galería punto y línea)

proportions of this old Oaxacan house, propelling the visitor backward and forward at the same time. It is a place for dreams: there is a round, glass-covered hole; looking into it (as if peering deeply into an Alice in Wonderland moment), the visitor sees a source of fresh water for Oaxaca. This well triggers a memory of simpler dreams. Surrounding the floor space is a continuous bordering stream of the fresh water, quietly reminding the visitor that art, like the ancient pre-Columbian waters, nourishes the soul and needs to be honored and maintained.

Hernández has created a museum, a collecting institution, so that the public will have yet another venue for the quiet and tranquil contemplation of contemporary art. At the same time, Hernández is ensuring that younger artists have a chance to flourish in Oaxaca. He has put his brother and sister-in-law in the art gallery business, where they energetically promote younger artists. Explaining how they can afford the extensive and unique marketing that they use to promote these up-and-

coming talents, the owners said: "It is all based on the sales of Sergio's work. His work supports the next generation!" Thus Hernández fulfills his responsibility, born of huge success in the tradition of Toledo but achieved on his own terms. The new artists he is supporting bear no obvious resemblance to the Oaxaca Style: they are alive to the changes in their world. But because of the achievements of the previous generation, because people come to Oaxaca to buy that generation's art, many of these younger artists have inherited the opportunity to experiment while knowing that because of their elders there will be an influx of buyers in the city.

The second artist, Santiago Filemón, is slightly younger than Hernández. Seemingly from another world, he too was born in the state of Oaxaca. But unlike Hernández, who visited Europe and New York in the tradition of Toledo and Tamayo, Filemón decided to live in Chicago for a decade and a half, and his work looks nothing like the expected Oaxaca Style—except, one might perhaps argue, in the palette. The subject matter is tortured and earthy, far from the atemporal paradise that the ordinary Oaxaca Style painters promote and imagine. Filemón's locations are the pueblos of his native Mixteca, a factory setting, or some other site where the alienation of modern life has robbed the spirit of joy from the humanity that exists there. Bodies are drenched in melancholy or tragedy. Deeply influenced by the American painters whose work he would have known intimately from his Chicago stay, Filemón reveals shades of Hopper, of Raphael Soyer, and of any number of the WPA realists. Filemón is also oddly and disjunctively influenced by the French post-Impressionists, as well as by artists he would have frequently seen in the Art Institute of Chicago—artists such as Signac and Seurat. These two groups of antecedents allowed Santiago to find a way to attack the canvas with a kind of formal affirmation that contradicts the apparent nihilism he is communicating. At the same time, some of the formal style of the Mexican muralists, much maligned by recent generations, is channeled through

Filemón. His message, though, is unlike that of the muralists in that it is always grim and hopeless: sexuality without joy, work without reward, nightmares without surcease, secrets told without release. Lovers are surrounded by police brandishing billyclubs; bodies are always taut. There is no comfort in Filemón's paintings; loneliness is the pervasive human condition. Even a circus scene with Signac-like coloration is fraught with horror as a lion growls at a felled clown, a woman humorlessly smiles, and a rider on horseback blithely ignores the horrific scene. Filemón's latest work seems drained of his potent coloring, perhaps indicating his growing spiritual and aesthetic distance from Chicago with its influence of the post-Impressionists. And his artistic distress seems only to deepen with age. Filemón Santiago's art has earned him a position as an important player in the Oaxaca scene; he needs to be seriously considered as part of the city's artistic character and makeup. Unlike so many of the other Oaxacan artists, Filemón is a loner, although he is said to be amiable. Still, he reminds us that paradise, if it ever existed, is fleeting and that pain is still the essence of the human condition.

And then there is José Luis García, who embodies still more of the contradictions intrinsic to the Oaxaca art scene. Of the generation following Toledos and Morales, he had a moderately successful career, showing in Europe in the 1990s and selling his work in Mexico City. After founding the Polvo de Agua group, he did not give up his own marketable painting, which might fall into the category of a medium-quality subset of the most popular Oaxaca Style. Those canvases reveal a pastel palette inspired by Tamayo and an imagery made popular by the "high-Oaxaca Style" artists, including Zarate and Nieto. But astonishingly, García has developed two artistic streams of his own in recent years. The first is his work with vessels: pottery made from the earth of Mixteca and from the imagined memory of Monte Albán. Shapes molded by his hands and polished by a piece of quartz transform from seemingly amorphous mounds of clay into sometimes shining, sometimes matte, but always living

Santiago Filemón,
Paradoja (Courtesy
Arte de Oaxaca)

objects—fluid forms with colors in a range of greens, purples, and browns. This unglazed pottery is art in the sense that Picasso's pottery is art: it transcends functionality and lives in the realm of the visually, sense- lessly, uselessly, sensually thrilling. On these pots, García incises single figures that combine the pansexuality of Picasso and Toledo with ele- ments that are uniquely and potently his own. He will also paint and/or draw on, for example, a *jícara* (a gourdlike object for washing and drink- ing). This *jicara* might then be attached to a swelling basket, transforming that basket into an object of fascination rather than a thing for carrying. In all of García's vessels, whether they are drawings on a nonclassically formed pot or drawings on a peasant-inspired basket, he suits the paint- ing to the shape of the vessel, a characteristic of the best Greek pot- painters. He thus displays a power, daring, and freshness seldom seen in the Oaxacan artisan production.

And then García presents another surprise. In the tiny town of San Juan

Bautista, Tezoatlán de Segura y Luna, founded in 1500, is an altar. In the northwest section of the state of Oaxaca, 172 km. from the capital, San Juan Bautista, a town of 2,500 people, is definitely off the beaten path. The official population figure seems like an inflated number: the streets are empty, and the pueblo has been abandoned by all but its children, old ladies, and even older men. The setting is beautiful, high in the mountains but existence is a daily struggle. The church, a focus of life, was built in 1721 in the Baroque style, but it has undergone additions that have robbed it of aesthetic coherence. A new altar was needed, and García agreed to undertake the work.

The work began in June 2001 and was completed in March 2002. In the way that things get done in the villages, the project was supported by Mayordomos Señores Hildegarda and Capriciani, as well as by the local priest. Aware that money was still needed, García helped fund the project by donating his own labor and by raffling off one of his popular Oaxaca Style paintings. The wood out of which the altar was made was taken from *sabino* trees that had already fallen down. Gathering the local youth, García taught them the skill of gold-leafing and burnishing, further reducing the manpower costs. García also consulted with the architect Juan José Santibañez so that, together, they could better integrate the architecture with the sculpture and painting that would compose the altar. Since the church no longer possessed a definite style, they did not want to add further artistic confusion to the building. Then García consulted with the denizens of the town to prepare them for what might otherwise be a shock. This would, after all, be a work of art of their own time—an altar like none they had ever knelt at before.

Today, the sheer size of the altar is unexpected: almost seven meters wide by nine meters long. Thousands of six-by-six square-inch blocks are placed on that huge surface. Colored with cochinilla red and then covered with gold leaf, the wooden blocks seem alive. Situated at regular intervals but facing a myriad of directions, they deflect and reflect the

José Luis García,
altar at church in
San Juan Bautista
(Courtesy
Maffalda Budib)

light differently at any given moment. In the center is the town's vener-
able and venerated figure of Christ—a figure that, in the context of
the new altar, seems as up-to-date as tomorrow and as ancient as the
beginning of Latin American Christendom. The frame is painted a pre-
Columbian blood-red. A code of poetic symbols that evoke miracles sur-
round the altar, miracles about the land, earthly angels, hearts, death, the
devil, the Saint of the Church, and all manner of votives—legs, arms,
houses, animals. All of this is communicated by the syncretic language of
the pre-Columbian and the Catholic. These are the kinds of signs that

might have, after the Spanish Conquest, been secretly incorporated into a Catholic religious object, but they would never have been so blatantly presented to such a devout public. García's altar revels in and celebrates the syncretic tradition that had long existed but that was rarely celebrated as such in Oaxaca. Here, the once-hidden layers of pueblo Christianity's ancient origins are both proud and overt. Here, the links to all of the fragments that constitute the history of worship and have indelibly marked this complicated region are displayed. As García said: "In the iconographic sense, it is my intention that there be an amalgamation of gold and color with contemporary elements, all of which has the goal that the viewer be struck with images of before and now in the 'Cruz Monumental.'"[7] Yet the real miracle of this project may be that the conservative, black-shawled *señoras* seem to adore being in its presence. They stream in, carefully placing their flowers in front of the altar at the *vestales* as if this was the most ordinary thing in the world. An absolutely contemporary art piece is thus thriving in a traditional and extremely poor and isolated town. Yet without the magical spirit of the artist infusing the congregants and the townspeople, it would certainly have been an alien and alienating presence.

This altar is part of the Oaxacan art scene, although it will never be displayed or sold as a piece of art. García thus plays a number of roles in Oaxaca. First, his paintings are true "Oaxaca Style," easy to spot in their familiar palette and subject matter. Second, his vessels are private works of art seen only in the privacy of this home. And third, his altar in San Juan Bautista is as resonant as any piece of religious painting or sculpture anywhere in the contemporary world. It is as universal as a Tamayo, as local as a Toledo, and as empathetic as a Morales. Additionally, it is a religious masterpiece (with the spirituality of the Rothko chapel) that will probably remain forever unheralded because it is so hidden from view— difficult for collectors to find, impossible for curators to buy, hard for the

normal art lovers to see, and above all, too confusing for critics to write about when they choose to either condemn or praise with the umbrella term "Oaxaca Style."

The Next Generation: Natives and Foreigners (Propios y Extraños)[8]

Artists from Oaxaca

A new generation of artists in Oaxaca are carrying on certain traditions but are creating work that is consistently outside of the expected "style." Although they are heirs to local experience and do not appear to struggle with their identity in the same way that Mexican artists from the capital do, they are choosing to highlight different aspects of their Oaxacan background. Impossible to dismiss as "Toleditos" or "Moralitos," they are utilizing heretofore unexplored imagery while moving away from painting into collage and sculpture (not typical media for Oaxacans in the last years of the twentieth century). Yet they still carry the sense of civic responsibility engrained in them by Tamayo, Toledo, and Morales.

Demián Flores, born in 1971, is one of the more exciting artists of his generation. Rather than emerging from a study of plants and animals of the Zapotec memory bank as filtered through Toledo, his work casts a hard glance at contemporary customs. One of his print series is named *Resistencia Florida* and was shown at the Casa de las American in La Habana, Cuba. *Despoblamiento* communicates, with line and without color, the chaos left in a town without its men, all of whom emigrated to the north. One gripping image, called *Intolerance*, depicts a simple, frontally posed, nonspecific figure, with arms outstretched, both lower arms pierced by spears. Flores's human figures are superbly rendered *in extremis*. The artist elaborates on his images with sayings at the bottom of the pictures, almost as Goya did in *Los Disparates*. "Don't ever strike, don't punish a child in anger" is, in effect, illustrated with a furious parent and a broken child.

The critic Fernando Gálvez, wrote: "The art of Demián Flores is both a denial and an affirmation. His rigorous formal freedom, his characteristic style, his lucid domination of technique, his creative renewal and transitions by means of tradition, his youthful mastery of objective form in engraving, deny the mechanical existence of a Oaxacan school of painting which is subordinated to the primary artists of the last generation."[9] Gálvez added that Flores embraces the contradictions that characterize his own culture, such as indigenous culture and globalization. By 2002, Flores began to incorporate text into the imagery of his paintings so that an equivalence of the two means of communication was posited. Violence emerges now as increasingly explicit scenes, inspired more and more by the popular culture, confront the viewer with an ambivalence that alternately confuses and confirms. At the same time, Flores began assimilating pre-Columbian sculpture and confronting some of the more uncomfortable issues intrinsic to the pre-Columbian duality. Asian influences and medieval manuscripts are incorporated. A certain intentional simplification began to characterize his work by 2003 as his panoply of imagery expanded to include cartoon characters, Mondrian-like modernism, and baseball players. Flores's incredibly popular installation Novena, a paean to baseball, is the perfect example of his lack of snobbery when it comes to imagery. Mixing up media and mixing up the worlds of art and sports in one room at the Eduardo Vasconcelos Baseball Stadium, Flores brings it all together in an extravagant endeavor that was supported by the Friends of Oaxaca, Alfredo Harp's foundation. By 2003, clashes of culture and styles of art-making seem to be the expanding theme—a controlled violence as the leit-motif. Flores's colors have meanwhile become ever more primary and deceptively luxurious, with golds and silvers gleaming in unexpected places. Clearly Flores, who is now receiving prizes and international residencies, will be a top artist in Oaxaca in coming years. His way of representing the world, both old and

Demián Flores
Cortés, *Tlazoltéotl*
(Courtesy
Galería Quetzalli
and the artist)

new, makes him an artist from Oaxaca who both acknowledges his root
and transcends them in the manner (potentially) of a Tamayo, a Morales,
or a Toledo.

Guillermo Olguín is another artist who exemplifies the best of the next
generation. The son of a Mexican father and an American mother, Olguín
is at home in Oaxaca. Still, his restlessness is surpassed only by his talent.
One of his unforgettable early bodies of work, *Heroes y Dioses* (*Heroes and
Gods*), was the outcome of his long voyage to India. Burning colors sum-
mon up and reimagine that country for Olguín and for the viewer of his
art, with vivid references to living gods of the ancient Southeast Asian
culture. Abandoning the pre-Columbian for a season, he plumbs an exoti-
cism that he discovered for himself rather than inherited. Camels on
smallish, burnt-orange, manuscript-like pages, sketches inspired by Indian

miniatures, show up on huge canvases painted in Oaxaca after his return. Olguín stained the manuscript-like pages with a steamy blue and scratched the backgrounds with indecipherable, Sufi-seeming scrawl. Shiva-like forms dance on floors covered by monkeys and peacocks while Schiele-like female nudes sprawl with hennaed toes that seem to dance independently of the rest of their bodies. Blackened birds peck on cadaverous figures while nudes float above, awaiting their own deaths and rebirths. Lily ponds cover or make a bed for headless androgynous figures, with only spiral markers for head and sex. A camel runs, flys across the desert with a male figure atop, holding the reins in impossible flight from/toward freedom. Do these paintings and pages mark Olguín's attempt to free himself in the last years of the 1990s from the strictures of the art that surrounded him in Oaxaca?

The answer is "No." Olguín was not running away from his roots. It is simply that, whether he is in Europe, Asia, the United States, Havana, or Mexico City, Olguín is seeking and absorbing experience while metamorphosing it into something aesthetically compelling. Even in Oaxaca, Olguín chooses to explore. Before his trip to India, he had painted a series now known as *The Black Paintings of Guillermo Olguín*. This is not, as one might expect, an homage to the haunting *Black Paintings* by Goya now in Madrid's Prado Museum; rather, it is an homage to the Afro-Mexican people living on the Costa Chica of Oaxaca with town names such as Corralero, Ciruelo, Coyantes, Santo Domingo, and El Cerro de las Tablas. The black men and women of Mexico are a relatively unknown and unstudied part of the Mexican population. No one seems to be able to identify precisely how they arrived in Mexico; furthermore, they are not, in the way the indigenous people are, major characters in the nation's metanarrative. The first paintings Olguín made on the Costa Chica were reminiscent of work he had already done. But by the time the series reached its maturity, he was exploring entirely virgin territory. His large diptych *Mis Amigos Negros y Mis Amigos Blancos* is drained of any colors other than black and

white. The figures stand in stark contrast to each other, but only in the
alternation of being black on a white ground or white on a black ground.
Stretched and abstracted, they owe more to Giacommetti than they do to
anyone painting in Mexico at the time. All legs and drips and gesture,
they defy individual personality but remain intensely human and rela-
tional. Eschewing decorative color or seductive form and entering into
a timelessness that has nothing to do with the atemporal faux paradise
of the Oaxaca school, these panels are all intensity and power and pow-
erlessness, melded and drawn out into a kind of vulnerable elongation.
The figures, near but never touching, speak volumes about the essential
isolation and interminable needs of the human experience.

Attesting to Olguín's growth, Fernando Gálvez wrote: "Nothing could
be further from the beautiful, highly detailed watercolors of Budapest
than the diptych titled My black friends and my white friends. Here, two or three
broad strokes of house paint enable the painter to portray a few spiky and
schematic characters which embody the simple and intense fluidity of
friendship. Artistic Oaxaca has rarely been witness to work so little
engrossed in seducing a public accustomed to exotic and highly colored
painting."[10] Not all of the work in this series is equally strong; some bears
too much resemblance to Toledo or Hernández. However, when Olguín
frees himself from those overwhelming influences, his spareness of line
and his almost puritanical approach to color allow him to both seek and
find something that they had not. Olguín's most recent art work is his
"artbar" on Hidalgo Street in Oaxaca. Just as Oaxaca had not seen paint-
ings like his before, it had never enjoyed such a performative contem-
porary anti-art art space in its midst. Unmarked and largely unknown
except to friends, local and traveling artists, and wandering accidental
tourists, this bar quickly became a stage for an ongoing theatrical. Olguín
is the handsome star and careful stage manager—tall as a basketball player
and gentle as a teddy bear. Blithely, he walks around, dispensing vodka
tonics with floating gardenias; several of his artist friends also tend bar;

Guillermo Olguín, *Mis Amigos Negros* (right side) and *Mis Amigos Blancos* (left side) (Courtesy Galería Quetzalli)

his friends' paintings are displayed casually on dedicated walls; dancing and conversation float above the convivial din. And Olguín, not caring whether or not he makes any money (he won't), wants only to know that his pals will be able to survive by running this bar for him once he goes back to his painting. Notwithstanding the gesture, many of his friends and colleagues are worried about whether or not the artist will go back to his art. But one of his best friends, Fernando Gálvez, counsels calm: "The bar will inevitably function as another of Willie's [Olguín's] trips: it will become the raw material for his next art series." Olguín has time for such a series to gel. He is young. He has already produced a tantalizing oeuvre. Olguín lives and works in odd tempos—generously creating and nurturing the very environments that will undoubtedly become the raw material for his next body of paintings.

Ever younger artists than Olguín and Flores are coming along, and they are increasingly working both within and liberated from standard Oaxacan expectations. That they are gaining acceptance is partially due to

the breakthroughs of Olguín and Flores and others of their generation. The younger artists seem even less willing to turn to the tried-and-true Oaxacan conventions and incline toward a kind of international creative production that nevertheless springs from their particular life experiences. Joel Gómez, not yet thirty years old, is breaking the mold by building small sculptural scenes in diorama-like formats. His abstract podlike forms, many presented in boxes reminiscent of those of Joseph Cornell, excavate new territory. Gómez uses seductive materials: oil and photocopy on silk; spoon, wood, paper, and glass to make a mounted object called The Past Is a Dangerous Land. His work, with its warning, may be a lament for the future in Oaxaca.

Finally there is Emi Winter, who—like Olguín—is part Oaxacan and part American. She was born in Oaxaca but was educated in Europe and the United States, and her best abstractions have long summoned up disjointed thoughts of Agnes Martin and Clyfford Styll. They demonstrated nothing obviously of the Oaxaca style, except perhaps her use of color— never imitating or paying homage to the local artists but, rather, indirectly referring to nature-burnt or polished land or to products of the land. Her more recent paintings refer more directly to Oaxacan textiles and designs, but she at no time mimics them or sacrifices her rigorous, disciplined abstraction to anything resembling reproduction or illustration. Winter always endows her work with a formal majesty, forgoing any temptation to insert coded representational references, as so many of the Oaxacan painters do when they attempt abstraction. Winter has worked both with and against the inspiration of her native city—where, according to one of the most demanding critics in Mexico, "the visual stimuli on all levels are such that they intoxicate the senses in the same way that mezcal does. . . . It seems as though [Winter] wanted to bear witness to the perennial restlessness in an artistic tradition that continuously confronts its own history on all latitudes."[11] Winter's restlessness serves her well and is advancing the artistic conversation in her natal city. With

native artists like Gómez and Winter coming and going in Oaxaca, one can only be optimistic of what the future will bring to its studios, galleries, and museums.

Artists from Elsewhere

Part of the enlivening of the Oaxacan art scene is due to the influx of foreigners who now live and work there. Not to be from Oaxaca is to be an *extraño*, or a foreigner. Selma Guisande, although having lived in Oaxaca for a number of years, is still considered to be from Mexico City, where she was born and where she studied art. She also studied at Mexico's National University and in London. Guisande has participated in numerous shows, has had commissions in cities throughout Mexico and Spain, and has received scholarships and a prestigious residency at the Vermont Studio Center in the United States. Guisande has introduced a new flavor to the city's menu of expected media with her production of sculpture. Sculpture is a medium little practiced in Oaxaca in modern times, even though it was one of the defining arts of the pre-Columbian civilizations that populated the region. Guisande is innovative in that medium, carving huge pieces of hard stone but also experimenting with juxtapositions of soap, photography, paper, string, and wood. Her art explores feminist themes, a particularly strong example being her *Mujer Montana*, an Amazonish puppet figure, part of a group called *Los Sentados*, where Guisande sensitively juxtaposes the intractability of nature with the exhaustion of a laboring person. On a grander scale, Guisande is constantly investigating oppositions and dualities, a not uncommon theme in Oaxaca. Certainly the pre-Columbian world was obsessed with dualities; Guisande adopts that passion as she adopted Oaxaca itself but adapts it to her own modern concerns about human relationships and historical and political events such as September 11 or the Zapatista uprising in Chiapas.

Guisande moved to Oaxaca to look for a better quality of life, and she

Selma Guisande, *Aún se puede tejer la historia* (Courtesy the artist)

stays there because of its increasingly rich and rewarding cultural context. Guisande has said that Oaxaca gave her the privilege of being closer to the earth, closer to the making of tortillas, cheese, and ceramics. She sees Oaxaca as being both about those basic elements of life *and* about a highly elaborated civilization and its architecture, music, dance—the museums and even the art market itself. And it is clear that this mix has encouraged her daring artistic and personal explorations. Guisande also notes the joy of working near the origins of her favorite materials: the green, pink, yellow, and white stone that she chisels is the same stone that was used in the ancient pyramids and steles and in colonial architecture. Guisande's artistic presence, her connection to the Oaxacan past, but her perspective as someone who has settled there of her own adult volition has already influenced the production of yet more sculpture in the region by other artists—both *propios y extraños*.[12]

An element of the new art ecology of Oaxaca has been to welcome *extraños* into its midst—not only artists from other regions, Mexicans such

as Selma Guisande, but also artists from outside the country. James Brown, originally from California and then a successful New York and international artist, settled in Oaxaca in 1995. He was attracted to the area because of its enormous variety of plant life and because his brother Matthew had already been working with the Zapotec Indians, learning dyeing and weaving techniques. The immensely talented Brown, who works in fine arts as well as furniture, paper, and a variety of other media, stayed because, he said: "At the end of the twentieth century, it seemed much more interesting and unusual to live in the isolated Mexican mountains than in any of the other more civilized options that I had experienced up until then."[13] Brown was treated well and found that Oaxaca lived up to his expectations. Brown finds Oaxaca less exotic now than it was when he arrived, but with respect to his work, Brown continues to feel free of the confines of the New York art world. He insists that he can do fabulous things as a result of that freedom. At the same time, he writes, this could not be so had he not been accepted by the movers and shakers of the art world in Oaxaca, by the directors of MACO and by Toledo himself, all of whom have allowed him to show in their spaces. Brown and his wife have recently embarked on the creation of artist books, through their Carpe Diem press. They feel that by being foreign, they recognize opportunities and beauties and interesting things that local people might ignore. In addition to his own exhibitions in Oaxaca, Brown has brought other artists there for exhibition—artists that Oaxacans might not normally have seen, such as Alex Katz and Francisco Clemente. This particular extraño has, therefore, further opened up his adopted city to foreign points of view even as he has sharpened his own vision by being there. By 2004, James Brown was talking about moving on to another emerging "art city," Mérida in the Yucatan. Oaxaca had become too expensive, but no less precious, to him and his artistic evolution.

Another American artist in Oaxaca is George Moore. Moore comes from a self-described "old WASP family," and he was, he says, in need of

wider pastures.[14] He and his wife first traveled to Rome and only later
discovered how much they enjoyed Latin America, and they spent a great
deal of time in Nicaragua. After that long stint, they returned to New York
State for several years, where George painted the body of work that was
the result of the Nicaraguan experience. The family later went to El Sal-
vador, where they stayed for five years, leaving only after having built a
library of 25,000 books above the National Gallery of El Salvador. Moore
recruited volunteers in this endeavor from his old New York art world
friends such as Leon Golub—friends who contributed both their pres-
tige and their money to this project. By that time, Moore and his family
were ready to leave El Salvador. They next landed in Oaxaca, where
George had been attracted to Toledo's civic commitments and accom-
plishments. He explained: "I love the fact that Toledo is here doing what
he is doing. I think it lends a nobility to the idea of being an artist." The
plant life, the other artists, and the high level of political and intellectual
discourse that funneled into his life from Mexico City also attracted him.
Moore is not bothered by the "provincial" nature of some of the art sec-
tors, something that he says disturbs other émigrés; rather, he sees all that
happens in Oaxaca as part of the challenge and the opportunity. He loves
the high level of craftsmanship and the aesthetic sensibility that imbues
the city. The constant flow of visitors keeps him stimulated. He has noted:
"As far as the Oaxacan artists I know, almost all of them are very sophis-
ticated people who have lived also outside of their own country. Although
I appreciate their tolerance (tolerance being the great virtue of the Mex-
ican people) of my presence here, I really do not think it has changed
what they do, having extraños in their midst." Perhaps not directly, but the
exposure to George and Jim and their strikingly un-Oaxacan artwork
must have made the world a little larger for the Oaxacans, as well as for
the other ex-patriots who live and work there.

A long time extraño, the New Yorker Laurie Lidowitz, has also talked
about her decision to live in Oaxaca: "I arrived in Oaxaca in 1984 at a

time when I was disillusioned with Europe. After years of living in different European countries, I now found it to be another consumer society like the United States. I wanted a simpler life, and Oaxaca nineteen years ago had few consumer distractions. In fact, after only a couple of weeks, I realized that I had so much more mind space. From the beginning I was aware of the fact that this was not a good career move, but some deeper part of me needed this change. . . . During my first several years in Oaxaca, the exhibitions were almost all 'Oaxaca School' painters. At the same time that I witnessed these artists becoming financially successful I also noticed, by observing their work over time and meeting several of them, that experimentation had no place in their professional lives. By 1990 I was showing my work on a regular basis in Mexico City—clearly a more varied and open art environment than Oaxaca. With the return of Francisco Toledo to Oaxaca, the range and quality of fine arts offerings greatly improved, . . . [and] the art climate has so improved in Oaxaca that I have shown my artwork several times over the last few years, principally in the MACO but also in a few other locations. Fortunately there are now a number of artists living here, both Oaxacan and outsiders, who are experimenting in various directions."[15]

Represented since 1990 by a Mexico City art gallery, Lidowitz's work displays no direct influence of other Oaxaca artists but is nonetheless, filled with a sense of Oaxaca's natural life, mostly visible in the materials she uses or refers to and in the earthy colors she so loves. There are also references to a sort of prehistorical involvement with ancient tools that could relate to pre-Columbian Mexico or to prehistoric civilizations anywhere. Her concern for the state of the world is another aspect of Lidowitz's art. Although never pedantic or didactic—even when she integrates text and image, as she has with her *Peace Project*—she does have a point to make. For *Peace Project*, Lidowitz researched the word for *peace* in every language. On fragile white silk, she appliquéd these words in gold, and she placed these delicate cut-outs on an even more fragile table. This

installation is now traveling around the world. Yet in Oaxaca, Lidowitz is both recognized for her foreignness and is also little noted for it. A more cosmopolitan Oaxaca than when she first arrived perceives that being from elsewhere is both integral and peripheral to who she is as an artist and what she has to offer Oaxaca by living there.

Dozens more *extraños* work as artists in Oaxaca, either permanently or on extended or shorter stays. Though no one artist from elsewhere has profoundly affected the Oaxacan art scene, the openness in Oaxaca and the movement of its artists to and fro are freshening up the artistic offerings. As the younger generations of artists come into increasing contact with new blood, the lines between *propios* and *extraños* will no doubt become more porous.

The openness of Oaxaca to *extraños* extends to the gallery offerings. Galería de la Luz, a photography gallery dedicated not just to traditional photography but also to digital art, opened in 2003. It was the only commercial gallery in Mexico (with the exception of a traditional gallery in San Miguel de Allende) dedicated exclusively to photography by extending the medium into the realm of the experimental. With a complex program of workshops and residencies as well as generous exhibition space, Luz promises to be a valuable venue for Oaxaca. The gallery owner, Antony Turok, is an *extraño* from Chiapias, where he lived for almost thirty years after he left Mexico City. He is an accomplished artist in his own right, a photographer who published a book of photographs on Chiapas. It was the first Aperture Press book to be printed in Mexico. Turok's artist sensibility blends well with his business plan, and with the advice and counsel of his American-Mexican wife, Marrietta, he is extending the gallery's mission internationally. Luz has the equipment for high-technology applications and is welcoming artists, even those who are not technically photographers, to use the equipment. With the great and vital Mexican tradition of photographers, the availability of exhibition and creation space in one site, and a new look at technology and business, this gallery

will no doubt create new opportunities for artists to experiment and to show their work.

Perhaps more important, this new gallery is situated at the heart of the issues that color contemporary art in Oaxaca and the discussion of whether or not the art actually is contemporary. Turok contradicts the capital's definition of contemporary art as being essentially international and Eurocentric. He knows that in Oaxaca there is a place for the local and its particular meanings to be expanded. But at the same time, he and Marietta want to present an array of options to artists working in Oaxaca—to liberate them from the rigid assumptions made by museum curators and directors. Turok hopes that residencies can be created in partnership with the ideas for residencies that are developing in San Agustín, that fund-raising partnerships can be pioneered with foundations such as the Getty, American universities such as UCLA, USC, and governments of foreign countries, and that the study of art in Oaxaca and such attendant exchanges will become interdisciplinary and increasingly open. Finally, he hopes that Luz will bring together artists, entrepreneurs, universities, technology, and imagination in a form that is both for profit and not for profit and that will be new not only to Oaxaca but to Mexico as a whole.

MACO

No vital contemporary art scene can exist without a dynamic museum of contemporary art. MACO (Museo de Arte Contemporáneo de Oaxaca) has filled that bill since it was founded in 1992 by Francisco Toledo. It is housed in the palace legendarily thought to have belonged to the conquistador Hernán Cortés. It was Toledo who arranged for the newly conceived museum to receive support from the government of the state and from INBA. Immediately, MACO began to bring in and to create exhibitions that added to the panorama of possibilities for the visual artists and

audiences for art of the region. Marc Chagall, Piranesi, Caricature from
the time of Juárez, and contemporary artists from Oaxaca but also from
other Mexican states were all exhibited. But, as is typical of projects with
which Toledo has been associated, MACO has become more than just a
place for the collection, preservation, and display of art. For example,
when the secretary of tourism suggested putting a covering on the ven-
erable open-air market in Tlacolula, MACO quickly organized a market
exhibition of *maquettes* (models) that referred to the theme of markets;
and the museum became a place for reflection about controversial new
ideas such as this one. At the same time, MACO has been a center for a
wide range of cultural activities. With a constant program of concerts,
lectures, dances, and symposia, it is a vital and open locus for experi-
encing and debating the arts in all forms. As the museum catalogue notes,
the institution provides, with its art and its collections, a "fragile link
between the forms of living and aesthetic experience."[16]

 This is not to say that directing MACO has been simple. Because Toledo
stayed so close to the helm, the directors he chose were beholden to him
and eventually became resentful of him. After a kind of love affair in the
beginning, the relationship would often degenerate to a fight or at least
bad feelings.[17] Finally, at the end of the twentieth century, Toledo hired
Femaría Abad, his good friend who had been instrumental in bringing
Toledo to Oaxaca in the 1980s. An independent person, she has been able
to retain her integrity and to make decisions on her own. And she has
retained Toledo's respect. Her privileged situation was abetted by Toledo's
year-long residence in Los Angeles during 2001and 2002. Abad used the
time to consolidate her autonomic decision-making. She originated
shows of the shocking English artist Frances Turner, with an oeuvre that
challenges every idea of beauty and ugliness. She mounted the Propios
y Extraños exhibition, which addressed the supposedly closed nature of
the Oaxacan art world by mixing native and foreign artists in a single
show for the first time. She has featured George Moore, James Brown,

and Laurie Lidowitz, as well as other artists such as the French Georges
Rousses. Certainly, Abad has honored the Oaxacan greats such as Morales
and Toledo, but she has also given retrospectives or monographic shows
to non-Oaxacan Mexican artist heroes such as Vicente Rojo and Julio
Galán. More significantly, she has created international exchanges; for
example, seven German artists charged to intervene in the museum's
architecture at the sides of seven Oaxacan artists. Under her leadership,
MACO plans to venture far beyond Europe and America with a show of
photographs of Asian women who have had surgical operations, once
again highlighting an "unseemly" theme and bringing questions of pro-
priety to the fore. Nor has Abad forgotten the museum's connection to
the social and political life of Oaxaca. Soon after the US invasion of Iraq,
MACO welcomed peace demonstrations, the first taking the form of an
all-day concert, with space dedicated for installation and performance;
the second was a silent vigil. All these demonstrations and actions were
free to artists and the general public alike.

One of Abad's intriguing ventures was the original exhibition of the
Lebanese artist Mona Hatoum. Against the most daunting financial situ-
ation, Abad managed to fund, mount, and travel this exhibition during
the summer and fall of 2003. The Hatoum exhibition is a symbol of
Abad's goals: to bring respectful attention to the heritage of Oaxaca and
to open up Oaxaca to new ideas. She wrote in the Hatoum catalogue:
"The sojourn that was agreed on with Mona became a four-week period
of intense and arduous work. The pieces built by the native craftsmen of
our area include intimate connections that have allowed us to present
something that is more than just an exhibition."[18] Abad constantly finds
delight in encouraging Oaxacans to look outside of their formerly closed
society through the open window of the museum. She has approached
the universal problem of contemporary art museums and their tense rela-
tionships with their own cities by balancing insiders' demands with the
desire to bring in the outside world for stimulation and education. She

Mona Hatoum, *Sombrero para Dos* (Courtesy MACO, the Museum of
Contemporary Art Oaxaca)

has thus tried to create a museum that, she says, "allows us to have our
own voice and wins us a place in the environment of the cultural life of
our country wherein each museum creates its own way of settling and
establishing its complicity with other institutions."[19]

Though by no means an outstanding collection, MACO owns a sub-
stantial number of works of international, but mostly Mexican, creation.
This collection is a project that has only just begun, but the effort that
has been put into creating a catalogue and inventorying the pieces will
no doubt inspire more acquisitions. Since MACO has a tiny budget, with
no money for acquisitions, it would be truly helpful if citizens bought
works to donate to the museum. But with the exception of Alfredo Harp,
this culture has not yet developed in Oaxaca. Still, it is a mark of chang-

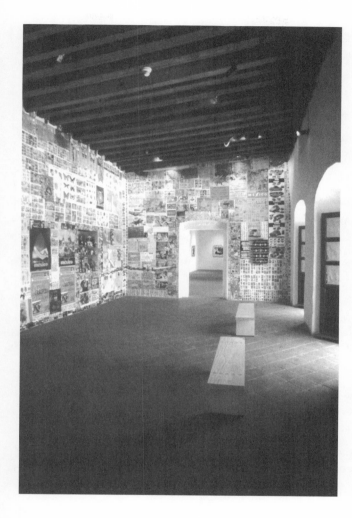

MACO interior
(Courtesy
Manuel
Jiménez)

ing times that Abad, in addition to producing exciting exhibitions, is learning how to raise funds aggressively and imaginatively. This is a new obligation for museum directors in Mexico and is certainly indicative that Oaxaca is at that crossroads; in accordance with the neo-liberal agenda, government patronage is lessening and private support is becoming indispensable to the survival of cultural institutions. No doubt, Abad will be one of the winners—or at least her museum will be. She has grow-

ing ambitions for Oaxaca and knows full well that if she were to depend on the government, MACO would never be more than a provincial artistic satellite of Mexico City. Her goal is for Oaxaca to be a city open to new ideas and for its contemporary art museum to be one of its listening posts for its own more expansively defined creativity. As she adapts new ways of administration while also preserving that which is precious in her own city, MACO will undoubtedly thrive and evolve in the directions she envisions. And if she becomes yet more successful, MACO will have a better chance of sustaining itself beyond her own and Toledo's eventual disengagement. As long as Abad can run MACO independently, as long as she can avoid being run out or overruled by Toledo, she will be successful in leaving a legacy of a great Oaxaca museum.

Collectors

A vital art scene needs collectors, but there is no significant collecting base in Oaxaca. For the most part, other Mexicans and visitors from other countries—not Oaxacans themselves—purchase works of art in the city. Alfredo Harp is, perhaps, the only significant art purchaser whose base is Oaxaca, but Harp denies being a collector: he buys art (primarily) in order to help social projects in which he is deeply interested or to give away to friends for Christmas or wedding presents. When Harp buys art, it is strategic—never decorative or acquisitive—in nature. For example, there was a project organized for the benefit of a famous music school named for Eduardo Mata. A Mexican society woman, Pepita Serrano, recruited several artists in Mexico to contribute to an auction at Sotheby's in New York for the school. The day of the auction, Harp received a call saying that things were not going well. He then came up with the idea of bidding on all of the Oaxacan works himself; not surprisingly, he ended up purchasing two of them at high prices. One was a major Toledo

work that is currently hanging in Harp's house simply because he and his wife like it—not, as his wife stresses, because it is a collector's piece.

And so, despite Alfredo Harp and his idiosyncratic purchasing of art, in this city that lives by and for art, there is no personal or institutional collecting base in the traditional sense. This could change in the future: Sergio Hernández's foundation is buying for his new museum. A museum of Oaxacan painting is scheduled to open in 2005, which could alter the collecting panorama. But mostly, this is not a high-powered art-buying city on its own account. The buying of art in Oaxaca has been left to travelers, collectors, curators, writers, and critics worldwide. Perhaps that is enough—as long as Oaxaca remains a destination totally identified with art and its creation. This reputation shows, it should be concluded, no signs of abatement.

5

Crossing Indelicate Lines
Artisanry in Oaxaca

Oaxaca is known throughout the world for its crafts. The name of this southern Mexican city is recognized by scholars, collectors and curators, travelers, and shoppers of all stripes, whether the discussion is about black or green pottery, painted-wood animal figures, Zapotec rugs, palm *sombreros*, figurines, embroidered smocks (*huipiles*), or silver and gold jewelry. Much has been written about each of these crafts: Marxist and gender-based analyses of their production; detailed accounts of technique in anthropological treatises; poetic elegies; and inevitably, guides for the avid buyer. There is no lack of information about how and why each of these crafts has developed and come to thrive Oaxaca.[1]

One reason that crafts have survived is that many towns and villages are dedicated to particular crafts; in a discrete, eccentric, and concentrated way, certain pueblos are identified with certain types of artisanry. Some of these towns enjoy a degree of prosperity, and a few have crossed the line from dire poverty to a more reasonable existence. They have been able to accomplish this precisely because of the crafts—which, when

added to the population's normal agricultural activity, have yielded a livable income stream. A few such pueblos have moved from a situation of high emigration rates to one of relative stability. Other artisans remain mired in poverty because the crafts they practice are not clustered in a town and are not part of any pressure group that can demand support from the government under the rubric of the maintenance of traditional folk art. Authentic folk art is a visual form of creativity that comes from the spirit of a people. It is executed with a collectively acquired and transmitted skill. It is not a mindlessly repetitive action.[2] Yet clearly, the spirit of folk art in Oaxaca is a constantly evolving one: New folk traditions emerge while old ones wither.

There is always pressure on the artisans. In addition to the problem of poverty, there is well-intentioned pressure from some Mexican activists and intellectuals who are pushing for governmental support for fresh ideas, for a rejuvenation of traditions through a freer exploration of new forms. Their suggestion is that the regional memory that nourishes the crafts of Oaxaca needs to embrace changes that would make Mexican arts and crafts more attractive to modern globalized taste and markets: "In order to conquer new markets and to preserve the ones they have, Mexican artisanry must change its image. Globalization, competition from low-cost products, such as those made by the Chinese and the Thais, and the diminishment of the taste for the ethnic and the traditional, place Mexican folk art in the horns of a dilemma of whether to hold on to its identity or transform itself to please the fashion of the day."[3] Yet the pressure from the would-be modernizers of Mexican folk art is met with fierce resistance from other well-established factions. The latter position is that the Mexican government must—through FONART, its unit dedicated to folk art—support the traditional crafts far more aggressively than it currently does. The government's support of the crafts has been increasingly suspect since the PAN won power and its efforts to disincorporate FONART.

According to a recent report, most artisans are interested in change and

innovation. They seek national recognition for their contributions to the nation's aesthetic patrimony and protection of the craft universe as a national legacy, similar to the recognition afforded archaeology, history, and the fine arts. Some of their suggestions include tax relief, help in marketing and promotion, subsidies for raw materials, minimal health care, significantly more prizes for excellence, and protection of the natural resources that enable their work. They are not looking for handouts. The president of the organization Populart insists that without a more acute recognition and protection of the traditional crafts, they are in danger of fading away as a vital force. She adds that this recognition needs to come urgently, and sooner rather than later: "An artisan in Mexico, when he was promised that 'we are going to change this and that,' answered 'Yes sir, but while the grass is growing, the burro is dying.' We hope that the burro doesn't die and that the grass does keep growing."[4]

It would seem that the two camps (the champions of change and the conservatives) gain nothing by being adversaries. Neither the direct response to market forces nor government support will solve the problems that surround the poverty and neglect of artisanry in Mexico.[5] Oaxaca, perpetually in the center of the storm caused by extreme poverty and emigration, does, however, have a powerful resource for stability: its variety of individual artists as well as its groups of artisans living in their craft pueblos. At a time when the forces toward homogenization are being questioned and when the traveling and consuming classes' thirst for authenticity is growing, Oaxaca has an advantage in that its regional crafts are already a vital part of the state economy.[6] Giving Oaxacan artisans some extra attention, attention that would fill their fundamental personal and professional needs, such as health care and serious promotion of their crafts, might enable more of them to maintain their roots at home rather than leave Mexico for the United States in order to live and work productively. The traditional crafts would then evolve naturally, and newer forms would emerge naturally as well. The retention of pro-

ductive human resources could, it would seem, only benefit the country as a whole.[7]

An encouraging trend is that in some lesser-known Oaxacan pueblos, such as San José del Pacífico in Miahuatlán and San Sebastián Río Hondo, untraditional crafts are emerging, ones that may be suited to the changing times. These new or newly conceived crafts are a quiet indication that Mexican artisans will survive and that they will not have to serve the preconceived needs of the globalized community. When the fruit growers of San José del Pacífico had the idea to bottle traditional mezcal with organic fruits in an artisanal way, when they received prestigious encouragement in this project from Francisco Toledo, and when they realized that they could earn considerably more money by bottling those organic fruits in mezcal than they could by either growing mezcal or selling fruits in the old ways, the new artisanry began to develop. Evolving crafts for wooden chairs, *serapes*, hats, gloves, and blouses are likewise being supported in this poor region by several groups, including Amistad Altruista Internacional, the FOCOICA, and the municipality of San José del Pacífico. These groups supply the artisans with needed training and machinery in the hope that through such training and aid, the artisans may be able to extricate themselves from extreme poverty and the inevitability of migration. And as the local artisans develop crafts that serve genuinely developing desires in society, they can also defeat an insidious and growing trend of copying their older crafts, a trend that is emerging from, for example, China.

The Well-Known Craft Pueblos

Oaxaca is the home of famous craft pueblos. The Oaxacan craft towns of Teotitlán del Valle, San Bartolo de Coyótepec, and Arrazola are only three of the most outstanding examples of these communal concentrations of artisanal energy. They are regularly written about for their exquisitely pat-

terned rugs (Teotitlán del Valle), their shiny black pottery (San Bartolo de
Coyótopec), and their colorful woodcarvings (Arrazola). Emblematic of
the phenomenon, each of these pueblos has managed to construct a spe-
cial place for itself in the universe of craft production. The rug village of
Teotitlán del Valle flourished because it strategically transformed its age-
old craft into a modern, globalized industry functioning on numerous
levels: the rugs are sold locally in the town; they are sold in Oaxaca City
to tourists who do not have the time or interest to go to the pueblo; and
they are sold internationally using the Internet and shipping services.
Ranging in quality from the banal to the sublime (measured by their
finesse of execution, the complexity of design, and the richness of col-
ors) and from the repetitive and derivative to the more adventurous if
not always original, they serve all markets. A number of Teotitlán's
denizens used their earlier experiences of legal immigration to the
United States (during the *bracero* days after World War II, when both the
American and the Mexican governments benefited from Mexican labor-
ers temporarily sent north) to accumulate some capital and to learn how
the larger business world functioned. Teotitlán's highly organized social
structure allowed it to preserve aesthetic traditions as well as to adapt
them to the needs of the ever-changing marketplace in such a way as to
create a model of prosperity. The black-pottery town of San Bartolo de
Coyótopec, also practicing an age-old craft, crossed the line from the
ordinary production of gray mezcal *ombligo* jars to the regular creation
of an extraordinary body of work. This happened because an artisan-
artist, Doña Rosa, accidentally discovered how to transform the tradi-
tional dull pottery into the brilliant black that has subsequently reinvig-
orated the life of both the craft and the town. Her discovery, the industry
of her family, and the cleverness and adaptability of the surrounding
community transformed this product into the local trademark. Doña Rosa
currently has many imitators, but the quality of her pots has resulted in

museum exhibitions worldwide as well as in purchases by both con-
noisseurs and casual consumers. The subsequent increase in tourism,
aided by the pueblo's proximity to Oaxaca City and the pan-American
highway, along with the published mentions of the black pottery by art
and travel writers, has helped the town move forward economically and
socially. Finally, Arrazola, La Unión Tejalpan, and San Martín Tilcajete
became sometime-prosperous places due to their eccentric painted
woodcarvings, which, in the case of Arrazola, remain closely allied to the
traditional economic base of agriculture. Although most travelers to Oa-
xaca assume that the wood-carving tradition is an old one in these towns,
this is not the case. The majority of these artisans adopted the craft in
the late 1980s. By 1985, after lifetimes of struggle, a very few persistent
carvers of wooden animal, human, and fantasy figureswere finally being
appreciated by American patrons.[8] Indeed, this artisanal "tradition" began
with one Arrazola man, Manuel Jiménez, who discovered that the wood
of the copal tree would make his craft viable. Jiménez traveled far beyond
the miscellaneous local traditions of toy-making and mask-making into
what has become a true communal folk art. Though the woodcarvng
pueblos are riddled still by poverty and played with emigration (and
remain tightly dependent on market fashions and tourism), their success
has spread. This craft now seems traditional, but it is really a contempo-
rary manifestation of a sporadic folk art that was spurred by the creativ-
ity of a few carvers and their American buyers. But the copal trees that
are the foundational material of the craft are endangered, and for a long
time there were no solid plans for their perpetuation. Many observers
have deep-seated fears of what might happen when those trees cease to
be, and the artist Rodolfo Morales was one of the first to make efforts to
reforest the copal. Practitioners need also to worry about what might
happen if the market for the craft dries up. In the meantime, between the
maintenance of the agriculture that persists in all of the villages and the

Black pottery from the San Bartolo Coyótopec pueblo (Courtesy Manuel Jiménez)

crafts themselves, the towns are managing to stem some emigration and to enjoy some improvements in this somewhat less extremely poor segment of Mexico's Oaxaca State.

Still, artisans produce their crafts in many other pueblos, bringing in some, but nowhere near enough, additional revenue to the region. These artisans and their crafts can be found ubiquitously, if sporadically, throughout the state of Oaxaca. But the general lack of support they receive is creating a dire situation, and artisans have arrived at a crisis point. The state needs to recognize this situation if it wants to avoid their extinction by emigration to the United States or "the other side."

In June 2002, a series of newspaper articles in the local daily, *Las Noticias*, took up the cause of the artisans.[9] *Las Noticias* described the lives of the women of Atzompa, near Oaxaca City. The creators of the so-called

green pottery, they begin to work at this craft when they reach six years old. They suffer for long periods of their adulthood in extreme muscular pain because of the unforgiving nature of the work. This unrelenting pain adds terrible strain to their already difficult lives. The women of this pueblo have absolutely no access to health care, which would allow them to visit the medical specialists who might be able to relieve them. So, many of the women rely on home remedies, which do not provide sustainable comfort. Furthermore, they are turned away from the country's Social Security system because they are not associated with an "institution" and because they therefore do not have a guaranteed minimum salary—requisites for receiving that kind of benefit. Finally, the women are asking why the local protectors of artisans (ARIPO) cannot help them organize in order to guarantee deposits into the system, thus qualifying them for medical care. The *Noticias* articles ask why students can receive free health care but the most vulnerable artisans continue to be ignored by the government. Clearly, this craft cannot continue to thrive if its producers do not have access to minimal health care in today's world.

The palm industry is a dying craft. This is a traditional craft of the Mixteca, the mountainous region far from the urban life of the capital but still a part of Oaxaca State, where the palm artisans produce and sell about three thousand *sombreros* in any given week. The number of practitioners has dropped 70 percent in recent years. The palm industry is now the lowest-paid craft in the region: a hat sells for six pesos (around fifty cents), and one person is capable of weaving only about three hats per day. The artisans who make *petates*, the colorful pads for sleeping, are in a similar situation, as are those who weave the little palm figures. Between the modern attraction to plastic and the exploitatively low prices paid to the people who make the palm, the once dynamic craft is being destroyed. The exodus of the palm workers, and sometimes their whole families, to the United States or to Baja California is already a disaster. The palm workers say that there is no one to complain to, that the govern-

ment is not even interested in their plight. One can only imagine the loss to tourism revenues if the neglect of this palm craft, in conjunction with the neglect of other craft industries, continues. The silk craft in San Pedro Cajonos, Villa Alta, is another artisanal tradition in crisis. Some of the craftspeople here make colorfully patterned silk shawls, others make sandals, and some make hammocks. As far as they are concerned, their work is totally devalued and will soon be forgotten. Their pieces sell for little more than the cost to make them, and the time invested is intensive. In addition, the prices they pay for the raw materials are increasingly making their products impossible to pursue as a life's work. The silk crafts involve many steps over several days. To make a hammock, the workers need first to extract the fiber from the maguey plant, then prepare it to obtain the threads, and next dye the threads. Only then can they make the hammock. The final sales price, about $80, barely covers the cost of making the item. In contrast, a synthetic hammock costs about $30, is finished in a couple of hours, and sells immediately. The older generation is, or course, dying out, and the young people would rather cross the border than stay and perform this backbreaking and unrewarding labor.

Can the government help these people organize to promote their work, which is hardly even known? According to the articles in *Las Noticias,* the small aids programs—loans at 7 percent received from the Instituto Nacional Indigenista (now defunct)—and the ability to take courses in tinting and dyeing offered by ARIPO have been useful. In a nearby town, San Miguel, ARIPO has given some encouragement to the craftspeople with incentives for the cultivation of the worms needed to make silk. But these successes have benefited only a very few people, the most minute percentage of the craft-making population. Workshops and loans aside, the major complaint continues to be the lack of promotion from the government for the work. Certainly, these artisans of many stripes will die out; and Oaxaca, for lack of investment in them, will lose industry after industry to plastics. The indifference is shortsighted and unnecessary.

With the loss of each craft, Oaxaca will become that much less an attraction, that much less unique in the world of tourism, and will put a significant element of its identity at risk.

Projects and Proposals

A few government projects, some generated from outside of Oaxaca and some from within, have been proposed in recent years. These projects, both those that succeeded and those that failed, have made it very clear that it is possible for traditional crafts to advance and for new forms of artisanry to emerge. At the same time, they have demonstrated that the folk-art endeavor needs to be handled with extreme care. The government is, most notably, responsible for FONART on the national level and for ARIPO on the state level. ARIPO has been as hamstrung and often ham-handed as FONART. Prizes offered by ARIPO and by FONART are of great value to the artisans, but there are never enough of them to broadly encourage elevated levels of creation. Both of these organizations have done some good and, occasionally, some harm. ARIPO was initiated with great expectations, as a private organization. It had the best of objectives in its early days: quality control; protection of the economic well-being of the artisans; prizes; and the development of commercial possibilities for the artisans. It was begun with a love and respect for folk art and for an understanding of what folk art brought to Oaxaca. But once it was transformed into a government organization in 1981, ARIPO laid out a number of less well-considered paths to try to improve the plight of artisans in Oaxaca. In the process, the original goals became somewhat twisted and the value system changed, to the detriment of folk art and the folk artists.[10] Yes, some workshops teach better means of production and alternate technologies, and yes, travel support allows some folk artists to attend international fairs to promote their work. But at the same time, the objectives have become more about promoting commercialization,

in the sense of making the crafts faster and cheaper but not necessarily better. This contradicts the very notion of folk art. But as the ARIPO representative explained, the idea is to improve the process of producing crafts that are already being made but are too expensive to sell because they take so long to make. The artisans are taught to diversify and to make things they can sell in quantity. They could, he explained, still make the huipiles, the beautifully and intricately embroidered women's smocks, for themselves, but they should make the tablecloths, coasters, and other quickly produced items for the market. He talked about encouraging creativity and protecting the artisans economically, but the actions being taken suggest what is really encouraged: more and more; faster and faster.

To be fair, the problem is bigger than the budgets of the local and regional governmental organizations and is evidently bigger that the imaginations that run ARIPO. There seems to be little sympathy from the electorate; thus, the artisans feel themselves to be (indeed, largely are) on their own. Undoubtedly, the grand projects—such as traveling exhibitions—have helped to secure appreciation for the folk-art field in Mexico in the abstract. And certainly, the renewed museum of folk art in the capital will do the same. Unfortunately, the point is missed that the fertile ground for the great masters is in their own villages. There, and only there, will the future masters emerge. In the game of mass production of cheap objects for the global economy, Mexico will not likely beat out other countries, which can accomplish that goal ever more cheaply every day. In the long run, the artisanry will need to be encouraged at the most local level in order for Mexico to win in this arena.

Oaxacan craftspeople have thus far profited painfully little from traditional governmental and nongovernmental support. They have, however, received some creative support from individuals and corporations. That Banamex sponsored and organized the exhibition of national folk-art masters was positive. The exhibition traveled throughout the country for several years and featured a number of Oaxacan master artisans and their

masterpieces. It was an eye-opener for many people who did not know of the high level of production that occurs all over Mexico. This exhibition was, naturally, displayed in Santo Domingo and has been seen by thousands of people during its itinerary. It was also displayed in Los Angeles at the Museum of Natural History in 2003 to enthusiastic audiences. But perhaps the projects with the most potential are generated by individuals.

Outside of Oaxaca, there is a little-known example of a "fine" artist who has engaged with a branch of the folk-art community in order to experiment with "social architecture," a means by which folk art can be preserved and advanced simultaneously in Mexico. Sesma's "social architecture" is based on the idea of working with exacting onyx craftsmen to move the town they lived and worked in from a poor to a more prosperous existence. Its larger objective was to cross and blur the boundaries between artisanry and fine art so that one would nourish the other. The project, Advento, was conceived in 1995 by Raymundo Sesma, one of Mexico's principal contemporary artists. Sesma has had innumerable exhibitions and has been the country's representative at the Venice Biennale. Living half the year in Milan, Sesma is acquainted with many international contemporary artists. Advento housed in the town of Tecali outside of Puebla (like Oaxaca, in southern Mexico) and is based on the exchange of the skills of the onyx makers with the imaginations of the "fine art" contemporary artists who are invited to Tecali from all over the world by Sesma.[11] The artists are given the opportunity to work with the craftsmen and to live in the town for an extended period of time. Each group profits from contact with the other, as each teaches a hitherto unknown expertise to the other. Sesma is haunted by the Mexican dilemma of the impressive but underutilized legacy of craft skills and the state of poverty and marginalization in which so many find themselves trying to forge an existence. He has been determined to take advantage of this trove of human resource by mixing the artists with the craftspeople: The artists

bring their experience of trying to create something new to a craft previously unknown to them; and the craftspeople become intrigued by the idea of making a previously unimagined piece. The artisans become fascinated with the freedom of not having to make the same objects, for the tourist trade, that they have always made, and the artists gain the advantage of a "skill set" they themselves do not possess. Thus both sides enter into a far more complex world: for the artisans, a world of exhibition, civic event, publication, and a different sense of identity; for the artists, a world of intense, focused, rooted, and time-sharpened skill.[12] At present they have created over 250 prototypes, which they believe will advance the national culture.

Tecali is a historically resonant place for this idea. As Sesma notes, it is "the last social vestige of a Franciscan urban utopia."[13] In a kind of time warp, the pueblo has hardly changed since the arrival of the Spaniards. And the men have been onyx makers since that time. Tecali is also architecturally compelling. It is the site of a former convent, two ancient water-storage centers, and a three-hundred-year-old theater. "Social architecture" is not meant to be a way of going backward, of encouraging what Sesma terms "involution," but rather it is meant to be the stuff of evolution, something that, by rescuing the best of the past, is capable of positively transforming the culture of today. Sesma would like to accomplish this by means of the world of arts and crafts in the broadest sense: the organization of art exhibitions, dance, theater, and music as a result of the encounters he has organized. Visiting artists and researchers would come together to promote a multidisciplinary approach in "a place where traditions are recovered and where art and popular customs are nurtured close both to the historical roots of our culture and to the contemporary tendencies of the present day." Tecali, according to Sesma, could be a place where "the whole mission of artists, curators, creators, politicians, scientists, philosophers is questioned through this concept of the shar-

An onyx vase,
from Advento

ing of citizenship, the sharing of scales of values, of knowledge, of expe-
riences, of decisions concerning the children of the future."[14]

This private vision has not been easy to fulfill. Sesma spends time in
extensive fundraising, looking for private and public grants. Yet as he has
struggled, he has enjoyed successes. The onyx works that have been cre-
ated are gorgeous fusions of craft and new ideas, of utility and pure
beauty. Advento has allowed artists to transcend their technical limita-
tions through intense relationships with the artisans. It has allowed arti-
sans to escape from the land of dull repetition. Plates, mortars and pes-
tles, vases, sculptures, and abstractions transcend definitions as objects

only useful or only artful. Interviews with artisans and artists show them both to have been inspired by the other. Crossing boundaries—past and present, art and craft—this kind of idea could be a tonic to purchasers and creators alike. Exploring new techniques and ideas and investigating new materials are ideas that have been espoused in Oaxaca as well. At last look, Advento was struggling for life and might not be, indeed, sustainable in Puebla. Certainly, Toledo tried to promote this kind of fusion with the rug makers of Teotitlán del Valle, where he lived and worked for a few years. But the idea has never been brought up quite to the level of articulation, or with a parity of achievement on both sides of the equation at the beginning point of the project, as it has with Sesma's idea. Advento's success will take years to measure, but it is an idea that would perhaps play as well or even better in Oaxaca than in Puebla, a far more conservative environment with a less established identity as a city of art.

Memory and Change in Oaxaca

Two special situations exist in Oaxaca with respect to artisanry and its relationship to memory and change, which also cross lines of art and craft on their own terms. The first involves an unusually gifted artisan who made a career for himself in both the world of crafts and the world of fine arts and who constantly tests one against the other, enriching both universes. The second found its genesis at the intersection between extreme poverty and the now familiar artistic concept of "paying back," while also testing the line between art and craft. In both cases, a Oaxacan faces his own crossroads and comes to his own conclusions about the direction that the road ahead should take. The two situations occurred in that Oaxacan environment where artisanry and "fine art" normally exist in distinct societal categories; the main characters have daringly crossed those lines to create something of their own, something that

nevertheless lives and breathes Oaxaca's overwhelming civic personality as a center for creativity.

Arnulfo Mendoza

To understand Arnulfo Mendoza, Oaxaca's greatest rug maker, one must get close to the town of Teotitlán del Valle, where he was born and where he still maintains a home. About four miles from Oaxaca City, Teotitlán is populated by Zapotec people, most of whom still speak the Zapotec language and adhere to their ancient culture while actively and productively living in the modern world. Teotitlán is an agricultural village with a special relationship to weaving rugs, *tapetes*, which its citizens originally pursued as a sideline to agriculture because of the unpredictability of the crops. Teotitlán, a prosperous pueblo, has learned to maintain as much distance from the central government as possible because Teotitecos, as they call themselves, quickly grasped that the government was driven by its now infamous "indigenous policy," the goal of which was to homogenize the indigenous peoples and to make them more like mainstream Mexicans. Teotitlán has been quite successful in its strategy of distancing itself from the government—except when Teotitecos deemed it to their advantage to do otherwise. With some small exceptions, the Teotitecos have, indeed, helped themselves. They continue to prize their independence, believing that the less the government is involved in their affairs, the more they will be able to protect their gains. Nevertheless, they have had bad experiences with FONART, the government artisan institution, to remind them that the government is not their friend or ally. (FONART, for example, has been guilty of nonpayment to artisans at the point of delivery and of grouping all Mexican crafts together in retail outlets as simply "*hecho en Mexico*," made in Mexico).[15] It is only because of their refusal to be absorbed into the hot cauldron of "Mexican crafts" that Teotitecos have been able to preserve their niche. At the

same time, their virtuoso ability to reproduce any design they were given meant a predictable income stream from making reproductions of, for example, Oriental carpets or Navajo rugs. In fact, although they have been involved in such reproduction for years and they can produce these carpets, they engage in that activity only for business purposes. Their essential identity does not spring from this kind of reproduction but rather from their persistence in holding on to their own designs.[16] At the same time, they are pragmatic about design issues and will, for example, downgrade their wool to a less-expensive cotton/wool mix so that they can sell to their importers en masse at globalized chains.[17] The point of their decision-making, though, whether or not every decision proves to be a sound one, is that they make the decisions themselves after having taken into consideration the market and their own issues of community identity. They do not depend on the government or trust it.

The Teotitecos have always calculated how to outwit the government when possible in order to gain an advantage without having to mold themselves to the expectations of the indigenous policy. For example, they figured out how to answer government questionnaires so as to garner whatever incentives they could for their business operations. On the other hand, it never occurred to the Teotitecos to hesitate to turn to the government for help—for example, to ask for its help in preventing the Japanese from copying their designs.[18] As a result of its clever history of negotiations and its deep and broad craft achievement, Teotitlán del Valle enjoys electricity, running water, pavement and cobbled streets, a health center, a public market, a pharmacy, and small stores as well as a library and handcrafts market. The town has a lovely and large communitarian museum in the old market building. Teotitecos travel back and forth to Oaxaca City by car, truck, taxi, and bus. The pueblo has a preschool, an elementary school, and a secondary school, although students must commute to the capital for high school and higher education.[19]

Teotitlán del Valle can also afford an inordinate number of lavish festi-

vals, with music supplied by its five adult bands and its children's band, all of which the people pay for communally through their own system of guelaguetza and compadrismo. The famous guelaguetza system allows for long-term lending and borrowing, carefully recorded in a notebook. This structure organizes the lending and paying back of transactions—sometimes over many years. By reclaiming the debts only when needed instead of automatically, the lender can produce a lavish wedding or fiesta that his or her family might never have been able to afford otherwise. This, combined with the system of compadrismo, whereby one is obligated to work or to help out a godchild at his or her celebrations, allows for the production of these elaborate affairs. As brilliant as it is in stretching a community's or an individual's resources, the system presupposes a relatively healthy economy. Its participants need to be well enough off to lend money, to offer a hand, to live without that turkey for the time being, or to make a hundred tortillas for a fiesta.[20]

This is the prosperous pueblo in which Arnulfo Mendoza was born in 1954. Prosperity, though, is relative, and Mendoza grew up in an economy in Teotitlán del Valle in which everyone in the community needed to participate in the work for that prosperity to be maintained. Even young children were required to learn to weave; by the time they were ten years old, they were quantifiable factors in the local economy. Mendoza's father, Emiliano, was a well-established weaver, one of the most accomplished in the pueblo. Like all of the other young boys, Arnulfo was weaving at a very early age, but he was also drawing. When Toledo was living in Teotitlán, he noticed this young boy who had begun his traditional Zapotec weaving in the family workshop in 1964. Toledo, always building libraries, had already donated a number of books to the town, books illustrated with pictures of the works of Pablo Picasso, Joan Miró, Salvador Dalí, and other modern artists. That donation coincided with a new demand from the market: collectors wanted rugs with images from Picasso or Miró or Dalí woven into them. The weavers were so skilled that

they could imitate practically anything, but first they had to draw it. Drawing had become useful; and Arnulfo had become addicted to drawing. Toledo noticed the youth's superb draughtmanship and told Arnulfo's father that he ought to send the boy to the Academy of Fine Arts in Oaxaca City. Arnulfo's father was unsure whether this was the best thing for his son, and he knew that he would lose his son's economic labor by acquiescing. But after many more people commented on his son's talent, he finally allowed Arnulfo to go. According to Arnulfo's wife, Mary Jane Gagnier, this was a very generous act and, in the face of community norms, an extremely independent-minded thing for him to do.[21]

Attending the Academy of Fine Arts in 1972 was a superb experience for Arnulfo. He immediately began to work with master artists. When he first went, his role was only to observe and then decide if he should apply when he reached the legal age of admission. But unbeknownst to the administration. Arnulfo had gone ahead and presented a picture to the "VII National Competition in the Fine Arts" in Aguascalientes, where he won honorable mention. He was then, despite his youth, automatically accepted to the academy. During Arnulfo's studies, at the Academy of Fine Arts and then later at the Rufino Tamayo Studio in 1974, run at the time by Donis, he had the luck of coming into contact with Toledo again and later with Tamayo, who showed up occasionally to lend moral support to the studio that bore his name. Arnulfo felt that he had many secrets to learn as he moved from a world of inherited patterns to one of invention and self-motivation. But the biggest secret he learned was from Tamayo, who whispered to him, "No hay secretos!" "There are no secrets. The secret is not to have secrets, but to have fun. Pure pleasure."

Learning the secret of art from the greatest master of the day in Mexico was a turning point for Arnulfo. At nineteen years old, he decided to go to Europe. He had been in some small group exhibitions in Mexico City by then and was full of curiosity and daring. The European adventure was very hard for him financially and emotionally. He had

thought he was receiving a *beca*, a scholarship, but it never came through. He went to Paris anyway. Somehow, a great deal of his work was sold from the Rufino Tamayo workshop, and he finally had a little money to enable the trip. He took along some rugs that he had made and an official letter of introduction. He went to the *Casa de Mexico* in Paris, which promptly gave him a show both of his rugs and of his paintings. In Paris he met a number of influential people, who introduced him to more people, all of whom encouraged him to go to Holland and Bruges. There he saw the tapestries made by the finest Old Master weavers, the tapestries from the Renaissance and Baroque periods. By now, Arnulfo's world had irreversibly opened up, spatially and temporally. Halfway through the trip, he ran out of money, and his father had to send him a ticket to return home.

Arnulfo returned to Mexico with a good number of recently completed paintings. Rather than go home broke and face his father and the pueblo, he went directly to Monterrey to the Gallery Miró. As soon as he showed his work to the gallery owners, they gave him an exhibition, and very soon thereafter they sold many of his canvases. Arnulfo was able to repay his father and to more comfortably return to Teotitlán, where he proceeded to follow the customs and traditions (*usos y costumbres*) of the pueblo and fulfilled a *mayordomía*. That is, he took on the full responsibility for his civic/religious responsibilities. These specific responsibilities, the *cargos*, are the unpaid duties that are expected of all members of the town and that keep the pueblo together as a functioning community. Whatever Arnulfo's involvements with the larger world, he always maintained close ties to his ancestral obligations. And the rewards were significant. It was not a boring time in his pueblo: there was a constant stream of visitors from Cuba and of artists from all over the world, wanting their images reproduced in the rugs. There was much contact with an unceasing and highly cosmopolitan flow of contemporary artists who came to visit the famous rug town. Teotitlán del Valle, therefore, was a

stimulating environment in and of itself, and Arnulfo began to make some original rugs, reawakening to the pleasure of creativity from the craft in which he was so well trained. At the same time, he was increasingly aware of the need for rigor in either of the paths available to him—whether original rugs or creative painting. He felt very free; he had discovered a way of life for himself.

The next stage in Arnulfo's development was to adopt both a deeper and a broader sense of responsibility to the work—that is, to rescue traditions for himself so that he could analyze what he was doing and better understand the profound nature of weaving. Arnulfo became more involved with other weavers, exchanging ideas and secrets about natural dyes, about *mordientes* and *fijativos*, about the dyes that very few people knew how to control in those days. At the same time, in the early 1980s, he also became involved with visitors to Teotitlán. One of those visitors, Pedro Preox, encouraged him to enter his work in three biennales in DF, where he began to win important prizes and to gain further recognition as an artist and weaver on a national scale. Arnulfo became interested in the *serape*. He based his work on the *serapes* of Tlaxcala but then became fascinated by the eighteenth- and nineteenth-century *saltillo serape* from the American Southwest. He loved the fine work in the oldest of these *rebozos*, which are "characterized by web like diamond patterns, some with hollow X shapes, others with grouped zigzag lines and terraced triangles across the horizontal axis of the design plane."[22] The weavings that he made as a result of that influence were later featured in the exhibition *Patterns of Prestige: The Saltillo Sarape*, at the Oakland Museum in 1992 and later at the Autry Museum of Western Heritage in Los Angeles.

By the early 1990s, Arnulfo was alternating between his rug making and his figurative painting. As a result of his explorations and research, Arnulfo had single-handedly changed the face of Teotitlán weaving, complicating the traditional designs and initiating such motifs as the speckled background, the undulating line, and the famous "eye dazzle" effect.

Arnulfo also initiated patterns that break up the angularity of the designs, making the weavings more varied and almost mesmerizing. Alejandro Avila (director of the Jardín Etnobotanico and an expert in textiles) invited Arnulfo to Berkeley to participate in an exhibition, Mito y Mágico. Arnulfo was later invited to oversee the design of the exhibition Hecho en Mexico at the Otis Art Gallery in Los Angeles, where, unlike the others who were invited, he was also asked to contribute his own designs.

In 1993, Arnulfo went to Tokyo for an Artist in Residency, sponsored by the Japan Foundation, to which he had been recommended by the major Mexican art critic Raquel Tibol. Accepted in the "weaver" category, Arnulfo arrived in Japan as a "living treasure." Treated superbly, given everything he needed to experiment, and provided with ample time to do his investigative research, he learned about new dyes and how to use silver and gold threads. Arnulfo was so inspired that even though he had been painting a great deal before going to Japan, he found his imagination expanding with respect to his weaving, and he and drifted once more toward the world of the textile artist more than that of the painter/artist. Subsequent trips to India broadened and further deepened his sense of the possibilities of the woven rug. Throughout, Arnulfo's work has remained respectful of his indigenous traditions while also changing them, even as his own pueblo was absorbing and being influenced by his innovations. Arnulfo has kept his craft alive and flexible by introducing new ideas, which the pueblo artisans have adopted and modified. Teotitlán has thus followed where Arnulfo led, keeping both tradition and innovation alive.

As for his paintings, Arnulfo uses that medium to create works of art that are independent of his rugs and that express different aspects of his personality. Whereas his rugs seem to summon dreams and fantasies of the still architectural and archaeological surfaces of Monte Albán (with a more formal complexity and inventiveness than those typical of his village and made with richer materials, such as strands of silver and gold),

Arnulfo
Mendoza, rug
(Courtesy La
Mano Mágica)

his paintings are lyrical, fantastic, and dynamic. The "paintings are the
reverse of archaeology; the surface parallels the mounds above a lost pyra-
mid, the texture hiding yet accentuating the form underneath. The pat-
tern of the glyphs from Monte Alban can be seen in the flamboyant loops
of a siren's fin. . . . Mendoza has discovered a world in which the rem-
nants of the mythological have blended with the mundane. A sense of
rapture has linked the forces of heaven and earth. . . . There is light in his

Arnulfo Mendoza, *Viaje Celestial* (Courtesy La Mano Mágica)

colors, motion in his shapes, delicacy in his ideas and, ultimately, passion in his eyes."[23]

Arnulfo's life has been exemplary in that he has continued the rug-making of his father's business for the well-being of his extended family. He employs many of his relatives, and they produce fine textiles, many of them signed by Arnulfo to indicate his involvement in either design or execution. He constantly experiments—for example, putting small rugs into handmade tin frames to see how they function as pure art pieces. After he experiments, he decides whether the line between artisanry and art has been crossed successfully—whether the experiment deserves to be perpetuated. Mendoza continues to maintain a close connection to his communal village too, where he fulfills his *cargos* and pays his *tequio* and

where it is rumored that he will someday be president. In 2002 he worked with an architect on a new health center for Teotitlán, fulfilling a current cargo. When asked why he wasn't charged with doing something more directly related to aesthetics, such as heading the communitarian museum, which needed his visionary presence, Arnulfo answered that the established hierarchy of the pueblo's *cargo* could not be overridden and that it was not his place to question that hierarchy's decision-making process. His wife, though, added: "The idea of having a special talent is novel still in Teotitlán. There really are no precedents to deal with a case like Arnulfo's. The village is comfortable with the status quo, they prefer no one to be "special" and . . . no one is a prophet in their own land. It probably hasn't occurred to the elders that there is a person in the village specially trained in the visual arts that could contribute more to the community museum than perhaps anyone else in the village."[24] Perhaps wisdom is buried in the traditional thinking of the pueblo. They do not want to anoint one person as king: just because Arnulfo has had unique success in the world advancing their primary artistic/artisanal product, they do not want to give him an all-encompassing, permanent privilege, and they do not want to remove him from other, equally important communal matters. He worked on and invested in the health center like any other citizen of the pueblo, and when that *cargo* is over, he will, like any other citizen of the pueblo, be a user of its services.

Still, his counsel would be helpful for the pueblo's communitarian museum. According to both Arnulfo and Toledo, this museum is a kind of quiescent place; it is not being used as a dynamic space where new techniques can be researched and new ideas played out by Teotitecos. Why isn't the museum a place where the young people of the pueblo can go to experiment with the possibilities that lie within the ancestral craft? If they could see the value, even the excitement and challenge and reward of making rugs, of meeting global market demands, of fostering their own originality, and of making still more money, perhaps staying home

and not emigrating might become an increasingly viable choice. As the town gets more and more wealthy, the possibility of losing population to emigration could become a serious problem—as it was at the time of deep poverty—because of the media and its glamorized stereotypes about life in the United States, because of the boredom and longing that inevitably afflict adolescents, and especially because of the imagination of a better life somewhere else. The communitarian museum, which by 2003 was considered seriously out-of-date and in need of renovation and expansion, could transform itself into a dynamic place with new educational opportunities within both the value system of the pueblo and the challenges of contemporaneity. Teotitlán del Valle informally functioned in this way before there was a museum—with the influx of artists from elsewhere, the inflow of books and of rug commissions for designs by famous artists, and the residency of Francisco Toledo. The museum could, if it were invigorated, formalize that kind of exposure and could be a catalyst for the weavers to invent new designs instead of only copying those of others. It could be a place for projects such as Raymundo Sesma's in Puebla, with the mutual enhancement of craftsperson and artist. It could serve as a kind of creative laboratory, in addition to filling its more ordinary role as an educational tool for tourists. (Amelia de Los Angeles, a young weaver, has explained that no native Teotitecos ever go to the museum, unless they are fulfilling a *cargo*, because they already know the story it tells. And it is boring for them.)[25] The communitarian museum could be the place where the indelicate line between artisanry and artistry could be crossed and recrossed and where Teotitecos could make exciting discoveries in the intersection of tradition and innovation.

Arnulfo has proven that crossing the border from artisanry into "fine arts" and back again can be done without sacrificing craft to mediocrity or triviality. His life and work parallel the question posed by Peter Schjedahl after a visit to the 2002 Dokumenta: "Why should an emerging country's young artists submit to a rigorous initiation in traditional

mediums when technology offers so many more efficient options?"
Schjehdal describes the contemporary Mexican art star Gabriel Orozco's
indirect answer to this question as he displays videos of his own "first
efforts with wheel-thrown clay, in which lively formal ideas are blunted
by the artist's rudimentary skills."[26] If memory and its attendant skills are
discarded rather than managed, Orozco seems to be implying, then the
future will be at a disadvantage in negotiating its hoped-for changes. It
will have to begin with pure idea—and that is not enough. Arnulfo Men-
doza's life and art are the argument for the profound value of continu-
ing tradition in the midst of the encounter with the new.

Polvo de Agua

One of the overriding clichés about Mexico is the ubiquity of poverty
and the huge distance separating the few extremely rich and the middle
class from the poor. And increasingly, a new descriptive is being heard in
Mexico: *la pobreza extrema* (extreme poverty). Oaxaca suffers from *la pobreza
extrema*, usually in its isolated indigenous pueblos, more than any other
state in the country with the possible exception of Chiapas. Long poor,
Oaxaca's poorest have now lost some of the collective memory necessary
for at least the subsistence farming techniques (such as the *milpa*[27]) that
had sustained them in the past, making a deprived situation only worse.
The decades of the now defunct indigenous policy that tried to eradicate
the "otherness" of the indigenous populations worsened their lives by
eradicating instead their ability to cope in their nonmainstream universe.
Additionally, poverty has resulted in the human tragedy of a mass exo-
dus of men from many of these pueblos. Andrea Mandel-Campbell
described one pueblo: "Most of Rosvelia Ramírez's friends left their home
town as soon as they turned eighteen, exchanging the verdant hills and
blue peaks of Mexico's high plains to work illegally as maids or day labor-
ers in the United States. At first, Rosvelia, twenty, also wanted to leave San

Jerónimo Slayopylla. The town with a population of just more than one thousand is a virtual ghost town now, its few scattered inhabitants—mostly elderly people, women and children—subsisting on the United States dollars their relatives send home."[28]

The Mixteca, a large region in Oaxaca, suffers from *la pobreza extrema*, from the subsequent absence of men, and from extreme isolation as well. Mountains and clouds imbue a relationship to nature that is personal and immense at the same time.[29] Its soulful people have been left behind in the material world. They have lost many of the old ways that sustained them over the five hundred years after the Spanish Conquest and through one exploitive government after another. But none of their losses have been compensated by inclusion into the modern world. Agriculture, the region's mainstay, has especially suffered with the loss of the indigenous lands. The immediate future will likely worsen with an even more disastrous reduction of their farm revenues from the flow of cheap, subsidized produce and meat products from the United States because of NAFTA, the North American Free Trade Agreement. However, one of the ancestral ways that still persist in the Mixteca is the production of popular ceramics; the Mixteca has been involved with the making of pottery for centuries. Indeed, many of the great funerary urns that can be seen today in the Regional Museum in Santo Domingo were created by the Mixtecos for their ritual practices and domestic use before the Spaniards arrived. The Mixteca also supported an age-old palm tradition. But the palm craft, mostly the making of *sombreros*, has long been in dire crisis.

At the end of the last century, a Oaxacan artist, José Luis García—a somewhat established painter, more or less in the famed Oaxaca Style, with some international experience, some awards for his paintings, and a sound collector base—decided that he wanted to "give back" to his pueblo.[30] He admits to having been influenced by Toledo in this desire but says the urgency was compounded by the fact that his mother was dying of cancer and he felt he needed to be nearer to Huahuapan de

León, his hometown in the Mixteca. Saddened by the social and eco-
nomic disaster of the Mixteca, García initially joined forces with a friend,
Claudio Jerónimo, and concocted an idea. They decided to rescue a num-
ber of women from their impoverished situations and to try to create a
new kind of subsistence economy, based on the craft of pottery. The
two men were determined to help the women help themselves in the
long term by working with an ancient craft and advancing it into a new
stage. García and Jerónimo decided to help them cross the border—not
from Mexico to the United States, but from artisanry to art.

García became the prime mover of the project, called Polvo de Agua.
He calculated the cost of training twelve women—the expenses of feed-
ing, housing, and teaching them during an intensive training period. The
cost amounted to $40,000. Next, he had to figure out how to come up
with the money. After he made his first forays into fundraising with the
government, it was evident that he would get no support from the state
of Oaxaca. He was told, bureaucratically, that the minimal, existing sup-
port for the crafts was only for the traditional crafts. There was a com-
plete rejection of funding any deviation from the most strict disciplinary
barriers and most traditional practices of artisanry. Any desire to use the
artisanry as an experiment for the future could not qualify for state fund-
ing on any but the most minuscule scale. Rules had to be followed! And
so, García figured out that he would have to fund Polvo de Agua him-
self. He thus went to Mexico City, where he painted furiously for a year.
Still supporting his family—a wife and two children—he had to earn
somewhat more than the budget for the project. After working that whole
year and selling his paintings successfully, he still found himself $15,000
short. He made a date to meet with the Oaxacan philanthropist Alfredo
Harp Helú, who bought a very large painting. Harp is not technically an
art collector, buying very little art for his own pleasure or for the deco-
ration of his house. But he does buy art to help support causes he believes
in. Generally, he then gives the art away to his friends for presents, hav-

ing decided that this was better than sending the normal appliances and imported objects for birthdays, weddings, and Christmas. After visiting with García and hearing his plan, Harp was convinced that the artist was on to something positive. Nothing appealed to Harp more than a project that would encourage independence and had sustainability. He thus purchased the remaining art to fill the gap in García's projected budget. This vote of confidence was just the push García needed, and went back to the Mixteca to recruit his women.

García recruited and trained the twelve women. After their initial period of intense study, they returned to their own towns. They had learned about artisanry, about classic forms, and even about how these forms had become dulled and repetitive over time. They understood that crafts had survived over the centuries, and even in recent times, by adapting to different societal needs. They began to grasp that their traditional rustic pots and cauldrons had become much less necessary in the modern kitchens of the travelers who would be their customers, and they began to develop other, more aesthetic and decorative pots. Thus they learned that they could go beyond mere repetition and even beyond fineness of execution. They learned that they could do original work. And so twelve women moved from barely being acquainted with the world of ceramics into the world of ideas and into the universe of "fine art."

Through García, the women were exposed to ideas about being in touch with what moved them individually, with their own emotions, and about how that could lead to creativity. They began, slowly but inexorably, to think of themselves as artists. García's message at the end of their training was twofold: after returning home, they would have the obligation (1) to train other women in this new way of thinking; and (2) to supply an upscale market with art and crafts that would be for sale at very high prices. Instead of the $5–$30 paid for a pot from the region, theirs would sell for an unbelievable $500–$700 each.

For the palm makers, also trained by José Luis, the message was that

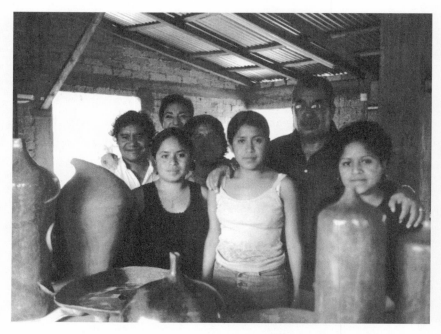

Polvo de Agua women pottery artists, with pots and José Luis García (left) (Courtesy Maffalda Budib)

no more *sombreros* or woven *petates* should be made, since these traditional products were being supplanted by plastic. Instead, the palm makers were taught to imagine the creation of contemporary screens and lampshades and lamps and baskets in new forms and to investigate still other ways of using palm previously unexplored in the state. García's apprentices learned to weave original rugs, make stylish lampshades, and experiment with natural dyes. Their expectations are to earn a living wage as their products, like the ceramics, enter into upper-class homes.

This was a tall order, but after the women returned to their pueblos, and once it was clear who would remain in the project and who would not, they began making the pots and palms themselves—without García's constant guidance and oversight. Made directly from the earth of the

Polvo de Agua,
palm lamp
(Courtesy Fred
Croton)

Mixteca, the pots being shaped and burnished laboriously in the work-
shops have many subtle and brilliant colors. Browns and reds and blues
and even purples meander through any single piece. They all have a shine
that can easily be mistaken for a glaze. But instead of being glazed, they
are built up without a wheel, dried, and only then burnished with a piece
of quartz until the jewel-like sheen emerges. They are subsequently
baked, and they emerge with a range of surprising and beautiful hues.
Their shapes surprise as well. The artisan-artists have been encouraged to
create what comes from within them. The pieces bulge, twist, and strain
with emotion; and yet they emerge somehow resolved. They are sensual

and of the earth, and they are emotionally full and complex, but they are also elegant—even if they do not look like anything that might have been described as elegant before.

Discipline reigns in these local workshops. The women know that they are required to destroy what doesn't succeed: anything that is too clumsy or too fragile; anything damaged in form or color. They work in clearly articulated and tightly managed teams: one woman is in charge of getting the clay; one is in charge of the shapes; another is in charge of the color; and another is in charge of quality control. The hierarchy comes out of the work itself (never from José Luis); therefore, a daughter who has a talent for color might supervise her mother in that area of the production. The old hierarchy of the village does not necessarily obtain. The atmosphere in the workshops is also a surprise. Dignity and joy and constant labor and conversation prevail. The life of the pueblo continues its natural rhythms, with children hanging around the workshops and the women discussing other aspects of their lives. A palpable optimism and overriding dignity prevails.

Soon after the project had consolidated, Amelia Lara, then the director of the Santo Domingo Cultural Center, learned of it and made the difficult six-hour round trip to Huahuapan de León. She was impressed and immediately offered the women a show at the center. Unlike normal exhibitions at Santo Domingo—which, like art exhibitions throughout the museum world, are noncommercial—this one included arrangements that these pieces could be sold. Polvo de Agua was becoming increasingly sophisticated about marketing, and García created some dazzling posters that helped attract visitors, among them collectors. Harp bought hundreds of pieces over time, again not for himself but as gifts to promote the project. The artists themselves were also invited to come to the opening, and these women, most of whom had never been to Oaxaca City, had the opportunity to visit the regional museum in the Santo Domingo Cultural Center. There they saw the many examples of the work

of their ancestors—the funerary urns and the pottery made fifteen hundred years ago, before the arrival of the Spaniards. García talked about their visit to the museum and the women's spontaneous critiques of the pieces on exhibit. "The form of this one was not complete—not harmonious; there was no sheen on the pot over there; there is a mistake in modeling in that display case; this one should have been destroyed; this one is right." By the time of the exhibition in Oaxaca, these women were not only artists; they had become connoisseurs! The other connoisseurs who came to the exhibition, the collectors, were thrilled with the work made by the women of Polvo de Agua and unhesitatingly paid the unprecedentedly high prices demanded.

Soon, the ceramics were on display for purchase at the restaurant adjoining the smartest bookstore in Oaxaca. They began to be proudly displayed in the most sophisticated homes in the historical center. After the exhibition in Santo Domingo, García arranged for exposure in select stores in Mexico City. The Museum of Applied Arts in Vienna has purchased a piece, and the National Museum of Anthropology in Mexico City is selling the pottery in its museum store. García now has plans to mount a display at one of the major design exhibitions in Milan. By 2004 he had been invited, with members of Polvo de Agua, to exhibitions in Toulouse and Paris, France.

The palm workers meanwhile have been engaged in other activities, making screens and lamps and supplying the vessels for a project called "Four Passions." In this project, the woven vessels normally made to hold the humble tortilla are transformed into women's accessories. They are reinvested with a meaning that comes from the amazing silks and feathers and semiprecious stones that adorn them. They are new as today but are deeply connected to Mexican ritual or artistic traditions and are the brainchild of Maffalda Budib, once associated with Polvo. "Four Passions" sell in elegant sites in Mexico City for hundreds of dollars.

Still, the women of Polvo de Agua have not yet emerged from extreme

poverty. The costs of the project are enormous and growing; needed are better ovens to produce the pots, more cars to transport the products, and always, the money to make sure that the women have a base salary for their work. García has allowed himself five years to get the project on a stable financial basis. After that, he has other things he wants to do with his life. This was a social effort to create other artists; to lift people out of a desperate situation; and to help them see the possibility of dignified, creative, large lives in the middle of the dissolution of their pueblos through emigration and through government neglect and betrayal. With Polvo de Agua, artisanry in Oaxaca has made a most unusual foray into the art world. The creative management of the memory of ancient crafts in the region has been an inspiration: these women in Mixteca are imagining and negotiating a changed world. Whether this transition will mean more wealth for them still remains to be seen. But their pride in their ability to create and to run a business based on their own creativity, on the pleasure of action rather than hopeless passivity, will not soon be taken away from them. Perhaps more women, women like Rosvelia Ramirez, will be able to stay home and will not have to clean someone else's house or care for someone else's children in order to survive. By January 19, 2002, 154 women were scattered in eight of García's pueblos. And they were working at home in the Mixteca, not in Los Angeles. As Rosvelia counters to her friends' criticism: "My friends think I am wasting my time, but I believe my future is here."

It would be a shame if Rosvelia's belief in her future was misplaced. Oaxaca, that special place where the collective energy and well-being intertwine with individual acts of imagination and generosity to create civic miracles, generated Polvo de Agua. Could these little groups of women scattered over the Mixteca be the beginning of a new constellation of craft villages like those nearer the capital? Could they function as new models of economic self-reliance based on artisanry and art? If so, José Luis García's vision will have yielded a variety of fruit that is, at

present, unpredictable in its final shape but delicious in its anticipation. If his project is successful and sustainable, the Mixteca will enter to the history of successful craft ventures in the state of Oaxaca in its own way—related to the larger artisanal story represented by the other pottery villages, the wood-carving villages, and of course, Arnulfo Mendoza and Teotitlán del Valle.

6

The Past as Sustainable Resource
Archaeology in Oaxaca

Every chapter in this book is a case study or is composed of several case studies that highlight and examine how Oaxaca has dealt with its present while taking into account its special past in order to gain a better idea of its future. But to say "Oaxaca" in this sense is to use a collective, generalizing abstraction. When there is change in Oaxaca, it can always be traced to a specific person, a leader, or a small group of inspired people who latch on to and elaborate upon an idea to make the desired change possible. When the government is involved, it is often in an unusual partnership—or as an enabler to the creative idea generated by an individual. Often, changes happen in spite of the government (even when government is a major player itself).

Such is the case with archaeology in Oaxaca. This chapter focuses on Monte Albán, one of the preeminent archaeological sites in all of Mexico; on the Institute of Anthropology and History (INAH), in charge of all national archaeological sites; and on Nelly Robles García, the head of

archaeology for Monte Albán and an INAH archaeologist. Together, Robles and the government have reshaped the nature of the nation's archaeological management at Monte Albán. They took on a pilot project in Oaxaca, in order to test a new vision.[1] The fact that this vision for the management of Oaxaca's archaeology has had so much success and been so respected is due to Robles's steadfastness, her humanity, and her creativity in the face of a very difficult responsibility: the heavy burden of being the guardian of one of the prime examples of Mexico's unique archaeological patrimony while addressing the demands of its local citizens, whose needs for homes of their own would have them encroach on and destroy that patrimony in the process of fulfilling their hearts' desire.

Archaeological excavations began in earnest in Mexico in the nineteenth century. After independence from Spain had been achieved, these excavations became an essential element of the growing urge to protect, to study, and ultimately to define the cultural patrimony and the national personality as distinct from the European model. The National Museum of Anthropology—home of the most stupendous collection of pre-Columbian sculpture in Mexico and one of the most overpowering archaeological museums anywhere—evolved into a world-renowned center for the display, investigation, and narrativization of the pre-Columbian past. Throughout the twentieth century, archaeology and that museum, under the aegis of INAH, took on the role of constructing the Mexican imaginary, of its collective roots as planted in the glories of the vanished pre-Columbian past. As excavations of that immensely rich and complex heritage gained in relevance, the preservation and interpretation of the colonial and postcolonial cultures, even up to the twenty-first century, remained a significant and contentious part of the debate. Thus, delimiting the personality of modern Mexico has never been easy, since this personality involves the complex rhetoric surrounding the value and weight of its component civilizations—the European and the pre-

Columbian—as well as the uneven and shifting admixtures of those two cultures in most of the population.

Oaxaca City is one of the most attractive repositories of the Spanish Colonial heritage. It is one of the treasured world cities recognized by UNESCO for its universal value and its significance for humanity. The care that is lavished on its historical center has attracted tourists from all over the world, and INAH regularly spends untold amounts of money protecting it from the ravages of the environment, from deterioration, and from the damage caused by the seemingly innumerable and frequently devastating earthquakes that plague the region. The *zócalo*, the city center, is a lively gathering place that transports the visitor into another time: the environment is conducive to the spirit of *paseos* and long conversation and slow eating. The site of the city's cathedral and many government buildings—as well as restaurants, art galleries, gardenia sellers, and balloon-wielding children—the *zócalo* is at the heart of Oaxaca's identity. INAH is attentive to its needs; for example, after the earthquake damaged the cathedral in the early 1990s, INAH began extensive repairs. Another treasure of the colonial heritage is the former convent of Santo Domingo, which was one of the recent recipients of government largesse enhanced by an unconventional private-public partnership. Although conserving and restoring every one of the colonial churches in the city and in the surrounding areas of Oaxaca would be impossible, the national government, in the form of INAH, makes every effort to respond, given budget and staff limitations. The hope is that as society becomes more responsive to its cultural patrimony, more private-public partnerships will emerge.

Monte Albán is one of the most significant of Mexico's pre-Columbian monuments. This monument, situated very close to the capital city, is also one of the chief treasures of Oaxaca State. Ease of access makes it an extremely popular tourist destination and also a constant subject of scholarly study. Dr. Nelly Robles-García, head of the Department of the Arqueological Zone of Monte Albán, has long played a vital and imaginative

role in managing the excavation, preservation, interpretation, and politicization that characterize this site. That Robles survived the change in government in 2000 when so many of her colleagues in the world of art and culture did not, and that she could say, even as late as 2003, that "little has changed" for her department, is testament to the fact that she and her office had already anticipated the revolution in political values and that she and her team had adapted early. By comparison, many others in the arts fervently believed that their concerns were going unheeded or that the needs of the cultural world they represented were being badly misinterpreted.[2] Yet Robles and her department were fully prepared to transition comfortably into the next stage of management of Monte Albán. Robles, then, was in the forefront of the transition from a totally state-directed and self-perpetuating environment, characteristic of the PRI and INAH and all of the country's other archaeological sites, to a more entrepreneurial and holistic mode of management ideologically more consistent with the victorious PAN. The shift occurred very early in Oaxaca; Monte Albán, the pilot project, was initiated well before July 2000 and was still considered a "pilot" five years after its initiation.

Monte Albán is an archaeological site that is familiar to every Mexican but that might not be as familiar to those outside the country. The main ceremonial, political, and economic center of the pre-Hispanic peoples who lived in the region, it was populated and inhabited for about twelve hundred years. It existed as a political entity, but in different forms and with different populations, from its origins in 500 BC until its decline in AD 800. The culture of this empire differed from that of the Aztecs or the Maya or the Purepechas, other well-known pre-Columbian empires. Its citizens spoke their own languages, had their own brand of architecture, created their own societal organization, and developed their own imagery and communications. The Mesoamerican, pre-Columbian cultures in this part of the world were indeed part of a single civilization,[3] but that made their individual empires no more alike than those that were part of Western civilization. Monte Albán, part of the Zapotec empire within Meso-

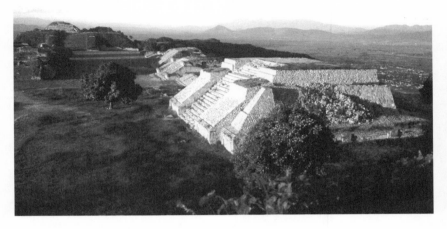

Monte Albán (Courtesy Manuel Jiménez)

america, flourished and then mysteriously disappeared, as did other Mesoamerican empires. It went through distinct phases that are constantly being investigated; and its material remains—buildings, ceramics, human, and jewelry—allow for an ongoing refinement of Oaxacan pre-Columbian history. Although it was a ceremonial center at its height, thousands of homes and also the priestly pyramids were built there. Visiting Monte Albán is one of the thrilling experiences in all of historical imagining, and seeing it on the ground is surpassed only by viewing it from the air. The site is perfectly maintained; trained guides are always available for touring; and vendors are kept to a minimum. The harmony of the natural and the built environment, the recollection of power, and the poetry of what remains are all reminders that absolute governmental control was not always as destructive of its immediate surroundings as it has been in the modern world. By seeming to materialize from the surrounding hills, and by having survived long beyond their obvious utility, the ruins pronounce themselves to be more dominant and certainly more eternal than today's skyscrapers and towers, which planned obso-

lescence, poor craftsmanship, and/or attack have made vulnerable and temporary.

Robles arrived at her position as director after a long stint in the archaeological trenches, having spent a decade working in nearby Mitla beginning in the 1980s. At Mitla (the origin of official archaeology in Mexico), Robles was involved early in her career with her core interest: the actual conservation of the sites. Mitla flourished in the latter days of Monte Albán, even into the Spanish Conquest of Mexico. The brutality of the imposition of the Spanish culture is still visceral in Mitla, where the Catholic Church is literally seated on the still-visible ruins of the pre-Columbian temple. As all archaeologists must, Robles got a sharp taste of working with an extremely tendentious indigenous population.[4] This population was one of the early casualties of the popularization of archaeology as its old ways of living were swallowed up by the dreams of economic prosperity resulting from the ancillary activities surrounding the development of the site as a "tourist destination." Sensing and living the advent of archaeological tourism, the population slowly gave up its sustainable agricultural base and moved toward the occupation of vending. Even their own craft-production base was decimated as the vendors took to selling objects that look Oaxacan but are imported from other regions and even other countries than Mexico.

Nevertheless, even after giving up its agricultural base, Mitla remained obsessed with protecting its perceived rights to the land. It is, according to Robles, a population that has retained its feelings of victimization and anger toward the larger authorities (the operative word here is *authorities*, which goes beyond INAH and its officials into the larger field of indigenous resistance throughout Mexico) over five centuries. In Mitla, the claims and the organization of the people differ somewhat from those Robles would later witness in Monte Albán, but the anger toward and suspicion of the authorities were similar.

Indigenous memory, whether in Mitla or in Montalbán, has not been eradicated. It erupts in occasional low-grade wars against the authorities,

with extremely poor, marginalized, and disenfranchised people laying claim to what they understand to be their land and its products—in this case, the archaeological site itself and the objects found within.[5] These local urban claims often collide with academic ideas about the preservation of the site and the objects within it. And the claims are also usually coincident with a genuine need for services, for housing, and for jobs.

At the time that Robles was in Mitla, Carlos Salinas de Gotari, then president of Mexico, had just dissolved the *ejido* system. The *ejido* system, a manifestation of the 1910 Mexican Revolution, had allowed for the distribution of unused private land to the landless, but in communal properties. As compensation for the dissolution of this system, each of the residents received portions of these *ejido* lands for themselves. These lots often were on archaeological sites. They had no services, but the recipients often wanted to sell them and thus profit from them—even if the properties were supposedly protected for the archaeological patrimony they represented. In this period, the obvious conflicts between patrimony and bread found a perfect time to ferment and to erupt. It was not only the farmers who wanted to sell their lots. The woodcarvers had discovered that there was income to be earned in the painted animal figures they had only recently developed as a craft. In a shortsighted but understandable trend, they began to deforest the copal forests of the region for the sake of their new means of making a living. Since there was no urban plan for managing Oaxaca or its outskirts—either for growth or for preservation—there was also no coherent plan for purchasing the plots from the very people who sought to sell them or for reforesting the copal. Nor was any arrangement made for appropriate zoning for those who bought those lots. Even more problematic, there were enormous gaps in the legislation about the land—about which uses were legal and which were not and about how to protect that land for posterity. Thus Robles, first in Mitla and soon in Monte Albán, learned about the problems of the people and the patrimony, about how intricately they were

intertwined, and about how dismal the situation really was—on both sides of the equation.

By the year 2000, Robles was now in Monte Albán. The problem had become even more devastating for Oaxacan society than it had been during the time that Robles served in Mitla. The destruction of the pastoral buffer around Monte Albán, the ugly modern dwellings that disdained traditional means of construction such as adobe, and other individual-istic interests had all been ruinous. Less than thirty years before, this whole region had been a beautiful place where "the harmony of nature was integrated with communal life, where there was the highest collective spirit"; it had now become a society that "had no idea how to defend the right to a dignified urban life, family and personal life, at the same time as it might defend the collective right to enjoy the universal archeological patrimony . . . and to preserve it for generations to come."[6] Monte Albán is a double tragedy: its many unexcavated sites are continuously being ruined and their knowledge base impacted; and the people, because they are increasingly scattered in their individualized frenzy to find a place to live (and thus less protected by the pueblos and the responsibility they normally take for their members), are not reaping any of the advantages and services of a decent place to live.[7] No one was winning.

Robles worked through the crises and learned to see the many sides of the issues. Her perspective is highly unusual in the panoply of Mexican archaeology. She even admits to not liking archaeologists because of what she sees as their narrowness and overspecialization. Robles explains what happens when a team of archaeologists comes for a summer or a period of time to excavate. She will warn them about the local sensitivities, and they will proceed as if they had never heard her. Problems inevitably erupt as they alienate the locals. And then the archaeologists leave their messes behind and go back to their universities and their museums. Robles, on the other hand, understands that the protesters who live there have

no education, that the idea of protecting the patrimony is a luxury of the educated, and that they have not been prepared for the disruption caused by the archaeologists. When asked why she saw the world differently than did her colleagues, she described her upbringing: she was the daughter of rural schoolteachers who were always involved in the building of a local hospital or a school, who knew they needed to have a larger picture of the environment in which they were working in order to succeed.

Robles has clearly documented all of the problems in managing Monte Albán, including the damage that has already been done to the site, in her doctoral dissertation. Titled *Manejo de los recursos arqueólogicos en Mexico* (*Management of Archaeological Resources in Mexico*), her work was published by CONACULTA, was later translated into English, and became the definitive study in the field: rigorous, insightful, and compassionate on the many challenges facing the management of archaeological resources in Mexico. Using Oaxaca as her case study at the end of the century, she lets no one off easily. One of her targets is extravagant tourism. Robles faults the government for encouraging an elevated degree of tourism. She describes the rush to welcome the thousands of people who came to watch the solar eclipse in the ruins, as well as the other thousands who visited the spectacular sound and light shows put on by the government. She is angered by their destruction, their inexcusable carelessness, and the cumulative damage from traffic and congestion. One of Robles's goals is that tourism be controlled as a respectful activity rather than being allowed in an uncontrolled rush for entertainment at the expense of the region. She also worries about the government's rush to excavate and to rebuild the ruins spectacularly instead of slowly and thoughtfully. Robles is also concerned about the merchants and peddlers that crowd the sites and cause damage of their own to the monuments. And she complains that the INAH, of which she is an official part, is perceived as an oppressive institution while it tries—sometimes naively, sometimes calculatedly—to protect the monuments against all of these and other communitarian

competing claims. Nor does Robles excuse the land-rich aristocracy of the region: she recounts the exploitations by the rich and the old families of the areas adjacent to the sights and accuses its members of indifference to all but their own profit and well-being.

Yet Robles knows full well that the federal policies that she must enforce are based on Mexico's long-established plans to exploit the major archaeological sites "for the nation," for their subsequent development in the name of providing the public access to education, and for entertainment. There is no naivety on her part. She is aware that tourism is an irreversible phenomenon in the globalized world, and she has no desire to squelch it. But she understands her local politics too, and she struggles to reconcile the integrity of archaeology as a discipline with academic idealism, communities' demands, tourism, and a wide variety of social problems. Her grasp on all of the relevant issues and her insistence that new, participatory solutions to millennium-old problems must be based on education represents a call to action that cannot and is not being ignored. Of course, a call to action is only a starting point. Amazingly, Robles's writings were published and translated well before the 2000 election and the defeat of her bosses, the PRI. Her description and analysis of the problems and her willingness to deal openly with their policies suggest a wisdom and bravery that have served her well in defending the site for which she is responsible.

Robles was the first archaeological site director to have been trained in cultural management, along with receiving the requisite education in her academic discipline. Her unusual dual preparation allowed her to be a leader in the new ideas about Mexican archaeology—ideas that gained in credibility during the Zedillo regime. She became responsible for an experiment in management, one that is remarkable for the decentralization it allowed in a highly centralized government. The plan was based on an agreement that 30 percent of the ticket revenues would revert to the site that had generated those revenues—in this case, back to Monte

Albán. The money could be used for maintenance at the discretion of the director and would relieve her of having to wait for the central government and its normal budget cycle. The policy allowed her to manage her own funds and chipped away at the extreme centralization of the agency. Obviously, this pilot program did coincide with the thinking of the newly elected PAN government, where such entrepreneurial and decentralized efforts are applauded, are key to the rhetoric, and are, at least in principle, encouraged.

After the elections, Robles promised to make her site as profitable as possible so that it could reap the advantages she was fighting so hard to secure. As a result, Monte Albán, with one-quarter the visitors of Teotihuacán outside of Mexico City and one-half the visitors of Chichén Itzá near Cancún, received over three times the budget of the former and six times the budget of the latter for research and maintenance.[8] (Robles notes that all of the governors and "big shots" of the various states want to be admitted free but that she makes everyone pay; each free ticket is, for her, lost revenue!). At the same time, Robles perseveres in her reluctance to completely mercantalize the sites, and this principled stand nuances all of her decision-making. Her job is a formidable one—not only because of the fragility of such an ancient site but also because of the enormous demands of the society in which the monuments are located. Thus, just about any move made by Robles's department will be scrutinized by the often opposing attitudes and efforts, the productivity projects or the politics, that pervade the region. Since these attitudes, efforts, projects, and politics may not align with the preservation and research projects of Monte Albán and Mitla, Robles is in a constant state of struggle. But, above all, she always keeps in mind that only 10 percent of the site has been excavated, that it is constantly yielding new information about the social, economic, and political life of this ancient city, and that it must not be taken over in such a way as to render it useless for future investigation.

That Robles's pilot project has continued for more than five years is testament to two things. First, no matter how successful the pilot may be, the government does not want to make this a national policy and give up the 100 percent control it has in the other archaeological sites. In other words, this is no longer a pilot but is, rather, a separate Oaxacan phenomenon. Second, there may not be anyone at the other sites who is capable of using the approach taken by Robles. In other words, Robles insists on an interdisciplinary methodology, one that is not only about the specialty of archaeology but also about the reality of the community in which the monument lives. She insists on much more than excavation skills in her staff; she works for the education of the public. Monuments must be preserved and also restored; the archaeology must, therefore, live and breathe in a complex environment. There are probably not many other archaeologists who would wish to or even could undertake this approach successfully.

One of Robles's favorite community projects is one with which she hopes to educate the next generation of citizens about the preservation of the patrimony. The Children Volunteer Custodians program of Monte Albán swings into action during the spring vacation period. This is the season when Monte Albán attracts up to fifty thousand visitors, a number that stresses the ancient monument and will harm it profoundly over both the short run and the long term if the visitations are not in some way controlled. But how can control be exerted without appearing like a police state, something the newly democratized Mexico is loath to do? Of course, there are the standard adult guards for the tourists' protection, as well as Transit Police and medical help when necessary, but the solution turned out to be to bring the children into the effort. Working with Teresa Morales and Cuauhtémoc Camarena of the communitarian museum movement, children are trained to understand the importance of respecting the monument, the disrespectfulness of strewing garbage everywhere, and the dangers of entering restricted zones or of desecrat-

ing the monument in any way. The success of this program is due to the expectation that adults will listen when children point out what they are doing wrong—that they will even be shamed and will thus become sensitized. Since the majority of the children that participate in this program come from the local pueblos, many of whom have not had the luxury of contemplating the importance of the patrimony before, this creative way of bringing their heritage to their attention is for the good of all.

At the same time, indigenous peoples still place intractable demands on the larger society, demands that cannot be easily solved by outreach programs such as these. The demands of indigenous society in Oaxacan, especially with respect to Monte Albán, are both similar to and different from the demands emerging from the urban population in the historical city center. They are similar in that both populations are fighting the history of overweening authority of or neglect by government. In the historical center, civil society was trying to preserve an ex-convent from devolving into a convention center, to prevent a fast-food restaurant from destroying the colonial atmosphere of the Zócalo, and to protect native species from extinction and cultural irrelevance. Leaders in the historical center mostly followed the model of Francisco Toledo, who worked toward the achievement of certain goals in which the dominant society could be persuaded to have an ongoing and committed interest and which might even have a possibility of gaining national and international support. Those demands generally were characterized by dialogue or court cases or open hearings and were often supported by the press as well. The demands of indigenous society in Monte Albán, also fighting what they believed to be the overweening neglect by and authority of the government, manifested itself in what Robles calls tumultos—where unrelated and anonymous civilians, without apparent leaders, would resist some specific aspect of the archaeologists' work.[9] In these demonstrations, the archaeologists would be blocked from the site, mocked, shouted at, and threatened (sometimes violently). Another common tac-

tic involved passive resistance: the participants would talk only in the indigenous languages (even if they also know Spanish) so that the archaeologists would not know what was going on (this is more common in Mitla, where indigenous language is better preserved than in Monte Albán). Other passive resistance tactics were to keep archaeologists waiting interminably, to not keep appointments, to tell contradictory stories, and after hours of negotiation, to refuse to sign the agreement that has been reached. The goal of all of these tumults was to discourage the archaeologists from pursuing their projects of documentation, excavation, and preservation (or appropriation) of the archaeology. According to Robles, there are several issues that the indigenous pueblos are resisting: the entry of the authorities into what they see as their own spheres of power; the actions of the federal government (INAH) with respect to land issues; the entry of individuals and groups into matters of conservation or destruction of the patrimony; and the defense of their rights to decide how the land should be used—a defense that flies in the face of what the archaeologists consider necessary for the integrity of the sites.[10] Understanding the justice of their five-hundred-year-old complaint is one thing and the preservation of the cultural patrimony quite another. Robles constantly struggles with these competing complaints. She recognizes that there are legitimate and illegitimate claims—sacred and profane, economic and political—on the land and its resources.

Robles has called again and again for more education. But she doesn't just wait for the government to come to her aid. She educates the community directly through her Children Volunteer Custodians program. She also educates site visitors by constantly updating the site museum, where spectacular original objects from the excavations are preserved and where a context is provided for the visitor through specific information: site maps, models, and labels. And Robles promotes education at the academic level as well. Her series of round-table discussions dedicated to Monte Albán bring experts from all over the academic world to discuss

the problems and opportunities presented by the site. Publications are produced afterward, and the roundtables are covered by all of the national and local media.[11] In addition to the experts, the local director of INAH comes to the round tables to offer support, as does the director of the Instituto Oaxaqueño de las Culturas and other cultural figures and politicians of note. These intellectual explorations are both purely academic and may have practical implications—a means of discovering the innovative thinking that might emerge as scholars come together to share and analyze their research. The round table held in 2000 was particularly timely, since it concentrated on the dangers caused by the populations surrounding Monte Albán and documented the communities' growing lack of interest in maintaining any distance whatsoever from the archaeological zone. Robles stated that even though it was important for the federal government to be engaged with the problem, the state and the municipalities had to be involved as well. It was a problem not just for government, she insisted, but for civil society. The problems of flight from the agricultural fields into the zone itself, of extreme poverty, and of the illegal sales of once-communal lands were all part of a larger issue that, she believed, required academics' help to bring society closer to resolution or, at least, understanding. The round table of 2000 dealt with a range of issues: the diversified strategies that are needed for the protection of the monuments and their associated treasures; the dimension of the problem in Oaxaca; and the question of the patrimony in the face of modernity. The result was the creation of the Commission for the Rescue of Monte Albán. This was to be an interinstitutional organization that would try to find effective means of collaborating on the rescue mission. Robles, in an uncharacteristically harsh comment about the indigenous incursions, said: "The cultural value of Monte Albán is alien to those groups. It has been difficult to integrate them into the conservation of the site."[12] That has not, however, stopped her from trying or from also noting: "In the Colonial times there was an effort to eradicate

the indigenous cultures, and they suffered degradation and negation, but here they are, present, alive, after all of these centuries."[13]

The third round table, in 2002, looked into ancient, pre-Columbian political structures and systems. The discussions were characterized by an ongoing respect for the persistence of indigenous memory and for the understanding that the indigenous cultures did not disappear and continue to have relevance in modern-day Mexico. The specialists at the round table posited that both colonial structures and precolonial systems might have a continuing impact on local struggles. The third round table was held very soon after a tragic massacre in which twenty-six Oaxacans from one mountain town were killed by citizens from another town. Occurring in the mountains of Oaxaca, far from the historical center, the massacre touched the whole state. An unending flow of accusations, ranging from criticism of the government to criticism of the communities, ensued. The first criticism suggested that it was to the benefit of the government to encourage local feuds and thereby demonstrate the pueblos' inability to govern themselves. In the second criticism, the communities were accused of continuing ancient feuds that had preceded the Spanish. In addition, every explanation between these two poles was offered to try to understand the horrible incident.[14] The round table provided a rational structure in which to discuss some of those ideas and many more as well. Notably, the head of INAH, Sergio Arroyo, insisted that the government was interested in confronting the present with the past by means of these academic inquiries. Arroyo said: "We want an archaeology and an anthropology that always includes the present as a part of its horizon. And these roundtables constitute the possibility of tying the ancient past of Mexico to the concrete problems we have today."[15]

Robles remains an archaeologist, despite all of her concern about the limitations of the profession. In her book and in her professional life, she repeatedly calls for more in-depth, advanced, and complex training for those professionals responsible for these sites: for training in the archae-

ological disciplines; for training in community awareness; for humanistic training so as to be better able to deal with the people from the communities; for training in management of financial resources; and for enhanced awareness of how such problems are dealt with in other parts of the world. She has plans for INAH people who work in her area to be educated for the long view. Robles's ambitions to enhance the capabilities of archaeologists extend beyond Oaxaca to all of Mexico and Central America as well. She has set up courses to train archaeologists in the management of documentation, pointing out that after the 1999 earthquake in Oaxaca, she was immeasurably aided by having access to the archives that had been kept by archaeologists dating back to 1931. She intends to teach others how to learn from the archaeological past so as to deal better with the recurring problems of the present. As a result of her indefatigable efforts, in September 2002 Robles received the first grant to Mexico explicitly for the preservation of the cultural heritage (and the largest grant of the year), from the Department of State of the United States. The grant was aimed at the establishment of a research institute for managing archaeological zones. The institute will be located in the Santo Domingo Cultural Center, and the grant will allow the creation of the institute's infrastructure. The Japanese government also recently made a grant, to benefit the world patrimonies of Monte Albán, Palenque, and Teotihuacán, as has the European Union. The money has been spent for many of the infrastructural needs Robles identified, including elevators for the handicapped, humidity-control equipment, and a geographic information system.

The passion for the integrity of Monte Albán is shared by other members of society. For example, the concern for the incursion of the "urban stain" on Monte Albán prompted, in September 2002, the beginning of the encircling of the archaeological zone with 26 kilometers of cyclone fencing. The whole area to be encircled is over 2,000 hectares, larger than any other of the nation's archaeological monuments' circumferences. This

action was taken by the civil society in Oaxaca City in response to those from the villages who want to settle on or exploit the archaeological site. Members of professional associations (including the Association of Businessmen of Oaxaca), service and social clubs, some elements of the state and federal governments (including PROOAX), and other groups (such as the College of Architects) pooled 3 million pesos ($300,000) to erect this fence—which, along with enhanced security stations, is expected to respect both private property and the archaeological zone.[16]

It is notable that this fencing project is not sponsored by INAH but rather by the Secretary of Urban Development, Communications, and Public Works. According to Robles, INAH, in its desire to be politically correct and ecologically sound, proposed a "green," all-vegetation barrier. But it soon became apparent that goats—ubiquitous and hungry and owned by the local peasantry—would eat the green barrier. Robles talks of coming to some kind of terms with the communities, who were not in the least interested in the concerns of the archaeologists or PROOAX or the College of Architects or the Association of Businessmen. The communities were interested in services for their pueblos, services that had for so long been withheld. With Robles's guidance, a deal was struck that the heads of the pueblos would respect the fence and would restrict advancement beyond the fence if the services were provided. Nelly Robles works for the win/win solutions.

Robles has noted that many of her colleagues question and criticize what she is doing, saying that she is putting the cart before the horse. They tell her that the social problems need to be fixed first and that only then can the patrimony be dealt with within the communities. She knows, though, that there are hurts and wounds that will never be healed in Oaxaca. There are divisions in indigenous society that precede the arrival of the Spaniards. She knows, sadly, that one cannot wait for reconciliation to occur before trying to save the country's irreplaceable cultural heritage. Robles believes that Oaxaca is a special place and that

it should not be treated the same as other sites. Indeed, even INAH describes Oaxaca differently than it does the archaeological context of other states. For example, in the INAH history published in 1995, Oaxaca is the only state for which the demands of civil society are considered to be of the highest order. Oaxaca's entry in this book is almost entirely devoted to the civil society's demands and requests and INAH's attempts to deal with them.[17] Oaxaca is different and must be treated differently. With the defeat of the PRI and the victory of the PAN, Robles has generated new plans, new means of financing, and alternate ideas for her agency—as INAH now insists must be done in the archaeological sites throughout the country. Her managerial style has evolved to work in the new bureaucracy.[18] Nevertheless, there is no evidence to suggest that her methods will be ubiquitous, since they suck too much power from the government at the center of the nation.

Once again, Oaxaca has generated, fostered, and nurtured a person who has built a unique relationship with the Mexican government and with one of its often intractable bureaucracies. The great precinct of the ancient pre-Hispanic culture, Monte Albán, appears to be in good hands—even as it continues to be threatened on a daily basis by unrelenting demands from its surrounding society. Robles's mission of managing memory and negotiating change—sensitively, creatively, and rigorously—is what Monte Albán needs in order to survive and thrive. The world of Monte Albán is unlike that of Oaxaca City, and its citizens do have different needs. But in both cases, the patrimony needs to be preserved in light of the demands from all sides. With continuing permission from the new government, the management of Monte Albán might become a model and not just a pilot program; it might become a window into the archaeology of tomorrow for other states of Mexico even as it responds to the challenges that beset the country today and, inevitably, in the near future. It might; but then again, it might not if the government persists in resisting change on the most fundamental level.

7

Pueblo Culture: In OaxaCalifornia

Where does Oaxaca begin or end for migrant Indians? Does it begin
or end in the Vicente Guerrero neighborhood in San Quintín Valley,
Northern Baja California. . . . Does it begin or end in the streets of Los
Angeles, California, where during the last six years the Oaxacan Guela-
guetza was performed for an audience of over 2000 people? . . . Does
it begin or end in the fields of San Joaquín Valley in California, where
more than 40,000 Mixtecs work, and every Sunday you can attend the
Mixtec ball game in Madera City . . . ?[1]

Oaxaca is not just a state in southern Mexico. It is also a major exporter
of people, of men and women who constitute an important percentage
of the growing Meso-American population living in the United States
today.[2] Oaxacan migration is not typical of Latino or Hispanic migration;
Oaxacans form their own patterns in this arena, as they do in so many
other aspects of living. Although they may come to the United Sates under

the horrific, alienated conditions that have been described by T. C. Boyle in his classic novel *Tortilla Curtain*, Oaxacans do not normally come to the United States and live a deracinated existence for very long. They are not the lonely and desperate souls without human recourse who could disappear in Topanga Canyon, as Boyle's couple did, coming as they did from a *mestizo* pueblo outside of Mexico City. Although tragic deaths and circumstances are endured by Oaxacans crossing the border, they will usually go to Los Angeles with a plan that will allow for improving both their own lives and the lives of those left behind in their pueblos. They will migrate to what they know is a strong Oaxacan enclave in that city. Strongly traditional Oaxacans will hew to their time-honored conventions, share their living quarters to get started, attend their dance festivals, eat their foods, read their newspaper, and attend a community-based church. Yet even as they take succor in tradition, they will enthusiastically adapt to life in their adopted country and will reinvent themselves to suit changing times.

In general Oaxacans shape themselves to the new/old world much as immigrants have always done in the United States. The major difference seems to be that a greater percentage of them hold on to the idea of returning home to live out their old age in comfort and to be endowed with a higher prestige and status than they had when they left—or, at the very least, to be buried in their pueblo in Mexico. Their hope is that their children and grandchildren will continue to return to Oaxaca and see it as a homeland in the same way they do. Whether or not that actually happens and whether or not the same values will transfer to succeeding generations depend on how deeply their children and grandchildren plant their roots into the earth of OaxaCalifornia.[3] Oaxacans, then, live their lives in the laboratory of globalization as they bravely and consciously struggle to materialize the dream, to avoid its nightmares, and to "have it all."[4]

Every generation in every corner of the world produces people who work desperately to fulfill the most progressive opportunities and aspi-

rations of their own time and who, in the process, unwittingly create their own peculiar set of monsters. Others in that same generation will ignore or deny those aspirations and will, in turn, create monsters of their own. One of the greatest artists of the Spanish past, Francisco Goya, captured the inherent tragedy of this human dilemma in the best-known image in *Los Caprichos*, his most famous book of etchings. A self-portrait reveals the artist sleeping, his head on his arms, slumped on the desk, surrounded by horrifying flying bats and witches in nightmarish profusion. Goya's handwritten text beneath the image reads: "*El sueño de la razón produce monstruos.*" Over the more than two centuries since Goya etched the plate, this apparently simple Spanish sentence has produced its own confusions, having been alternately translated to mean "The sleep of reason breeds monsters" or "The dream of reason breeds monsters." Such opposing meanings are credible because, in Spanish, *sueño* indicates both "sleep" and "dream." It is the mark of Goya's genius that he could divine, even in his own time—during the "age of enlightenment," the historical era that worshiped reason—that both reason's denial (as in "sleeping" through the possibilities it offered for human progress) and its idolization (as in "dreaming" that it could cure all human ills) would breed monsters. In a turn on Goya's insight about the dominant progressive ideal of his own age, today one could substitute the word "globalization" for "reason." Emigration and immigration are the conjoined-twin fellow-travelers of globalization and carry with them the inevitability of the same polarity of meaning for poor but adventurous Mexicans as did "reason" in the eighteenth century. That is, both the excessive belief in globalization and the denial of globalization have bred and are continuing to breed monsters.

Globalization and Emigration

Globalization and emigration have indeed, made a decent life possible for many of Mexico's poorest people—even as they have transformed life

Francisco Goya,
plate 43, *Los
Caprichos*

for those who stayed behind. To trigger the dream is to come to the
United States—legally if possible or, more likely, illegally by enduring the
dangers and trials of crossing the border. That journey to the "other side"
often includes death, exploitation by "coyotes" (those who are paid to
transport people, illegally and dangerously, over the border) and other
criminals, broken families, and threats to personal and communal values.
Risks such as these are most frequently taken in the hopes of bettering
personal and familial financial situations and creating wealthier, if
increasingly abandoned, pueblos. Sometimes, of course, the risks are

taken for the adventure of it all. To grab for the dream from Oaxaca is always dangerous, but on the other hand, to sleep through the dream—that is, to deny the possibilities attendant to the windstorms of globalization and emigration—most likely means to endure poverty (or at least limited expectations) forever at home and to have little or no chance for an economically more fulfilling future.

Although it is debatable whether globalization is as new and positive as its proponents boast or as redundant and destructive as its enemies fear, it undeniably represents both the hope and the horror of our times. The North American Free Trade Agreement (NAFTA, as it is known in the United States) is one of the Western Hemisphere's most obvious manifestations of globalization. Mexico, as a Third World country, signed on to NAFTA with the expectation that the economic well-being of its whole society would rise as jobs flowed into Mexico—that once-destitute populations would be able to work, even if at extremely low wages, and that Mexican consumers would benefit from lower prices. The United States contended that goods and services would be cheaper for Americans too and that business investments south of the border would increase. The result has been mixed. Of course there were more jobs in Mexico, especially when their wages were the lowest in the world. And consumer prices have, by and large, gone down for all. However, it became evident after ten years of NAFTA that the notion of the "lowest wages" is a floating phenomenon. American businesses, having relocated and providing many jobs in Mexico, unceremoniously picked up and left Mexico when other countries—in Asia, for example—signaled their willingness to accept even lower wages for their workers. As the businesses abandoned Mexico, they left many border towns worse off than they were before, with families and values shattered by the massive internal migrations that had followed the hopes for a richer future. The *maquiladores*, as the hastily erected factories came to be called, had appeared in seductively cheap border towns, consumed the local labor force, and rapidly attracted des-

perate would-be workers from the interior of the country. When the workers arrived and settled in, they often overwhelmed the cities' abilities to provide decent urban services. Life in Ciudad Juarez (the worst case), for example, has been a nightmare—with almost three hundred women murdered over several years in a lawless binge that the authorities have seemed unable or unwilling to handle. The *maquiladores* ranged across the long US-Mexico border and rising expectations did set in. Money was made, but often at high costs to the stability of Mexican society, to the environment, and to urban civic structures.

Mexico's agriculture, once the pride of the nation, became the next player in the globalization story, a further feeder into the dream/nightmare cycle of globalization. US subsidies for agriculture are extraordinarily high, and Mexico is unable to provide similar subsidies to its own farmers. By 2002, with the end of restrictions on the importation of US agricultural products into Mexico, the United States began to ratchet up and test its ability to sell its agriculture more and more cheaply to Mexico. Naturally, Mexico began to import US produce. With that importation, which made US fruits and vegetables much cheaper than Mexican produce (the dream for Mexican consumers), Mexican farmers found themselves unable to sell their produce at home and began to abandon untold parcels of farmed land. Having lost their livelihood, more Mexican farmers had to and will have to go to the United States as illegal farm workers (the nightmare); and again, Mexico will lose more of its human resources. Thus, due to NAFTA, Mexico loses not only more of its people and their income and the dignity they had of autonomously farming their own lands but also an integral signifier for Mexican lives. Corn, which had been the central agricultural product and the spiritual symbol of the nation's mythology from pre-Columbian times, has become, as it has been imported from the United States and is being genetically altered, just another food, a commodity. This is not just an economic but

also a cultural loss. Inevitably, Mexican fields will become increasingly irrelevant to the Mexican poor with the influx of multinational farmers moving in to take over the lands. The burgeoning wine industry in Baja California is a case in point. Ironically, at the same time, US agriculture will need more Mexican labor, especially in California, and the long river of migrants over the border will overflow with more desperately poor people. Mexicans will thus continue to provide cheap labor in US cities as well as the fields; US service industries will have all of the low-paid waiters, nannies, and gardeners they need. And the mass migration of Mexicans, internally and externally, will show no sign of diminishing.

The Oaxaca Experience

The Dream

Globalization and the accompanying mass movements of people between Mexico and the United States are not only a recent phenomenon. Oaxaca has long played a big part in this recurring shared dream. The perennial migrations to the north gained force legally and in earnest during the *bracero* days after World War II with a much-anticipated government-to-government program. Now, though, a new twist has been added. In the *bracero* days, many of the migrants returned home—a little richer than before and often with a little capital to make a better life for themselves and their families in Mexico. Now, as poverty has become more and more pervasive throughout Mexico and with no relief in sight, Mexicans, and notably Oaxacans, are fleeing their homes and staying away for good.[5] Globalization and dire poverty have made that hydra-headed solution of migration to the United States even more attractive and certainly more inevitable and certainly more drastic than it had been in the past. Although most Oaxacans do go to California when they leave home looking for work, more and more Mexicans hope to work in other

regions of the country—even the Midwest. And the dream sometimes does pay off—just as the dream of reason sometimes paid off during the Enlightenment.

What happens when the dream does come true for Oaxacans? When the dream came true in the old days, a man and/or a woman left the family for a limited period of time, got a job, sent money home, raised more money for capital, and returned to an intact family, more financially stable than they had been before. The village would have thrived from the civic contributions that he or she had been able to make while away. Ideal migration scenarios were varied: they could be exemplified in Teotitlán del Valle, where a small rug business might be the result of the successful dream. These businesses, at their most successful, might even, years later, become a part of the globalization enterprise—as happened with the subsequent worldwide sales of the rugs of Teotitlán or the black pots of San Bartolo de Coyótopec or the wooden figures of Arrazola.[6] Another recurrent success story springs from the strong ties of obligation in indigenous families. Because of these relationships, huge amounts of money are sent back to Mexico: houses for the families will be built, and they will eat better, clothe themselves better, and provide better for their own health and education. The hope is always that the person who left will return someday and that his or her family will still be intact.

Some positive dream scenarios are more communal than they are personal. Not all of the money goes to the direct support of one's family members. A good percentage goes to the production of traditional fiestas, which might have been shriveled or been discontinued for lack of funds. In the pueblos of Oaxaca, these festivals are increasingly nourished by expatriates who come home annually to support them—more lavishly than they could ever have done before. The emigrants become the heroes who can afford the generous supplies of food, the drink, and the music for the great occasions and celebrations—for the marriages and for the saints' days and even for the newly minted holidays that have emerged and

are patronized by those who left and who come home only for their cel-
ebration.[7] Some of the money sent home also goes to desperately needed,
permanent civic projects: streets are paved; electrification is brought it;
roofs are put on schoolhouses; health centers are constructed; bridges are
built. Almost ten billion dollars a year is sent home: this money, *migradólares*,
composes the second greatest source of external income for Mexico as a
whole, ranking with oil and tourism. Yet the great irony of the Oaxa-
California phenomenon is that "the continuity of the tradition, as oner-
ous as it might be," is more and more in the hands of the migrants rather
than being directed by those who stayed behind.[8]

The sophistication and the implications of this practice of sending
money back to Mexico has grown impressively. Once powerless and
voiceless at home, these migrants are now the principal bearers of the
national wealth. Significantly, they are beginning to be aware of and to
make use of their new power. By the end of 2002, after years of simply
sending money back to Oaxaca without conditions, the president of the
Association of Oaxaqueños in Southern California could be found in
Oaxaca City personally negotiating with the governor of the state for the
new "3x1" policy that the nation was developing. He was insisting that
the associations should have a role in determining the Oaxaca State pol-
icy and that they should receive a guarantee that the money being sent
home to Oaxaca by the associations would be matched, 3x1, and directed
for the betterment of civic life in Oaxaca at the state and municipal lev-
els. Leveraging funds earned away from home for the betterment of Mex-
ico has become one of the most constructive Mexico-US economic proj-
ects in years.[9] (Remarkably, Mexicans had to leave home and go to the
United States to even receive an audience with the governor, let alone
be partners in such a deal!) Ironically, if the current scenario of constant
emigration were to change, this could prove to be an unmitigated
national disaster. Money returning to Mexico has de facto become a com-
munally endorsed tax on emigration (a variation on the *tequio*), to be ded-

icated to the civic needs of towns. Furthermore, the emigrants are now fighting for their right to vote in Mexico; if they receive the right, this will only expand further their influence at home. The bottom line is that once Mexicans are settled in the United States and have the funds and the free time to involve themselves with politics, they are treated far better by Mexican politicians than they were ever treated at home.

As recently as February 19, 2003, the governor of Oaxaca, twenty Mexican legislators representing all of the political parties, and a good number of community leaders came to the University of Southern California to meet with the immigrants there. Governor José Murat of Oaxaca firmly backed the necessity of Mexico to give the immigrants the right to vote, and the general agreement was that these people, composing 15 percent of the Mexican electorate, needed to have their voice heard if the transition to democracy was to be complete.[10] As the emigrants have already figured out, if they were to return to Mexico to live, they would be once again ignored by the same politicians, since they would no longer represent the money that has become so important to the state and municipal budgets. If they are granted the right to vote, the immigrants will have gained a double voice at home: the voice of their money and the voice of their votes. And so, as the Mexican population becomes smaller and smaller in the ever more beautified Oaxacan pueblos, one wonders whether there will be any voices left to command an audience from within them. With the large growth in Mexican political power outside the country, where and to what purpose will that political power be directed—when fewer and fewer people live out their lives in those towns?

The political power that Oaxacans are building for themselves outside of Oaxaca will be formidable—and it will be a key factor in compensating for the voicelessness of those left behind. As a Zapotec writer and activist has written: "The Oaxaqueños [outside of Oaxaca] symbolize Oaxaca Power. . . . They are an emerging culture that is confronting glob-

alization with their naked hands. One must pay attention to the Oaxa-
queños as they may be hatching a new Benito Juárez."[11] This conviction
is shared by Rafaél Fernández de Castro, a Mexico City specialist on US-
Mexican relations: "We're talking about a new, transnational politics. . . .
There is a Mexican nation within the U.S. nation. . . . They could become
a heck of a foreign lobby for Mexico."[12] The suggestion, then, is that this
growing political power *outside* of Mexico will, ultimately, be used in favor
of Mexico as a whole, or regionally, rather than only for the pueblos,
which in so many cases are becoming ghost towns.

But for the Oaxacans, it is not just about money or just about political
influence. The Oaxacan sense of its culture is also very strong. The
migrants who have settled and prospered in OaxaCalifornia and the Oa-
xacans who have been left behind have made conscious efforts to work
together to encourage that culture. The Oaxacans in California are often
behind the scenes in attempts to save artisanry in Oaxaca and are, for
example, members of the Amistad Altruista Internacional, which lends
financial and technical support to the struggling craftsmen in the mar-
ginalized areas of the Oaxacan countryside. They are channeling their
money not only to physical survival but also to enlightened cultural sur-
vival. In a surprising turn, the Fox government began to welcome Oa-
xacan culture in its adapted form in California. The state cultural arm, the
Instituto Oaxaqueño de las Culturas (supported by CONACULTA), has
supported twelve major cultural projects in Oaxaca. The unexpected part
was the invitation to all Oaxacans—those living throughout Mexico and
even those living in Los Angeles—to participate. There was a time when
Mexican migrants to the United States were looked upon with scorn (as
well as with anticipation of the money to be sent home). Vicente Fox
began his term by calling them heroes. Oaxaca entered the forefront,
embracing the ex-patriots, an embrace extravagantly manifested in the
realm of the arts.

The fortitude of these Mexicans, these Oaxacans, as they leave and

come, as they adapt and resist, as they take care of their families, their communities, and themselves, and as they persist in creating a living changing culture of their own in combination with that of the United States, is amazing. Many Oaxacans come to the United States not even speaking Spanish, let alone English (knowing only their native Zapotec or Mixtec languages), but they learn—both Spanish and English—in the most difficult circumstances. Oaxacans generally become stronger and have higher aspirations for themselves for having come to and succeeded in Southern California. Still, it cannot be denied that Mexico as a world nation has grown impoverished in human resources (even as it has grown monetarily richer) due to its loss of these brave and resourceful citizens to the United States. In the United States, Oaxacans renew themselves; they become a more hybridized people even as they hybridize the United States—and especially California.

The Nightmare

Inevitably, the dream of globalization and its twin, migration, has also turned into a nightmare for some Oaxacans. Families are strained as men go away for long periods—some never returning. When wives and children follow, often many years after having been left behind, they sometimes find that the men have created new families in the United States. Money is regularly sent south for food and necessities, but it is sometimes spent frivolously on makeup and costume jewelry once the ubiquitous and peripatetic vendors discover that a town is receiving infusions of cash. Returning migrants can be infuriated to see this kind of "misuse" of their hard-earned funds. New houses do get constructed in Oaxaca, but most of them are hardly ever lived in: the first generation born in the United States will return once a year for the fiestas, but their children, having been born and raised in another, faster world, often find themselves disaffected from pueblo life. Even as the children enjoy the festivities—the lights, processions, singing, bulls, cameras, balloons, fire-

works, dancing, and music, which their parents have joyously paid for—
the next generation does not fit in. They think their Oaxacan relatives feel
they are not really Mexicans. These American-born and/or -bred children
may be the last generation to return regularly to their parents' home
towns, as they become increasingly Americanized and bored with small-
town life. Grandparents who have remained behind note that the chil-
dren born in America are really not happy in their native villages,
although the children will bravely proclaim that they do not want to for-
get their origins.[13] Children left behind are inspired by the visitors and
obsess on the idea of going to "the other side." US tourists to these small
towns can all recount stories of having been stopped by a youngster ask-
ing to be taken back to the United States: the father is there, and the child
misses him so. Only the prospect of decently paid work will retain a crit-
ical mass of people in Oaxaca, and Oaxacans have figured out that even
getting an education in Oaxaca does not necessarily mean receiving well-
paying work afterward: there are many fully trained engineers and even
doctors working as taxi drivers in Mexico.

The double bind is tortuous. Globalization has fostered the dream of
migration; there is money to be earned and money to be sent home. It
has also created a nightmare; there is a country and a homeland to be
lost. On the other hand, the "sleep" of globalization—that is, sleeping
through its reality and opportunities—means living with the monster of
pobreza extrema, dire poverty. And waiting in the hills of Oaxaca offers no
way out. Migration is the only mantra. Some, not really wanting to leave
Mexico but needing work, are seduced by cynical agricultural agents who
come to Oaxaca and take them to San Quintín in Baja California in the
north of Mexico. They are promised decent salaries and decent existences
without having to leave their land. The Oaxacans form a large population
in Baja California, but the reality does not live up to the promise. They
are worked hard for $5 a day, live in horrific conditions, are not always
given their constitutional rights to an education, and are often spurned

by non-Oaxacans. From there, dissatisfied, many go on to California. Radio stations in the San Quintín Valley regularly warn the Oaxacans of the dangers of the crossing, but knowing that the temptation to leave San Quintín can be irresistible, the commentators inevitably go on to provide valuable tips on how to make the crossing and, hopefully, survive.

Yes, Oaxacans have left in droves, choosing not to sleep through the phenomenon of globalization and migration. But they have not done it alone; and they have not done it unconsciously. They count on their powerful culture to help them get through the ordeal. It is the persistence of this culture that has saved them again and again through their migratory history. Being a nomadic people (since pre-Columbian times, they have moved themselves and their livestock enormous distances back and forth across Mexico), they have always been adept at making do in changing places and times. Oaxacans always take their rich culture along with them: their language, their arts, their food, their sports, and their pluck. They have learned to travel across their state and even their country while preserving their collective memory and negotiating the changes required to live. As a result of their abilities both to resist total absorption in the new culture and to adjust as necessary, they have not disappeared as a people and have persistently maintained and even enhanced their local identities. They create, in the most astonishing ways, new communities that mirror the ones they left behind. They celebrate their fiestas in this yet more extreme migration in Southern California, in addition to supporting the fiestas back home in their pueblos. They open Oaxacan restaurants in their new neighborhoods (not everyone can get back for the annual fiesta in Oaxaca and they miss their *moles*). They dance to their favorite bands, pray at their churches, play soccer and the ancestral ball game *pelota mixteca*, make their arts and crafts wherever they live, and always perform their civic duties. The trauma of having had to leave their pueblos is mitigated by creating "mirror" pueblos wherever they land—especially in California, where Oaxacans can best keep their ties to home

tightly bound and where they believe they can keep their families attached to the old ways while also teaching their children the nature of the new opportunities.[14] They are, of course, unevenly successful, but that they have advanced and have often succeeded on their own terms is a miraculous achievement.

Having created their own systems for maintaining cultural meaning in their lives in the United States, Oaxacans go back and forth to Mexico constantly, keeping the airlines, bus lines, and "coyotes" rich—depending on their legal status. Living as both Mexicans and Americans in the United States, they are Mexicanizing, and to some extent also reconquering, the land that was once Mexico's. Much of the success of the Oaxacans in California is due to their strong membership in the Oaxacan associations, where community debts are reiterated and where compliance with the *cargo* and *tequio* obligations supersede the forces of individualism in their new home. El *Oaxaqueño*, the Spanish-language newspaper that is widely distributed in both Oaxaca and California, publishes everything that anyone would need to know in order to survive in both cultures. It is one of the primary instruments for managing memory and negotiating change within the community. And it is a formidable instrument for uniting Oaxacans. The newspaper constantly reminds them of the disappearing pueblos, of the poverty left behind, and of the fact that they are now a part of the globalized community of OaxaCalifornia, where they are a much larger and potentially much more potent part of society but where they still have obligations to the traditional, communal Oaxacan culture.

The Power of Oaxacan Culture

Yanhuitlán

The power of the Oaxacan culture is critical to managing memory and negotiating change. The story of the conservation of a major Oaxacan

monument in the pueblo of Yanhuitlán provides a good example. It demonstrates the growing self-image of Oaxacans in California and how that image was tailored to fit within the cultural power structure of Los Angeles. It also demonstrates the positive response by people in positions of influence in cultural California and the complications that can result when this transitional network is activated.

From the American point of view, this tale is an art world story gone slightly awry. From the Oaxacan point of view, it is a story of civic and religious responsibilities discharged. From the Mexican cultural bureaucracy's point of view (i.e., INAH), this is a story about the hoped-for development (through culture) of a drastically depopulated pueblo. From the point of view of the Getty Conservation Institute, it is about rescuing a piece of high art and about the complications that came after the commitment was made. By all accounts, this is a story about people claiming power over their lives—about Oaxacans who have come north, have maintained and even strengthened their positions in their own communities, and have managed to persuade the most powerful art institution in the United States to come to their aid in Oaxaca itself.

In 1992 or 1993 (it is not exactly clear when), Miguel Angel Corzo, then the director of the Getty Conservation Institute, received a telephone call from a Oaxacan community association. The spokesman asked for an appointment; it was granted, and soon a delegation of three Oaxacans— the president of the association, another representative of the association, and a priest—came to visit the Getty, where they explained their mission and made their request.[15] The Getty had always been perceived as a formidable institution, rather cold and elitist by outsiders. In the early 1990s, it was not yet known for making enormous efforts to bring "diverse" populations into its ken. And so, when the delegation of Oaxacans contacted the Getty, knowing exactly whom to call and where to go in that amorphous, daunting, hierarchical institution, it was clear that, once again, they had a plan. The president of the Association of Oa-

xaqueños was a native of Yanhuitlán, a small town about an hour and a half from Oaxaca City. This gentleman, perhaps because he was fulfilling an important *cargo*, a civic obligation assigned to him by his Yanhuitlán community, went directly to the chief officer of the Getty Conservation Institute, Miguel Angel Corzo. Did he know that Corzo had a mother who had been born in Oaxaca? Or was that only luck? Regardless, the request resonated positively for Corzo. He granted them an appointment, something that many personnel in art institutions throughout the United States could not dream of getting. But Corzo was curious: he wanted to see what the delegation was about.

What the delegation wanted was to obtain the Getty's help in restoring the pueblo's colonial altarpiece, called a *retablo*—one of the finest in all of Mexico. The first thing Corzo did after meeting with the group from Oaxaca was to call the directors of INAH, Mexico's enormous Institute of Anthropology and History. INAH is also the federal government agency that is responsible for archaeology—whether pre-Columbian or colonial in origin. Corzo believed in working in partnerships, and he wanted to be assured that the Mexican government, at the highest level, was committed to the project before he pursued the matter further. After he learned that INAH was a participant and that it would welcome the Getty's involvement, the Getty team went to Yanhuitlán, in 1994, for an exploratory visit. Twenty people, with their expertise and their considerable state-of-the-art equipment, did a site evaluation and together, as a staff, decided that it looked like a promising project. The new partners—INAH, the municipality of Yanhuitlán, the state of Oaxaca, and the Getty Conservation Institute—then met. After much discussion, they came to an agreement in 1996. Soon another partner was admitted: the Friends of Heritage Preservation, a group of wealthy Californians committed to the recognition, preservation, and conservation of artistic and cultural heritage. This would be their first project as a private support group. Thus the partnership set up to restore the *retablo* physically began in 1997. It

proved to be a unique partnership in Mexico, another experiment under-
taken in Oaxaca at its crossroads of past and future.

The *retablo*, the main altar of the Church of Santo Domingo in Yan-
huitlán, had been an extremely important work of art when the painting
was first commissioned. The church itself is overwhelming—a Spanish
colonial structure more imposing than many cathedrals in Spain. It is one
of a string of elaborate and fanciful Dominican churches in this part of
Oaxaca. The immensity and the architectural power of these churches
reveal not only the spiritual aspirations of the conquering powers but also
the wealth of the region soon after colonization. They are evidence of the
Crown's investments in the towns for future growth. Yet the prosperity
and potential that the Yanhuitlán church once represented stands in stark
contrast to the pitiful nature of the town today, emptied of so much of
its population and so many of its possibilities because thousands of its
people have left for the United States. It is hard to believe that this town,
with a current population of 1,600, was once a flourishing pueblo of
more than 30,000 people and functioned as a major urban center. Today
the residents can barely afford to feed themselves; according to munici-
pal authorities, they could never be expected to summon any of the
money necessary for the restoration around the church.

For the citizens of Yanhuitlán, it should be remembered, the church
was a site for prayer and for ritual celebration; it was not thought of as
an artistic or architectural monument. To conceive of the restoration
solely as an artistic project was to misunderstand the forces in the com-
munity. Luciano Cedillo Alvarez, a top government official involved with
the project, explained that the people brought in from the Getty needed
to understand this restoration as part of a much larger endeavor to rede-
velop the region; art would be a single element within this much more
complex effort.[16] Yanhuitlán is a tragic region: it is rich in cultural mem-
ory and in tradition, but its whole population had come to believe that
migration was the only way to improve the pueblo. The young people

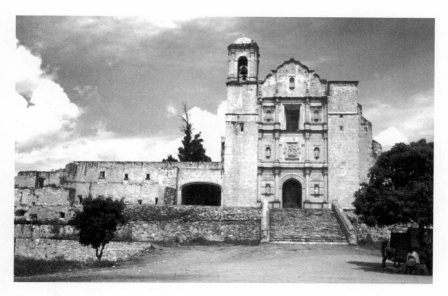

Yanhuitlán church (Courtesy Manuel Jiménez)

looked forward only to going north; the old people had come to accept
that the youths would leave. The project, from INAH's perspective, was
to develop other economic and social possibilities for the population as
well as to restore the altarpiece. Cedillo passionately believes that with-
out real economic development, the idea of cultural patrimony could
only be an abstraction for the population. For INAH, the restoration proj-
ect was, then, an excellent pretext to be in the community. The plan was
to help the community rebuild a viable identity through the cultural
project, which, it was imagined, would translate into a better life in Yan-
huitlán. Workshops were initiated; history was taught and recuperated;
productive projects were developed, offering alternatives to the dying
corn culture that had sustained the pueblo people for centuries. For
example, the Mexican team set up projects to cultivate *hongos* and *nopales*.
Furthermore, for INAH, the project was even more significant because
it figured into the larger national and state plan to revive the Ruta

Dominicana, within which the Yanhuitlán Church of Santo Domingo was a major component. Reviving the Ruta Dominicana was understood as a means to attract more tourism to the area. With the improved condition and attractiveness of all of the churches on the Ruta—which form a circle outside of Oaxaca City—tourists would have a reason, it was thought, to spend at least one extra day in Oaxaca. One more day translates into significant extra revenue for any city: from restaurants, hotels, car rentals, and purchases of local goods and services.

And in Yanhuitlán proper, local municipal officials insisted that everything its citizens undertook in the arena of culture had to be justified by an ability to enhance life in the pueblo. The municipality was busy working with INAH: organizing workshops for the improvement of artisanry as a revenue-producing activity; establishing special classes teaching new, marketable skills; and even creating a theater where children could learn more about their heritage. For the Yanhuitlatecos, the church was the most important and imposing expression of their popular identity. Despite being Spanish in origin, it was very much their own so many years after it had been built under the invading power.[17] Because they loved the church, they endured that it was closed for restoration, but they sorely missed celebrating the regular rites and rituals. They never thought of the altarpiece as art but rather as an aid to prayer.[18]

It fell to the Yanhuitlatecos who had left the pueblo—to the OaxaCalifornianos—to fight for the piece of the project that could fit into the context of "art": the restoration of their colonial *retablo*. The Yanhuitlatecos, like the Oaxacans involved with the Santo Domingo Cultural Center project in Oaxaca City, sought out an unprecedented partnership and invited one of the most modern of cultural institutions to assist them in fulfilling their assignment. Even though they were aware of the larger, non-art meaning of the altarpiece, they were willing to promote the restoration as an art project to the Getty Conservation Institute because that was how they could get the job done—and done well.

Thus, the project of restoring the altarpiece in the town of Yanhuitlán was compelling for all of the partners, for many different reasons. For the Getty Conservation Institute, Yanhuitlán was strictly an art conservation project; the Getty would put seed money into the project, but it would not be expected to provide all of the money needed. The altarpiece did fit the Getty's definition of "high art," and it also fit perfectly into Corzo's philosophy of partnering. Even though the Getty might put a great deal of money into a project, the Getty Conservation Institute, under Corzo's leadership, wanted the local people to be ultimately responsible so as to guarantee sustainability. The Getty also liked the idea that other private money was being invested in the work. The Friends of Heritage Preservation enthusiastically took on the project as their first commitment as a not-for-profit group. The restoration in Yanhuitlán fit the bill for the Friends because it had a short-term trajectory, with a beginning, a middle, and an end. The group's founders, Suzanne and David Booth, had been frustrated by long conservation projects, and they were seeking something that would have dramatic results and thus be able to help recruit others for future undertakings. They were searching for a successful model, and Yanhuitlán looked promising.

The altarpiece at the Church of Santo Domingo in Yanhuitlán was, from a "high" art perspective, a stunningly important object. Measuring more than twenty meters in height and nine meters in width,[19] it is composed of eleven panels of considerable size, numerous smaller panels, and sixteen major sculptural pieces. The paintings were executed by Andrés de la Concha in 1570. De la Concha was one of the chief Spanish painters to have come over to "New Spain" especially for the purpose of fulfilling commissions in the Oaxaca region and primarily for *retablos* in the numerous Dominican churches. The panels display an eccentric Spanish artistic style, notably in the panel of the *Adoration*; furthermore, de la Concha's style reflects a Spanish realism typical of the artist's home region of Aragón. In addition, in the Spanish mode of the time, the Spanish style

was combined with an identifiably Italian manner of painting. All in all, these stylistic conjunctions lent the *retablo* a strong similarity to the altarpiece in San Juan de la Peña in Aragón. For the Oaxacan church, that relationship cemented the importance of this immense colonial effort. San Juan de la Peña in Aragón is absolutely splendid; carved out of a mountain, with no expense spared, it served to protect and pronounce the victory of Spanish spirituality in the face of the dreaded Moorish incursions. In the same way, this latter-day Church of Santo Domingo was meant to be a symbol of the ultimate and total replacement of the indigenous belief system by the Spanish church. Unlike so many other colonial *retablos*, the painting in these panels was in excellent condition, having escaped undue intervention over the years. Except for some changes made to the frame in the eighteenth century in order to make it more "up to date," the *retablo* retained its original artistic character and could be depended upon to yield enormous amounts of information about the techniques of the building of these altarpieces in the early period following the Spanish Conquest. The *retablo* also survived many earthquakes in Oaxaca's earthquake-prone region. Nevertheless, INAH foresaw various imminent dangers, including the growing deterioration of the wood itself and infestations of insects. In 1974, the altarpiece had already been substantially reinforced with steel and other supports, but INAH did not believe this was sufficient. Given the likelihood of more seismic activity in the future and the further deterioration of the structure, the INAH team believed that the *retablo* would have to be dismantled and then put back together in order to achieve the desired stability. This choice, whether or not to dismantle, became an intractable sticking point between INAH and the Getty as the project developed. The Getty, taking the opposite position, adamantly opposed taking the *retablo* down.

Although the Getty entered the project with a full commitment to the *retablo*, it did so from a uniquely privileged position. Unlike the Mexican teams, its team stayed in one of the beautiful and historic hotels in Oa-

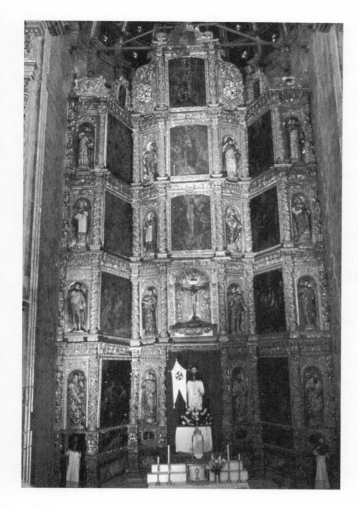

Yanhuitlán *retablo*
(Courtesy
INAH)

xaca City, traveling the hour and a half to desolate Yanhuitlán every day
to do their work. Of course the Getty enjoyed the multifaceted involve-
ment in and the huge and contagious enthusiasm about the restoration.
Since part of the larger project was the training of local people, local
involvement (not local money) was mandatory and people from the
pueblo were employed. The Getty staff brought their most advanced
equipment with them and dedicated themselves to the work based on

the very expensive study they had already completed. All was going well when passions and tensions exacerbated over the difference of opinion about whether or not to take down the *retablo* for restoration of the individual panels. According to Corzo, the now-departed head of the Getty Conservation Institute, the Getty team did not sufficiently respect the knowledge and wisdom of the locals when they decided that the Mexican approach to the restoration was not up to par. INAH, on the other hand, had enormous experience—specifically in *retablos*—that the Getty did not yet possess.

 The Getty people believed in the integrity of the structure and wanted to restore the altarpiece in situ. Believing in minimum intervention, they felt they could do all the necessary repairs and reinforcements with the altarpiece standing where it was; they were adamant that it was intrinsically stable enough to remain in place. Andrea Rothe, the painting conservator of the Getty Museum, was invited to consult on the project. He also became deeply opposed to taking the piece down, since he was convinced that this would entail far too much intervention in the panel paintings themselves. Rothe believed that he could almost guarantee the retention of the aesthetic quality of the altarpiece by keeping it in place. This would also pose, he believed, the least risk to the paintings.[20] Suzanne Booth, with the Friends of Heritage Preservation, noted concern about the different panels being worked on by different conservators throughout the region once it was taken apart, and about whether the consistency of the artwork would be maintained.[21] The American and the Mexican sides became more and more polarized. Each side believed that its position better promoted both the aesthetic and the religious meaning of the *retablo*. Rothe was, further, convinced that INAH was ignoring its real responsibility, which was (he believed) the repair of the church above all. He felt that this much more expensive project was the one that should have been proposed by INAH. In his opinion, all of the work done

on the *retablo* could be undone in a moment because of the infrastructure's decay: there were terrible drainage problems in the building, he said, and there was no electricity or running water. Rothe felt that completely dismantling the altar and then putting it back together again would be a wasted effort, even if it turned out to have been a good job of restoration, when the container itself (the church) was going to damage the altar again anyway, by virtue of its imminent deterioration.

This difference of opinion ultimately proved to be unresolvable. Today, all of the players on the US side (Suzanne Booth, Andrea Rothe, Miguel Angel Corzo) feel that this difference might have been resolved if the Getty personnel had been more open to and respectful of the local ways of managing the project. According to Eduardo López Calzada, the Oaxacan chief of INAH, the Getty was finally asked to leave: "They had gone so far as to suggest that Mexico ought to change its INAH team and had thereby bordered on stepping onto Mexico's sovereignty with respect to patrimony. They had to go."[22] *Noticias,* the local newspaper, reported that the Getty wanted to do the job quickly, leaving open the question of whether the Getty wanted to do the job in situ because this was the best methodology or because this was the quickest one.[23] Soon a major earthquake did rumble through Oaxaca and made all of the discussions moot; the *retablo* now had to be disassembled. The Getty had left Yanhuitlán as requested, leaving their equipment behind. The confidence of the Oaxacans had thus brought the Getty to Mexico, but the Mexicans' pride in their own work and in their own way of seeing the conservation project caused them to ask the Getty to leave.

By 2001, the *retablo* had been restored. The viewer today can only marvel at how the necessity of this project was telegraphed from mostly abandoned Yanhuitlán to crowded Los Angeles. In Los Angeles, the Getty Conservation Institute looked on the *retablo* as an artistic treasure that needed to be saved for its own sake and also to be treated as an international cul-

tural monument. In Yanhuitlán, the *retablo* was considered to be a sacred object, in a sacred space, that needed to be preserved for the sake of the pueblo. The only way that Yanhuitlán could see itself fulfilling its responsibility to the *retablo* was to call in the OaxaCalifornianos. Thus, the care and preservation of the local artistic culture (like the care being lavished on the political culture) seems to be developing new and different forms in its expatriate nature, ones that could never have been imagined before there were so many well-organized Oaxacans living away from home. These Mexicans are not afraid of inviting new partners to help them manage their memory and negotiate their changes; nor are they afraid to set the terms of the collaboration or to call a halt to it if they feel their invited partners have overstepped the bounds of this hospitality.

Juego de Pelota

Change is constantly being negotiated in Oaxaca, where indigenous groups have, over the last two decades, made significant progress in bettering their social situation. Their work is continuing within all elements of the culture at home in Mexico—for example, the increasing acceptability of bilingual education and of "uses and customs" in political matters. But farther north, in OaxaCalifornia, populated by so many Mexicans and especially by so many Oaxacans, culture is playing an enormous part in negotiating change in California as well. Creative and entrepreneurial people are involved in that negotiation—whether they be craftsmen renewing and expressing their feelings with a renaissance of their artisanry, poets with words, painters with colors, or cooks with gastronomy. They all bring their rich culture to Los Angeles and to the United States, changing that country even as they are being changed by it. As Miguel Zafra, an artist-photographer and Zapotec Indian activist living in Santa Cruz, California, has explained, this is a natural road for his people to follow: "In Oaxaca, everyone is an artist in his fashion. My grandfather wrote poems, my parents sang songs."[24]

Cultural transformation is a constant negotiation that may be one of the most positive outcomes of migration. In that exchange, a rich culture gets only richer—and enriches the culture where it has landed. This may be most touchingly exemplified in the career of the singer Lila Downs, born of a Oaxacan mother and an American father and herself a citizen of both worlds. A trained anthropologist, Downs wrote her dissertation on the intricate weavings of Triqui women. She lives the hybridity to which she was born: singing and writing songs that move from native Oaxacan to indigenous Zapotec and Mixtec languages to Spanish, then to English, and back again, touching her listeners with an easy flow and haunting penetrability that reaches their hearts. The multifacetedness and endless circle of her creativity bring together her early love of Western opera and her profound connections to her mother's culture—especially to the land, the terruño, which she leaves and to which she returns constantly and where she is refreshed and reminded of the mountains and the sky and the people who remained against all odds. After being culturally refreshed in Oaxaca, Downs travels the world some more, writing and singing her songs, mixing them with American folk and jazz and her own ideas and lyrics. She thus perpetually expands the global reach of her mother's culture. Downs reminds her audiences of the depth and layered reality of Oaxacan life, of its intersections and complications. Her Academy Award–nominated performance in the acclaimed movie Frida introduced millions of people to her art. To listen to Lila, in California or anywhere else she appears, is to listen to the beauty and suffering of indigenous pueblo life, to the intimacy with the cumulus clouds that accompany them everywhere, to the pain of constant goodbyes as people prepare to go north, to the attraction and menace of the snake in the tree, to the characters—old women and ugly men—whose presence invades every Zapotec and Mixtec person's consciousness. Downs, herself epitomizes the wandering Oaxacan, gaining strength wherever she goes, adapting to and complicating the lives of those who enter her sphere.

Her power is not only that she negotiates change in her non-Oaxacan audiences (increasing their understanding and appreciation of the value of this indigenous culture), but also that she empowers her *paisanos* from the Mixteca by reminding them that they do, indeed, leave footprints wherever they have trod—and that their emotions, thanks to the art of her song, are increasingly recognized as universally apprehensible:

> Do not cry for me, no, do not cry for me
>> Because if you cry I will haunt you,
> But if you sing to me, my love,
>> I will always live. I will never die.

> If you want me to never forget you
>> If you want me to remember you,
> Play happy songs, my love,
>> Music that will never die.[25]

Downs leaves her mark in other ways as well. She is generous to other artists. For example, she agreed to participate in a photographic art event that opened in Centro del Arte Santo Domingo in Oaxaca City in June 2001. She was featured in a performance imagined and organized by Lucero González, a professional art photographer, also a Oaxacan native who had left for Mexico City but who felt the need to return to Oaxaca because her "umbilical cord was buried there."[26] González had built her successful career in photography in Mexico City, but she could never forget or renounce Oaxaca, which was for her the heart of *mexicanidad*. So she asked Downs to be the star in a "performance" of the ancient Mixtec ball game called the *juego de pelota*. Using this game, traditionally restricted to men, González's photo-essay—with Downs and a supporting cast of young Mixtec women—became an elaborated artistic com-

mentary that questioned this restriction, that silently but potently inter-
rogated the exclusion of women from the ball game when they are so
central to all Oaxacan life.

True to form, migrants in OaxaCalifornia continue to play the *juego de
pelota*, and, when they do, their most ancient myths are replayed. Even in
the United States, women are excluded. In its most intense form, the
game is meant to call on the pre-Columbian gods to summon up ele-
mental forces: fire, memory, and silence. By resorting to this ritual, Oa-
xacans believe that the order of the universe is both restored and altered
to fit changing times. But thanks to González's photographic, quasi-
documentary series with women as the featured players, a team of *pelota
mixteca* was organized in the Mixteca Baja with women as the sole play-
ers. What this means about the changing role of women in Oaxaca can
only be surmised, since this is a role that is being redefined daily with
the arts playing their parts.

That Oaxaca is a crucible for redefinition of social reality in Mexico
is undeniable. In modern history, it has repeatedly been the site of "a
multitude of initiatives and experiences in new domains: women's
rights, ecology, bilingual education, collectives of indigenous advocates,
radio, television and video workshops, and transnational organizations
(Oaxaca/USA)."[27] Surely, Downs's haunting performance in González's
photographic essay refers not only to art or to a game of ball but also to
the role of the migrant woman who holds the dream of the future in her
hands and struggles to prevent the metamorphosis of that dream into a
nightmare. This is made evident in the poetry inscribed on the exhibi-
tion's walls and in the exhibition catalogue:

What does the migrant woman's gaze dream?
 What is the dream dreamed by the migrant woman's gaze?
A dream of stone and fire, memory and silence . . .

feminine universe in the migrant woman's memory;
 women's bodies in the complicity of ritual, in the complicity of playing and gazing . . .
 women's hands today in the ball game;
 women's hands today in the Mixteca,
 in the dream dreamt by the migrant woman.[28]

Clearly, as the old Mixtec admonition says: "Naa-shica-dav'i.Those who walk in distant lands do not forget their gods nor their songs; they do not forget hills nor trees; they do not forget their language, the language of their forefathers; they do not forget the names."[29]Art, as always, becomes one of the ways to mold and frame, fight and accept, the inevitable alteration in migrant life. In the case of this performance/ photo-essay, art guides the viewer and the participants, through the mind of the artist, to think about the strength and the foresight of women who have left their homes and to reimagine how to better their lot and the lots of their families. At the same time, these are women who know that to forget the past or to leave it to its own devices is to welcome the monsters who inhabit the void.

The work of Oaxacan artists and artisans has been exhibited throughout the world. In one of the most ambitious of these exhibitions— Chiapas>Mexico>California, in the Parc la Villette, Paris—the curator, Yvon Le Bot (not an art curator by training, but a sociologist), based his interest in Oaxaca on the plethora of arts in the state. He explained: "Oaxaca is an extremely rich laboratory in which artisans and artists launch numerous communitarian cultural initiatives and whose creativity is, furthermore, enriched by the numerous contributions of the emigrants who go back and forth between their native state, other parts of Mexico and California."[30] Objects in these exhibitions are often works that were created in Oaxaca and were then sent to the site of the exhibition. But there are now more-contemporary creations or actions—ones like the pelota mixteca performance—that begin as political acts and transform them-

selves into art. These are works or performances that spring from native Oaxacan culture but that owe their special presence and generativity to the very fact of having meditated on that culture while far from home.

Conclusion

A delegation of émigrés approaches the unapproachable Getty; a photographer who was born in Oaxaca but lives in Mexico City ruminates on the possibilities and the limitations of her native home; a chanteuse wanders the globe, spreading the songs she learned from her mother, writing her own lyrics, and incorporating the blues and folk of her other land, the United States—the Oaxacan people seem to be especially suited to preserving memory for a very long time. But they are also well suited to managing that memory in such a way that it looks backward and forward at the same time. As long as they can actively maintain that balance—the balance of living in their own particular crossroads where memory and future intersect—they will be able to escape the homogenizing and alienating gloom of globalization/migration, and they will be able to transform the conjoined twins into more of a dream than a nightmare. If Oaxacans can maintain that balance, they will achieve something rare: they will be neither sleeping nor dreaming their way through their migrations; they will be navigating their own ship. And then, along with the flood of dollars sent home and the new education and experiences to be had on both sides of the border, they will be able to negotiate something truly better for themselves and their families and their communities in their new home, OaxaCalifornia.

Conclusion

Oaxaca does have a life of its own. Nevertheless, Oaxaca was in no way disconnected from the political changes that swept through Mexico before and immediately after the momentous election in the year 2000. Nor was Oaxaca insulated from the changes that then filtered down through the new government. In fact, there is no part of Mexico that can disconnect itself entirely from central government's long and determined reach. It is simply that Oaxaca's cultural life has its own rhythms and its own goals, most of which were plotted and were well on course before July 2, 2000.

Still, some very real positions taken by the national government affected the conversation about culture throughout Mexico after the historic elections. A genuine anxiety about the nature of the cultural policy filled the air. Artists and intellectuals soon expressed nervousness. They expected a well-articulated statement and hoped for a generous policy toward culture, toward contemporary art, toward the expression of the

arts inside and outside of Mexico: they had been used to the apprecia-
tion of the centrality of culture under the PRI. And they never did receive
much satisfaction under the PAN. For example, early in the new presi-
dent's tenure, all intellectuals and artists were invited to a meeting,
chaired by President Vicente Fox himself, in the Cultural Center of Santo
Domingo in Oaxaca. The attendees wanted to learn what his cultural pol-
icy would be, and how it would relate to them and their creative work.
Apparently, or so the story goes, Fox said that they would have to be
responsible for helping to create the policy—that there was nothing yet
in place and no ideas in the works. This did little to inspire confidence
in the new government's attitude toward the arts. In unrelated actions
and many months later, contemporary artists marched in the streets of
Mexico City, still demanding the articulation of a cultural policy. They had
their own specific requests: support of regional Mexican artists in the face
of the support that internationalized art stars were receiving; the provi-
sion of better academic training for all artists; the fiscal encouragement
of private support for the arts; and the creation of more spaces for show-
ing living artists' work. Later, with government funding for the Mexi-
can film industry threatened, the artistic establishment became only more
concerned.

Furthermore, high-level political hirings and firings throughout the
country unnerved the "art crowd." On the national level, the abrupt dis-
missal of Gerardo Estrada, the cultural impresario in charge of traveling
exhibitions to foreign countries, or what might be termed cultural diplo-
macy, seemed to make no sense. And on the local level in Oaxaca, the dis-
missal of Amelia Lara—because of disagreements with the governor—
from the Santo Domingo Cultural Center after her brilliant service there
was also cause for discouragement. But unnerving as these events were,
they were akin to the games of "musical chairs" that almost always takes
place in European and Latin American democracies when there is a

regime change. In Mexico there had been no similar fundamental change for seventy years. In took some getting used to!

There was also a general unease with the adoption of an awkward term that had crept into the new government discourse: "citizenizing" (*ciudadanización*). The nervousness stemmed from the use of a word that insisted on the utility of culture as a means of encouraging patriotism as opposed to supporting art for its own sake. This anxiety may have stemmed from the memory of the muralists and their seemingly unending hammering on the nail-head of the public consciousness with the nationalist ideology they were charged with communicating. Within months of the adoption of the word *ciudadanización*, the cultural bureaucracy dropped it and reverted to the more neutral rhetoric of support of the regions' artistic efforts and the encouragement of reading. That there were contradictions in this policy is not surprising, given that it emerged from the Mexico City bureaucracy: the government was espousing the promotion of reading in the regions at the same time that it was building a megacentralized library in Mexico City instead of fulfilling the needs of local libraries. It was also reducing the substantial tax subsidies it had long (and with great success) offered writers and the publishing industries, punishing the very sources of literature in Mexico itself.

The new government did persist, however, in its activities of cultural regionalization. According to Eurodo Fonseca Yerena, the director of Vinculación Cultural y Ciudadanización (his title still, when he spoke with me in June 2002), the goal of the PAN government was to better link CONACULTA, Mexico's Culture Ministry, with the states.[1] As he said, things were changing and could not remain the same; the old centralism was not possible to maintain any longer. Fonseca spoke of transferring the realm of decision-making to the states as being of equal importance to putting more money into the states. Fonseca noted (in language similar to that used by Fox when he commented on his cultural policy) that

the government was waiting for proposals from artists and intellectuals themselves and had no intention of imposing ideas on them or the states. He said that he wanted to stimulate creativity in a fresh way, to continue giving grants to individuals, and to encourage reading by creating small book circles and book festivals. According to Fonseca, for instance, the *fiestas* throughout the country would continue to be supported, providing artisans with greater economic opportunities. The government was creating an electronic network and a publication whereby people involved in cultural pursuits and tourism throughout the country could be in better touch with each other. Civic projects, special-needs groups such as the handicapped, seniors, prisoners, those in hospitals—the marginalized would receive more attention. But always, the goal of the central government was stated as a desire to encourage the states and municipalities themselves to raise matching funds and to secure commitments that would make these projects feasible. And always, the gap between what the government talked about and what it delivered widened.

Thus it is not surprising that Emmanuel Toledo Medina, head of the Instituto Oaxaqueño de las Culturas, has also insisted that the PAN government intends to dissolve some of the centralism of the old PRI days by means of culture, to encourage regionalism, to become involved with youth, and to work more creatively with the communities by means of art. That the government did not see fit to support Polvo de Agua, precisely because it had crossed the indelicate line from artisanry into art, was therefore indefensible: this was a local and creative and sustainable project. At the same time, this is the government that has created the cultural corridor that means to improve life in Ocotlán, to bring to fruition the dreams of Rodolfo Morales. And this is the government that is asking Oaxacans who have left Oaxaca to participate in the artistic life of the state. More significant, this is the government that is recognizing Oaxa-California. It is inviting the migrants to help renew the culture that has lost so many of its people to emigration.

Indubitably, at the national and local levels, governments have fallen into many traps and let down many artists and intellectuals with respect to the fulfillment of these policies of regionalization. Even their goals and the means to achieve them have been cause for disappointment. As a result, private efforts, such as the fabulous Jumex Collection in Mexico City, have offered a counterbalance to the Fox government. In Oaxaca, however, the failures of the government may be looked on with dismay but are never cause for despair because when the government fails to deliver in Oaxaca (as it so often has), there are always individuals to inspire creativity, spot opportunities, and solve problems. With the exception of the loss of Lara, Oaxaca's cultural world did not suffer profoundly in the transition and in the regime change: that is because its foundation is firmly of its own making. The national and regional museums elsewhere did, however, suffer terribly from the lack of responsiveness of the government to their needs. Oaxaca's archaeology policy was sustained in what seemed to be the longest-running pilot ever; the communitarian museums chugged along under the leadership of Morales and Camarena; Toledo continued to lead the charge for civic preservation; artists followed and developed their own strategies for success and responsibility; contemporary art took new directions while also continuing to follow well-traveled paths; artisanry sustained its unique and varied universe, fighting for its life and also experimenting with ideas that might; the Santo Domingo Cultural Center continued, though under new leadership, to be a destination for visitors from all over the world; and Oaxa-California grew to be a stronger and stronger outpost for the energies of emigrant Oaxacans who could never even receive a hearing in Mexico.

Oaxaca does thus appear to have been much less influenced by the grander, mostly negative cultural forces that affected the rest of Mexico so profoundly. In fact, because Oaxaca early anticipated the need for change, it began to assume the responsibilities for managing those changes. Seeing the looming crossroads ahead, Oaxaca, by the late 1980s,

had cleared the path for creative action in the cultural realm. Oaxaca may be neither synecdoche nor metaphor, but it is surely a positive phenomenon from which all cities (in Mexico and elsewhere) could learn and prosper. It has become, when all of its innovations are viewed as a constellation, the equivalent of a cultural laboratory. In that laboratory, experiments in the world of visual culture are performed daily: experiments in the telling of history from microperspectives, in the testing of previously unfamiliar forms of philanthropy, in the unselfish handling of artistic success, in the creation of new ways to make art and define crafts, in the management of archaeology, and in the empowerment of the diasporic condition. In varying measure, these experiments have improved the lives of the people who live in Oaxaca. To the extent that these changes have allowed for increased ownership of memory, and to the extent that they have encouraged and allowed people and communities to assume creative control of their present and of their plans for the future, they have been positive and life-affirming. Having been empowered by its citizens to lead and to create new partnerships, Oaxaca has emerged—both as a whole and in its component parts—as a model and exemplar.

Notes

Introduction

1. Luis Gerardo Morales-Moreno, "The National Museum of Mexico," in *Museums and the Making of "Ourselves": The Role of Objects in National Identity*, ed. Flora E. S. Kaplan (London: Leicester University Press, 1994), 181. This book has been an indispensable source for my research and should be equally indispensable for anyone interested in the subject of museums and identity.

2. Miguel Angel Fernández, *Historia de los Museos de Mexico* (Mexico City: Promotorado Comercialización Directa, 1988), 221. See this book for its complete account of the museums of the country.

3. Author's interview with Fernando Solana Olivares, former director of the Museum of Contemporary Art in Oaxaca and constant social critic, June 12, 2000.

4. See, for example, Sara Topelson de Grinberg, "Arquitectura y conservación," *Cuadernos de Arquitectura* (Mexico City: CONACULTA, INBA, Dirección de arquitectura y conservación del patrimonio artístico inmueble, 2002), especially the preface, p.vi, vol. 4.

5. Author's interview with Sara Topelson de Grinberg, in her office, July 2002. One could speculate whether her subsequent resignation, midway through Fox's term, registered her disappointment at the seeming impossibility of creating a legal infrastructure to protect the arts against business interests.

1. The Pueblos Speak for Themselves

1. This is a paraphrase of "Los pueblos indígenas, no hay que olvidarlo, impulsan de nuevo ser sujetos. Y ese proceso es ya irreversible." Written in Spanish by Marco Barrera Bassols and Ramón Vera Herrera, in "Todo rincón es un centro. Hacia un expansión de la idea del museo," *Cuicuilco,* vol. 3, no. 7 (May-August 1996): 104–40. Barrera continues: "That which is central to the democratization process is not the issue of opinion, consultation or vote—while the process is exercised by others. To exercise the process is to be the subject of one's own history" (134).

2. Translation from Guillermo Bonfil, *Obras Escogidas de Guillermo Bonfil* (Mexico City: Instituto Nacional Indigenista, Instituto Nacional de Antropología e Historia, et al., 1995), writing of the "interminable: despojo de tierras, reducción, esclavitud y servidumbre, aniquilamiento físico, desarraigo, represión intelectual, evangelización, mentira, censura, atentado permanente contra la memoria, contra la lengua, imposición, opresión, frustración, persecusión, no legitimidad, negación total, desprecio, discriminación, paternalismo, buena voluntad para el buen salvaje, folklorismo, enajenación del presente, del pasado, de la visión del futuro, de la posibilidad de liberarse por ellos mismo" in "Las nuevas organizaciones indígenas" (vol. 1:380–81), originally published in Enrique Valencia, *Campesinado e indigenismo en America Latina* (Lima, Perú: Centro Latinoamericano de Trabajo Social, 1978), 131–44.

3. In Latin America, the word *culture* suggests everything about a way of life that is "manmade," but more than that, "in Spanish, culture is indissoluble; culture is everything that connects me to the past and with a sense of myself as beyond myself." See Richard Rodriguez, *Brown: The Last Discovery of America* (New York: Viking, 2002), 129.

4. Jorge Hernández Díaz, *Las imágenes del indio en Oaxaca* (Oaxaca: Instituto Oaxaqueño de las Culturas, 1998), 17, 18, quotes Luis Cabrera: "El problema principal de México en materia humana consiste en procurar que su población sea más homogénea. Esa homogeneización tiene que hacerse sobre la base del mestizo, procurando aumentar la proporción de este último como procedimiento para reducir y hacer desaparecer la población indígena y absorber la población blanca," from Luis Cabrera, *Los problemas trascendentales de México* (México: Editorial Cultura, 1934), 47. Hernández goes on to affirm "que en el proceso de homogeneización la población india deberá desaparecer en tanto que la población blanca deberá ser absorbida. . . . Un grupo debe ser aniquilado, mientras el otro debe ser consumido, captado, que es lo que idealmente se descarta? Obviamente aquello que consideramos dañino, desagradable o inservible, e inversamente se debe consumir lo benévolo, lo virtuoso."

5. I am indebted to Guillermo Bonfil Batalla, *Mexico Profundo: Reclaiming a Civilization,* trans. Philip A. Dennis (Austin: University of Texas Press, 1996), and his sections on indigenous resistance (91), for references to this phenomenon and to the general corpus of

his writings to be found in Bonfil, *Obras Escogidas*. Furthermore, neither this book nor the above thoughts would be possible without the ideas of Enrique Florescano's recent evocative book: *Memoria indígena* (Mexico City: Taurus, 1999), esp. 283–313.

6. Hernández Díaz, *Las imágenes*: "La (re)construcción de los referentes de la identidad collective en el discurso de las organizaciones indígenas" (89).

7. Barrera Bassols Vera Herrera, "Todo rincón," 112.

8. This early history of the movement in Mexico is a summary of the author's interview and several telephone conversations with Miriam Arroyo in Mexico City in her home in the fall of 1999.

9. Michel Foucault, "The Subject and Power," in Michel Foucault, *Beyond Structuralism and Hermeneutics*, ed. H. L. Dreyfus and P. Rabinow (Chicago: University of Chicago Press, 1983), 208–26, discussed by George Yúdice in "The Globalization of Culture and the New Civil Society," in Sonia E. Alvarez, Evlina Dagnino and Arturo Escobar, eds., *Cultures of Politics/Politics of Cultures: Re-Visioning Latin American Social Movements* (Boulder, Colo.: Westview Press, 1998), 373, where he writes that "governmentality" refers to "the ways in which action is already channeled by the institutional arrangements of a society" and should not to be confused with "governability."

10. Svetlana Alpers, "The Museum as a Way of Seeing," in *Exhibiting Cultures: The Poetics and Politics of Museum Display*, ed. Ivan Karp and Steven D. Lavine (Washington, D. C.: Smithsonian Institution Press, 1991), 25.

11. Teresa Morales L. Antrop and Cuahtémoc Camarena O. Antrop, *Reflexiones: ponencia encuentro nacional de museos comunitarios* (Querétaro: El Pueblito, 1999).

12. This was unlike the typical city museums born in Europe and America, with their heterogeneous collections that reflected the original benefactors' collections and that actually included very few objects directly reflecting the identity of the city itself. See María Emilia Grandi, Florencia Lloret, and Alicia de las Nieves Sarno, in *Gaceta de Museos*, no. 25 (2002), 10.

13. Jeffrey H. Cohen in *Artisans and Cooperatives; Developing Alternate Trade for the Global Economy*, ed. Kimberly M. Grimes and B. Lynn Milgram (Tucson: University of Arizona Press, n/d), 134–37.

14. I am extremely grateful to Teresa Morales and Cuahtémoc Camarena for the many interviews in which they explained the structure and substance of the communitarian museums from their point of view.

15. There are occasional rumors about efforts on the part of INAH to control the theme of the museum, such as with the museum in Teotítlan del Valle. But as far as I can discern, these rumors are related to a concern for the reality of the theme. For example, some citizens of Teotítlan del Valle wanteded their museum to be about the mythical tunnels linking Teotítlan with Monte Albán, rather than about their history. These tun-

nels have, however, never been found, and any evidence that they existed is so insubstantial that there could be no objects or material with which to tell or support such a "wished for" story as the basis for any museum. (This conclusion is drawn from the author's interview with Dr. Nelly Robles, Director of Monte Albán, April 2003.)

16. E. Ing. Ramiro Flores Morales, *Gaceta de Museos*, no. 25 (2002): 45ff.

17. The indigenous style of consensus, created its own internal, severe problems, most dramatically in the struggle between Catholics and Evangelical Christians, and fostered a distinct lack of toleration within the communities themselves: Franco Gabriel Hernández, "Los usos y costumbres y el problema religioso actual en comunidades indígenas," *Humanidades* (April-July 1998), 28–40, and "Expulsiones religiosas en Tlahuitoltepec," *Humanidades* (December 1997–March 1998), 37ff.

18. Yúdice, "New Civil Society," 373.

19. Morales-Moreno, "The National Museum of Mexico," 183. Compare this development with the discussion of the present National Museum of Anthropology, which expresses the liberal path of "enlightened coercion" that has dominated Mexico since 1867. The phrase "enlightened coercion" refers here to a certain type of traditional political domination, paternalistic and authoritarian.

20. Yúdice, "New Civil Society," 358.

21. Barrera Bassols and Vera Herrera, "Todo rincón," 124: Still, not all indigenous cultural groups will accept the idea of the Western museum, saying it is too alien to adopt for their distinct purposes.

22. This is the message, the refrain, and the language of Bonfil Batalla in his classic book *Mexico Profundo*.

23. Gallaga Murrieta and Gillian Newell, *Gaceta de Museos*, no. 25 (2002), 27.

24. Barrera, in a conversation with the author in the Natural History Museum, spring 2000.

25. Author's interview with Francisco Toledo, fall 1999, at IAGO.

2. Paying Back

1. Fernando Gálvez de Aguinaga, "Los Claroscuros de un Siglo: Arte Oaxaqueño Contemporáneo," (unpublished manuscript), 46. "En las regiones indígenas la oralidad ha sido parte esencial de su subsistencia…su única forma de mantener su cultura ha sido transmitiendo sus mitos, sus conocimientos, sus costumbres y su idiosincrasia a través de la oralidad. Si bien los artistas oaxaqueños no son todos indios, lo que si es cierto es que casi todos estuvieron desde niños en contacto con estas tradiciones."

2. These *becas* were instituted in Mexico by Rafael Tovar, head of CONACULTA (the Mexican Ministry of Culture) after he went to France and encountered the scholarship program organized by Jack Lange, the Socialist French Minister of Culture. The French grants were meant specifically to serve Lange's Socialist Party political purposes related

to the decentralizing of French culture, and Tovar immediately understood how such funding for artists could advance his own government's objectives in Mexico.

3. He also donated land in the heart of Oaxaca for a senior citizens retirement home.

4. He was not the first top-ranked Mexican artist to think this way. Diego Rivera had previously built a museum collection in Mexico City dedicated to the pre-Columbian as art rather than anthropology. But nothing else of this nature and scope had occurred outside of the capital, where, according to the director of the museum, Alicia P. de Esesarte, the disdain for the pre-Columbian was truly profound.

5. Author's interview with Alicia P. de Esesarte, Director, Tamayo Museum, July 30, 1999; Fernández, Historia de los Museos de Mexico, 206.

6. Author's interview with Francisco Toledo, February 4, 2000.

7. All biographical information comes from the new biography on Toledo: Angélica Abelleyra, Se busca un alma (Mexico City: Plaza and Janes, 2001).

8. The direct quotations in this paragraph are from ibid., 220, 257, 271.

9. Gálvez de Aguinaga, "Los Claroscuros de un Siglo," 80.

10. From the edition and prologue of Cuadernos de la Mierda (Oaxaca: Museo de Arte Contemporáneo de Oaxaca, c. 2001), prologue by Dacid Huerta. This was published after the exhibition.

11. Toledo: Lo que el viento a Juárez (Mexico, D. F.: Ediciones ERA, 1988), prologue by Carlos Monsiváis, 11.

12. Robert Valerio, "La mitificación de la que ha sido objeto el propio artista," Atardecer en la maquiladora de utopias: Ensayos críticos sobre las artes plásticas en Oaxaca (Oaxaca: Ediciones Intepestivas, 1999), 164–66.

13. Abelleyra, 254, writes that Toledo claims he was never interested in political parties per se but rather that his primary interest was in demanding the return of a "disappeared" friend. This is a debatable statement given the historical record.

14. Zapotec Struggles: Histories, Politics, and Representations from Juchitán, Oaxaca, ed. Howard Campbell and Leigh Binford (Washington, D.C.: Smithsonian Institution Press, 1993), 3.

15. Ibid.

16. "Ironically, Guchachi'Reza, like the paintings of Toledo and friends, is fashionable and upscale despite its relatively humble origins. For example, the translation of Brecht and Neruda into Zapotec reflects the Juchiteco writers' circle's awareness of trends in literature. . . . In fact, Guchachi'Reza's readers were more likely to be Parisian anthropologists or urban Mexicans than Zapotec peasants. Nonetheless, PRI was so convinced of the magazine's subversive potential that they burned it and the rest of the COCEI bookstore in 1983." Victor de la Cruz, "Brothers of Citizens: Two Languages, Two Political Projects in the Isthmus," translation of "Hermanos o ciudadanos: dos lenguas, dos proyectos políticos in el Istmo," Guchachi'Reza (December 1984), 18–24. The above is

quoted from Howard Campbell, ed., *Zapotec Struggles* (Washington, D.C.: Smithsonian Institution Press, 1993), 226.

17. Daniel Lopez Nilio, in Campbell, *Zapotec Struggles,* 208.

18. Howard Campbell, "Class Struggle, Ethnopolitics, and Cultural Revivalism," in ibid., 224.

19. Author's interview with Graciela Cervantes, owner of Galería Quetzalli, in summer 2002.

20. *PROOAX Bulletin,* 1, no.5 (December 1995): 1.

21. Valerio, *Atardecer en la maquiladora de utopias,* 183: "En PROOAX, muchos de los que participan son pintores; tienen cierta conciencia y apoyan." ("Many of those who actually participate in PROOAX are painters; they have complete awareness and they support it.")

22. He said this to Fred Croton soon before the July 2, 2000, elections.

23. Reported in *El Oaxaqueño,* June 21, 2003, 5.

24. Author's interview with ex-director Alfredo Cruz Ramirez, May 2001.

25. Author's interview with Eduardo López Calzada, summer 2000.

26. The whole quotation was: "We will open a McDonald's franchise in the Historic Center of Oaxaca . . . although this does not mean to say that we are going to fight with the painter Francisco Toledo." Shortly thereafter, McDonald's capitulated. Unfortunately for its purposes, it had indeed gotten into a fight with the artist—a fight that it lost.[3] As quoted in Spanish (my translation) in the Internet edition of the Oaxaca newspaper *El Imparcial,* October 18, 2002, article by Felipe Sanchez Jimenez, quoting the McDonald's official Erick Fregoso.

27. Julie Watson, "Oaxacan City Defeats McDonald's, but All Not Happy about Victory," *Yahoo! News Mexico,* December 14, 2002.

28. Biographical information has been gleaned from a number of interviews with Dora Luz Martínez, Galería Arte de Oaxaca; from a long interview with Nancy Mayagoitia, initially partner in Arte de Oaxaca and then adviser and treasurer for Rodolfo Morales and his foundation for a number of years; and from the superb biography by Martha Mabey, *Rodolfo Morales: el señor de los sueños* (Benito Juárez, México, D.F.: Hoja Casa Editorial, 2000). See Mabey's book, 210ff, for a discussion of Morales's feelings about Ocotlán and 227 for his belief in the power of music, theater, and art to change lives for the better.

29. Mabey, *Rodolfo Morales,* as told on 260ff.

30. Author's interview with Nancy Mayagoitia, June 2002.

31. Translated from a personal e-mail from María Isabel Grañen de Porrua to the author, October 23, 2002.

32. I visited Santa Ana Zegache with Maestro Rodolfo Morales in 1999. We were accompa-

nied by Amelia Lara, the director of the Santo Domingo Cultural Center. I spoke exten-
sively with Dora Luz Martínez about this project, which was then in process, and later
with Nancy Mayagoitia in our June 2002 interview. I also wish to cite Mabey, *Rodolfo
Morales*, 230ff, for her useful insights into the history of the pueblo and the project.

33. Author's interview with Nancy Mayagoitia, June 2002.
34. Author's conversation in Ocotlán with Alberto Morales, May 2003.
35. Author's interviews with Dora Luz Martínez, 1999.
36. Note the following book on artist projects of Oaxaca, with an essay by Fernando Gálvez
(uncredited): *Oaxaca: la ciudad que suenan sus pintores* (Mexico City: Patronato Pro Defensa y
Conservación del Patrimonio Cultural y Natural del Estado de Oaxaca, 2000).

3. The New Philanthropy

1. The history of the building comes from *Proyecto Santo Domingo: Memoria de la Primera Etapa*
(Mexico, D.F.: Gobierno del Estado de Oaxaca, 1995), 116 ff.
2. "Proyecto Santo Domingo: Memoria de la Primera Etapa," interview by Ludwig Zeiler,
in "Entrevista a los frailes dominicos Javier Echeverría Irízar and Arturo Bernal Jiménez,"
67–75 (my translation): "They have not consulted us. The architects never, ever came
to consult with us, even to ask us what this room or that cloister might have been."
3. PROOAX *Boletín Informativo*, 1996, Notas Breves, 4, "Santo Domingo Centro de Conven-
ciones?" signed by Francisco Toledo.
4. The biographical information about Alfredo Harp comes from María Isabel Grañen de
Porrua, who sent me a series of informative e-mails. The translations are my own.
5. Author's interview with Fernando Peón Escalante, the head of the Banamex Founda-
tion, June 2000.
6. Banamex was later sold to Citibank, but Banamex retained its voice and influence, as
Harp had planned.
7. Certainly there had been major private efforts before, most notably "Adopt a Work of
Art," which began as "Adopt a Painting" in Mexico City and spread across the coun-
try over time. But "Adopt a Work of Art," which eventually developed its own kind of
partnership with individual governors, was never permanently tied to any single insti-
tution. Nor did it have any commitment beyond the particular conservation mission.
It floated, restoring pictures, monuments, ancient quarters, altarpieces as the need
appeared and as support could be garnered.
8. Author's interview with Fernando Peón Escalante, June 2000.
9. María Isabel Grañen de Porrua, personal e-mails to author.
10. "Museo (casi) imposible: el del códice en Oaxaca," *Acervos*, no. 8/9 (April-September
1998), article by Anselmo Arellanes Meixueiro, quoting Toledo in *La Jornada*, October
12, 1998. Author's translation of the following: "Independiente de la decisión a la que

llegue en cuanto al mejor espacio para la conservación de los originales (el meollo de asunto) siento que es muy importante resforzar la capacidad de los cuadros de investigación fuera de la ciudad de Mexico y no privilegiar los centros de investigación de la capital, como si fueran los únicos; es necesario capacitar a especialistas del interior del pais, especialmente en este caso concreto por el vínculo natural que han entre investigaciones y conservación del acervo."

11. Author's interview with Alejandro Avila at the Ethnobotanical Garden, June 2002, about the history and evolution of the garden.

12. Foundational documents and reports were most generously given to me for my use in this book by Amelia Lara. All references to the goals, objectives, and obstacles encountered are paraphrased and translated from the documents entitled "Centro Cultural Santo Domingo" and "Programa de actividades 2002 Centro Cultural Santo Domingo, Oaxaca."

13. The label copy is from the didactic panels, translated by the author.

14. Written by Miguel León Portilla, originally in Nahuatl and translated by him into Spanish. This is an excerpt (translated by me into English) of the longer poem.

15. Author's interview with Eduardo López Calzada, June 21, 2000.

16. Author's interview with Ing. Sandoval García, Institute of Indigenous Affairs (INI), June 2000.

17. See chapter 2 on the Mixtec/Zapotec experience in a neighboring village.

18. Lara relates the story of her friend, a niña bien (upper-class lady), who came with her daughter to Santo Domingo for the first time. On entering, the daughter said, "Oh Mama, are we in the United States now?" According to the mother, the strict order of the entry, the uniformed guards, and the masses of people checking in and entering made it look to her like a scene of crossing the border. Lara extrapolated how a Triqui child would feel, and she quickly determined to do something about it.

19. Author's interview with Sergio Hernández, one of the most recognized of the "next generation" of artists in Oaxaca, June 28, 2000. "Now," he said, "the reason artists have a voice is because it is good business. They needed someone after Tamayo died and that person was Toledo. He is pure, sincere, and clean. But he will pose with anyone and do anything to get what he wants done. Therefore, artists do really do things for the city and thereby help open it, but the circle of power is closed and kind of dictatorial in its own right. . . . Also, the real civil society is not involved: carpenters, cab drivers, etc. Oaxaca is not democratized yet. But it is learning."

4. Contemporary Art in Oaxaca

1. Valerio, *Atardecer en la maquiladora de utopias,* 168ff. Valerio's book and his incisive views of the art made in Oaxaca are essential for understanding both the critique and the pos-

sibilities of the "Oaxaca Style." Often cynical, always to the point, Valerio's views have also been essential to this chapter.

2. Gálvez de Aguinaga, "Los Claroscuros de un Siglo." Gálvez, the principal critic of the Oaxaca style, after the untimely death of Valerio, shared many but not all of his opinions. For example, the issue of the pre-Columbian is an important one. Gálvez fights for the vital connection of the Oaxacan artists to that past and will not accept that its utilization is just an imported exoticization of the Latin American from Europe. He argues that Valerio himself fell into a European critical trap by assuming and promoting that "the influences of the prehispanic in Europe create good and original works of art [but] the prehispanic elements of Indians in Mexico are symptoms of folkloricism and false utopianism."

3. All references to the Taller come from the author's interview with Juan Alcazar, June 2002.

4. The Taller has an early history of creating unhealthy dependencies in the artists it trained. Learning from experience, Alcazar has established a new system for the pueblo satellite program, one that encourages self-sustainability.

5. This is not to say that being a full-fledged member of the international art scene is the desire or ambition of every artist or artist group in Mexico City. For example, in early 2003, MAVO organized an elaborate demonstration. One of its major points was "to eliminate the noxious tendency of the government and private galleries to not value regional culture in the face of international trends now in fashion" (from public relations release).

6. From Mexico City: An Exhibition about the Exchange Rates of Bodies and Values, P.S. 1 Contemporary Art Center in conjunction with KW-Institute for Contemporary Art, 2002.

7. Author's conversation with José Luis García, at the site of the altar, June 2002.

8. The term propios y extraños is derived from an exhibition in Oaxaca at MACO in the year 2001; that phrase was its title, and it included artists from both categories.

9. Fernando Gálvez de Aguinaga, from a series of exhibition catalogues he curated in 2000–2001 on Demián Flores, at the Galería Quetzalli in Oaxaca.

10. Fernando Gálvez de Aguinaga, from his 2001 exhibition catalogue of Guillermo Olguín, at the Galería Quetzalli in Oaxaca.

11. Teresa del Conde, Emi Winter: Encáusticas, Galería Quetzalli, Dec. 1999, (Mexico, D.F.: Galería Quetzalli, 1999), 11.

12. Author's conversations with Selma Guisande in Oaxaca and letter from April 27, 2003.

13. James Brown, in a September 27, 2002, e-mail to the author.

14. George Moore, in September 8, 2002, e-mail to the author.

15. Author's conversations with Laurie Lidowitz in Oaxaca and letters over the two years of our conversations.

16. Amigos del Museo de Arte Contemporáneo de Oaxaca, 1992–2002: *Décimo Aniversario Museo de Arte Contemporáneo de Oaxaca*, vii.

17. The inevitability of succession is virtually ensured. A former director of MACO, Maestro Fernando Solano (hired twice and twice removed), has described the control that Toledo is always ready to exercise. The longevity of any director is directly connected to his/her level of tolerance of or ability to manage such interference.

18. Femaría Abad in *Mona Hatoum*, MACO, Oaxaca, 9.

19. Ibid.

5. Crossing Indelicate Lines

1. Shepard Barbash, *Oaxacan Woodcarving: The Magic in the Trees* (San Francisco: Chronicle Books, 1993); Luz María González Esperón, *Crónicas diversas de artesanos Oaxaqueños* (Oaxaca: Instituto Oaxaqueño de las Culturas, 1997); Néstor García Canclini, *Transforming Modernity: Popular Culture in Mexico*, trans. Lidia Lozano (Austin: University of Texas Press, 1993); Lynn Stephen, *Zapotec Women* (Austin: University of Texas Press, 1991). Stephen's book was originally published as *Mujeres zapotecas* (Oaxaca: Instituto Oaxaqueño de las Culturas, 1991); unless otherwise indicated, quotes are from the original edition. All of these classic works have informed my discussion of the crafts in the pueblos. There are always new indications of towns trying to adopt crafts as a way out of poverty; these are regularly noted in the *Oaxaqueño* newspaper. For example, in the tiny pueblo of Santa Catarina Roatina, a project of carving and painting animals evolved in 1995 into an effort to stave off poverty after the State Office to Support Artisans offered a workshop in the artisanry of wood carving. See *Oaxaqueño*, June 21, 2003, 6. Nevertheless, as the article underlines, this is a vocation that depends on the luck of tourism and scarcely brings food to the table. The "upstart" pueblos usually function as middlemen for the famous towns and have no direct market for their wares.

2. Author's interview with Professor Enrique Audiffred Bustamante, May 2002.

3. Conference results reported in Judith Amador Tello, "Fonart da un giro de lo tradicional a lo totalmente palacio," *El Proceso*, Internet edition, September 15, 2002, 1350.

4. Ibid. At the conference, it was reported that .65% of Mexican craftspeople are helped by FONART (that is, less that 1%). This calculates to about 8,000 people being helped in any direct way. More generously, it could be said that 65,000 people are indirectly benefited—out of 10 million craft workers in the country.

5. Amador Tello, "Fonart da un giro," 1351.

6. Similar gatherings of single crafts in single communities occur in other places in Mexico, such as Michoacán. Their specific histories differ from Oaxaca's.

7. See chapter 7 for a discussion of migration and the arts in OaxaCalifornia.

8. "Most of the people now carving the [animal figures] began after 1985. Lacking the

constraints and wisdom of a long artistic tradition, they rummage freely through the region's immense creative heritage, its jumbled culture of Indian and Spanish, Catholic and commercial, tourist and local. Motifs change monthly, driven by the competition, the market's emphasis on novelty. . . . Quality varies wildly. . . . Artisans—they almost never refer to themselves as artists—are the first to admit that they don't always know what they are doing or why a piece is deemed good. If it sells, they say, it's good. It it's big and it sells, then it's very good. (Clients pay by the centimeter.)" Barbash, Oaxacan Woodcarving, 14. This fine little book is the primary source for my discussion of the woodcarving tradition.

9. Silvio Aguilar, "Artesanía desvalorizada," Las Noticias, June 15, 2002, 2A; Silvio Aguilar, "Orgullo e identidad," Las Noticias, June 13, 2002, 2A; Silvio Aguilar, "El precio de la belleza," Las Noticias, June 10, 2002, 2A; Noemí Oropeza and Hugo Morales, "El sombrero de palma, en crisis," Las Noticias, June 19, 2002.

10. Author's interviews with Armand Ocaña Ruíz, ARIPO official, May, 22, 2001, and author's interview with Professor Enrique Audiffred Bustamante, May 2002.

11. Author's conversations with Raymundo Sesma in 2000 as he was developing his project.

12. Raymundo Sesma, Advento (Mexico, CONACULTA, 1999). This is a CD describing the history, philosophy, projects, and other activities of Advento.

13. Ibid., 72.

14. Ibid.

15. Stephen, Mujeres zapotecas, 178ff, first discussed in depth all of the strategies deployed by the pueblo to advance its economic well-being and to preserve its autonomy—with respect to the government and the global market economy. His research provided the background for this section on Teotítlan's relationship to the government.

16. Ibid., 176.

17. Ibid.

18. Ibid., 114.

19. Paraphrased from Gobierno del estado de Oaxaca, Secretaria de Desarrollo Turistico, Dirección de Desarrollo, "Teotitlán del Valle Monografía" (unpublished manuscript, summer 2002).

20. See Stephen, Mujeres zapotecas, 32–34, 194–201, and his thorough description of the guelaguetza system.

21. Author's interview with Mary Jane Gagnier and Arnulfo Mendoza, summer 2002, provided all of the biographical details and confirmed much of the information about the pueblo in which Mendoza was born and raised

22. Kathleen Whitaker, Southwest Textiles: Weavings of the Navajo and Pueblo (Seattle: University of Washington Press, 2002), 32.

23. Arnulfo Mendoza, *Arnulfo Mendoza: obras recientes* (Oaxaca: Galería La Mano Mágica, Oaxaca, 1992), introduction (by Russell Ellison).

24. Mary Jane Gagnier, e-mail, June 21, 2002.

25. In conversation with the author, June 2002.

26. Peter Schjedahl, review of the 2002 Dokumenta at Kassel, *NewYorker*, July 1, 2002, 95.

27. Bonfil, *Obras Escogidas*, describes the importance of the milpa as a part of the indigenous civilization: if one crop fails, there are two other crops planted to sustain the pueblo.

28. Andrea Mandel-Campbell, "The Front Line: How Pottery Is Putting People Back into Mexico's Ghost Towns," *Financial Times*, January 19, 2002.

29. "The Mixteca is located in the western part of Oaxaca and represents seventeen percent of the total state's territory with about 16,360 square kilometers of mountainous terrain. . . . About 500,000 people, almost one-fifth of the state's population, live in the Mixteca's 189 municipalities and approximately 800 villages of no more than 100 to 200 families. . . . The ethnic composition of the region is mainly Mixtec, and mestizo. However, there are some enclave communities of Triqui, Amuzgo, Chatino, Populuca and Ixcateco speaking people within the region." Gaspar Rivera-Salgado, "Migration and Political Activism: Mexican Transnational Indigenous Communities in Comparative Perspective" (Ph.D. diss., University of California, Santa Cruz, 1999), 73.

30. This section is the result of my visit to studios in Huajuapán de León, home of Polvo de Agua, and of several interviews with José Luis García in June 2002 and subsequently.

6. The Past as Sustainable Resource

1. According to Raúl Zorrilla, of INAH, the original plan was to conduct the pilot project in Palenque under his direction. After he left that office, the pilot was redirected to Monte Albán.

2. Author's interviews with Nelly Robles, June 2001, 2002, and 2003; author's interview with Eduardo López Calzada, head of INAL, 2001 and 2002.

3. See Enrique Florescano, *Memoria indígena* (Mexico City: Taurus, 1999), for his brilliant discussions on the nature of the indigenous civilization, the ties that bound, and the distinguishing factors of the individual cultures.

4. This is not to suggest that the indigenous peoples in Mexico are angered only by the destruction of their religion and their religious sites. Their complex series of disappointments is also inextricably tied up in the loss of communal lands and the denigration of the larger culture over the last five hundred years. Author's interviews with Nelly Robles, June 2001, 2002, and 2003.

5. Nelly M. Robles Garcia, *El Manejo de los recursos arqueológicos en México: el caso de Oaxaca* (Mexico City: CONACULTA, INAH, 1998). Robles's dissertation was written in 1991.

6. Jorge Machorro, "Individualismo y colectivismo en Monte Albán," *Quartopoder*, 16-31 (January 2001), 24.

7. Pastor Hernãndez Santiago, "Centros proveedores de servicios: una estrategia para aten-der la dispersion de la población en Oaxaca," *Oaxaca Población en el Siglo XXI* 1, no. 3 (2001): 39–41.

8. *Las Noticias,* June 8, 2002.

9. In Mitla, the resistance is often based more on ethnic and class solidarity. Robles Gar-cia, *El Manejo do los recursos,* 73.

10. Ibid., 72–74.

11. These are not the only archaeological round-table discussions in Mexico. The famous round table in Palenque has been organized since 1993. It, of course, concentrates on the Mayan ruins instead of Monte Albán's Zapotec ruins and its extant populations and problems. The Palenque round tables have been also characterized by extraordinary and, at times, crippling feuds at the professional and political levels.

12. Robles quoted in *Proceso,* July 23, 2000, no. 1238, Internet edition, by Rosario Man-zanos y Columba Vértiz.

13. Arturo Jiménez, "Vigentes: las estructuras de la antiguedad oaxaqueña," *La Jornada,* June 13, 2002 (my translation).

14. "No obstante las transformaciones sufridas durante la Colonia y los siglos XIX y XX, diversas estructuras políticas de la antiguedad oaxaqueña, como la organización comu-nitaria y el sistema de cargos, además de la profunda noción de arraigo a la tierra, sobreviven y tienen considerable vigencia. Incluso esas formas son en parte la cause de 'toda esta efervescencia' que hoy se experimenta en diferentes niveles en ese estado, como el reciente conflicto por el que resultaron asesinados 26 campesinos en el paraja de Agua Fría." Arturo Jiménez, "Anuncian tercera Mesa Redonda de Monte Albán: vigentes, las estructuras de la antiguedad oaxaqueña," *La Jornada,* June 13, 2002, 15a.

15. Ibid.

16. *El Imparcial,* September 14, 2002, Internet edition.

17. Julio César Olivé Negrete and Augusto Urteaga Castro-Pozo, coordinators, *INAH: una his-toria,* vol. 1: *Antecedentes, organización, funcionamiento y servicios* (México, D.F.: Instituto Nacional de Antropología e Historia, 1988), 493.

18. Consejo Nacional para la Cultura y las Artes, *Programa Nacional de Cultura,* 2001–2006, 56, in the section "Campos, objetivos y líneas de acción."

7. Pueblo Culture

1. Gaspar Rivera-Salgado, "Transnational Political Strategies: The Case of Mexican Indige-nous Migrants," in Nancy Foner, Ruben Rumbaut, and Steven Gold, eds., *Immigration Research for a New Century: Multi-Disciplinary Perspectives* (New York: Russell Sage Foundation, 2000), 134–38.

2. Oaxacans have also migrated to Europe and elsewhere, but this chapter concentrates on their migration to Los Angeles.

3. One of the most piercing inquiries into this generational expectation and the subsequent ambivalence is the film *Oaxacalifornia*, made by David Bolaños and produced by Faction Films. In the film, the immigrants' two children, born in Fresno, California, seem to fit neither in Mexico nor in the United States: "We are not from here / We are not from there." They like the *fiestas* in Oaxaca, but the boy wants to go to college in the United States and have all of the opportunities offered by America: "I want to live the dream but not forget who I am." Both the boy and the girl are always ready to return to Fresno after the *fiesta* season is over.

4. Ibid. The chief character says: "I think we all leave for economic necessity or for adventure or to experience new things."

5. Each state and each pueblo within a Mexican state has a different history with respect to migration. Migration from Mexico to the United States is a deeply nuanced activity. For example, not all migrants have been coming across the border for as long as have the Oaxacans, and not all have the same survival skills and the same abilities to deal with the "coyotes" or the moneylenders who make the deals with the coyotes possible. This a particular story and cannot be generalized as a Mexican-America story.

6. See chapter 6 on artisanry.

7. Olga Montes García, "Identidad y migración: el caso de los zapotecos en Los Angeles," *Revista de educación y cultura*, no. 7 (October-December 2001), 26–32, and the film *Oaxacalifornia*.

8. Montes García, "Identidad y migración," 31. "Como el del conocimiento de todos, la pertenencia a un pueblo india se da a partir del cumplimiento en el sistema de cargos. Si el migrante no participa dentro de el, no es considerado parte del mismo, por lo tanto su regreso se vuelve más dificil, puede ir a las fiestas, pero su calidad es la de un visitante, sin derechos."

9. Rivera-Salgado, "Transnational Political Strategies": "The 3x1 program is a federally administered program, but each state has implemented its own version. In Oaxaca for every dollar the associations send for community projects, the federal, state, and municipal government would match the amount, therefore the name 3x1." See also Rafael Alarcón, "The Development of the Hometown Associations in the United States and the Use of Social Remittances," in Rodolfo O. de la Garza and Briant Lindsay Lowell, eds., *Sending Money Home: Hispanic Remittances and Community Development* (New York: Rowman & Littlefield Publishers, 2002).

10. It is not unusual for Mexicans to have meetings with the governor and elected officials at, for example, the Davidson Conference Center at the University of Southern California. Elected officials will meet with the ex-patriot Mexicans to discuss any number of matters, including the right to vote in Mexico, if they are living in the United States. Such a meeting with this constituency would not typically have happened in

Oaxaca unless there had been a massacre or some equally horrendous event that demanded immediate political attention.

11. Macario Matus, a Zapotec writer quoted by Yvon Le Bot, in the catalogue for *Chiapas>Mexico>California: un monde fait de tous les mondes* (Paris: Parc de la Villette, 2002), 51.

12. Jessica Garrison, "Activist to Head Agency on Mexicans in U.S.," *Los Angeles Times,* November 25, 2002, B1, B7.

13. The film *Oaxacalifornia.*

14. Montes García, "Identidad y migración," 26, argues that in order not to have to live as a stranger, in the sense of Camus's stranger (without name, home, place, or identity), the Zapotec Oaxacans have "created different mechanisms, which certainly intersect and are simultaneous: that of how they make their new home in the USA, which is the future, and that which they do by going back periodically and honoring the traditions in Mexico—which is the past."

15. Author's telephone interview with Miguel Angel Corzo, November 2002.

16. Author's telephone interview with Luciano Cedillo Alvarez, then Coordinador Nacional (CNRPC) of the project from the INAH perspective, April, 29, 2003.

17. Néstor García Canclini, *Transforming Modernity: Popular Culture in Mexico,* trans. Lidia Lozano (Austin: University of Texas Press, 1993), 109: "What matters for a fact or an object to be popular is how popular sectors use it rather than its place of origin (an Indian community or a music academy), or the presence or absence of folkloric symbols (rusticity or the image of a pre-Columbian god). Let us add a paradox: earthenware from Tlaquepaque, in Guadalajara, produced by Jalisco artisans inspired by archaic designs but working in workshops owned by American business executives, where they submit to their stylistic modifications and lose economic and symbolic control of the work through selling to tourists, does not constitute popular art. On the other hand, a masterpiece by Goya, undertaken by Indian and mestizo peasants from Aranza, in Michoacán, with the aid of artists from the Taller de Investigación Plástica de Morelia (Workshop for Fine Arts Research of Morelia), to make a mural that addresses community problems from their perspective, does."

18. Author's interview with Gerardo Rivera and Gustavo Santiago Marquéz, the president of the Federación Oaxaqueño de Comunidades y organizaciones Indígenas en California (FOCOICA) and also vice-president of the Hometown Association of Yanhuitecos.

19. Factual information by Francoise Descamps, Valerie Dorge, and Giora Solar, "The Retablo of Yanhuitlan," *Conservation, the GCI Newsletter* 14, no.2 (1999): 16–20.

20. Author's telephone conversation with Andrea Rothe (after his retirement from the Getty Museum), December 2002.

21. Author's interview with Suzanne Booth, October 2001.

22. Author's interview with Eduardo López, in his office, summer 2001.

23. "Agenda Cultural," *Las Noticias*, December 19, 1993.
24. Miguel Zafra, as quoted by Gaspar Rivera Salgada, "Cultural Actors in Oaxacalifornia," in Le Bot, *Chiapas> Mexico>California*, 109.
25. "La Martiniana." These are lines from an indigenous folk song translated by Lila Downs and sung on her compact-disc *Border/Lila Downs/La Linea* (2001), quoted with permission from the artist.
26. Interview with Lucero González, at the opening of her exhibition in Santo Domingo, June 2001.
27. Le Bot, *Chiapas>Mexico>California*, 33.
28. Poem by Sandra Lorenzano, "Eyes are flames, what they see are flames," 44, in Lucero González, *Juego de pelota: metáforas visuals* (Mexico City: Centro Cultural Santo Domingo Oaxaca and Universidad del Claustro de Sor Juana, Mexico, 2002).
29. Ibid.
30. Quoting the curator Yvon Le Bot, in *Proceso*, no. 1334 (May 26, 2002), 68.

Conclusion
1. Author's interview with Eurodo Fonseca Yerena, June 2002.

Index

mexicanidad, 1–2, 19, 63, 131
Mexico City: cultural development of,
 15–22; Oaxaca Style *versus* art in,
 137–40; post-nationalist art in, 24
*Mexico City: An Exhibition about the Exchange Rates
 of Bodies and Values* (exhibition), 138, 139
migradólare, 233–34
migration: cultural preservation Yanhuitlán
 and, 239–50; culture of juego de pelota
 and, 250–55; dream of, 231–36; global-
 ization and, 227–31; nightmare of, 236–
 39; PAN government and, 260; patterns,
 225–27
mining museums: at La Natividad, 42–43,
 44, 45; National Museum of Coal,
 Coahuila, 43–45
Mis Amigos Negros y Mis Amigos Blancos (Olguín),
 153–54, 155
Mitla (archaeological site and pueblo),
 211–12, 218–19
Mito y Mágico (exhibition), 191
Mixed Feelings: Art in the Post-Border Metropolis
 (exhibition), 139
Mixtecos, 136–37, 177–78, 197. *See also*
 Hernández, Sergio
Monte Albán, 61, 95; as archaeological site,
 206–7, 209–11, 221–23; Children
 Volunteer Custodians program, 217–18,
 219; Commission for the Rescue of,
 220–21; indigenous peoples demands
 on, 218–19; revenues of, 215–16;
 Robles-García and, 208–9, 213–14;
 tumultos and, 218–19
Moore, George, 82, 159–60, 164
Moore, Henry, 82
Morales, Alberto, 98
Morales, Rodolfo, 89–99, 100, 260; artistic
 influence of, 131–32, 133; civic achieve-
 ments, 92–99; copal tree reforestation
 and, 175; Oaxaca-style philanthropy and,
 60; Toledo and, 75
Morales, Teresa, 38–39, 45, 47, 50, 54–55,
 217–18
Morales-Moreno, Luis Gerardo, 19
Mujer Montana (Guisande), 157
MUNAL, Mexico City, 21
Murat, José, 234

Murrieta, Gallaga, 52–53
Museo del Bellas Artes, Mexico City, 21
Museo del Virreinato, Mexico City, 20
Museum of Applied Arts, Vienna, 203
Museum of History, Mexico City, 19
Museum of Modern Art, Mexico City, 20–21
Museum of Natural History, Los Angeles,
 181
Museum of San Carlos, Mexico City, 19–20
Museum of the Templo Mayor, Mexico City,
 21

NAFTA (North American Free Trade Agree-
 ment), 197, 229–31
National Museum, Mexico City, 18
National Museum of Anthropology, Mexico
 City, 19, 37–38, 203, 207–8
National Museum of Coal, Coahuila, 43–45
national narrative, 3–4
Native American Graves Protection and
 Repatriation Act (NAGPRA), 52–53
Newell, Gillian, 52–53
Nieto, Rodolfo, 134
Noticias, Las, 176–77, 178, 249
Novena (Flores), 151
nueva museologia, 56

Oaxaca: arts and culture transitions in, 4–5;
 caciques/cargo-driven artist philanthropy
 in, 59–60; communitarian museum
 movement in, 9, 38–47, 55–56; con-
 temporary art museums in, 6–7; creativ-
 ity and politics in, 61–62; description of,
 25–26; INAH and historical center of,
 208; selection for study, 13–15
OaxaCalifornia, 261. *See also* migration
Oaxacan Union of Communitarian
 Museums, 46
Oaxaca/USA, 253
Oaxaqueño, El, 239
Ocotlán, 60, 92–97, 260
Olguín, Guillermo, 99–100, 152–55
Orozco, Gabriel, 138, 196
Orozco, José, 62
Ortiz, Rubén, 139
Otis Art Gallery, Los Angeles, 191
Oxatapec communitarian museum, 54